William
Fred T. I
Chrysler Building

MW00835017

William Van Alen, Fred T. Ley and the Chrysler Building

GEORGE C. KINGSTON

McFarland & Company, Inc., Publishers
Jefferson, North Carolina

LIBRARY OF CONGRESS CATALOGUING-IN-PUBLICATION DATA

Names: Kingston, George C., 1948– author.
Title: William Van Alen, Fred T. Ley and the Chrysler Building /
George C. Kingston.
Description: Jefferson, North Carolina : McFarland & Company, Inc.,
Publishers, 2017. | Includes bibliographical references and index.
Identifiers: LCCN 2017003977 | ISBN 9781476668475
(softcover : acid free paper) ∞
Subjects: LCSH: Chrysler Building (New York, N.Y.) | Van Alen, William,
1883–1954—Criticism and interpretation. | Ley, Fred T., 1872–1958. |
Skyscrapers—New York (State)—New York. |
New York (N.Y.)—Buildings, structures, etc.
Classification: LCC NA6233.N5 C3756 2017 | DDC 720/.483097471—dc23
LC record available at https://lccn.loc.gov/2017003977

BRITISH LIBRARY CATALOGUING DATA ARE AVAILABLE

ISBN (print) 978-1-4766-6847-5
ISBN (ebook) 978-1-4766-2789-2

Front cover photograph of Chrysler Building by the author

Printed in the United States of America

*McFarland & Company, Inc., Publishers
Box 611, Jefferson, North Carolina 28640
www.mcfarlandpub.com*

To the memory of my father,
George William Cassian Kingston, P.E.,
who taught me to appreciate the structure
of buildings and bridges

Acknowledgments

My thanks to the many archivists and librarians who aided me in my research for this book, especially Maggie Humberston of the Springfield Archives; Anne Guiney of the Van Alen Institute; Emily Gibson of the Vizcaya Museum; C. David Gordon and Kara Fossey of the Fort Devens Museum; Dennis Picard and the staff at the Eastern States Exposition; Peter Stern at the University of Massachusetts W.E.B. Du Bois Library; and the staff of the Architecture Collection at the New York Public Library. I would also like to thank the members of Sylvia Rosen's writing group and Carol Munro's Crit Group for their candid feedback and helpful suggestions. Special thanks go to my wife, Jean L. Delaney, without whose support, encouragement and editing this book would never have been completed.

Table of Contents

Preface

An important part of the history of architecture and construction in the first third of the 20th century is the evolution and refinement of steel framed, curtain walled structures. These gave architects previously unheard of freedom in designing buildings of not only unprecedented height but of entirely new forms. These buildings had to be constructed using new techniques and methods of organization which were evolving along with the designs. This book explores this parallel development in design and construction through the lives and careers of two of the most important participants in these developments, the architect William Van Alen and the builder Fred T. Ley.

This book owes its genesis to a meeting of the Pioneer Valley Planning Commission, which includes the city of Springfield, Massachusetts, as one of its members. A remark was made by someone I could not identify, that even though Springfield bills itself as the "City of Firsts," many of the formerly prominent people who came from that city have been forgotten. He followed this by asking: "How many people even know that the man who built the Chrysler Building came from Springfield?" That got me thinking, and after a little digging, I discovered that the general contractor for the Chrysler Building was Fred T. Ley, the son of a Springfield tobacconist and singer.

Additional research revealed that Fred T. Ley had started his career as a rod man on a city survey gang and proceeded to create one of the largest construction companies in the world. I thought that a book about him might generate some local interest. As I continued my research, I realized that his relationship with Walter Chrysler's architect, William Van Alen, was crucial to the climax of the narrative. However, when I tried to learn more about Van Alen, I found that there were no extended biographies of him in print, only anecdotal articles in a scattering of publications. It was then that I realized that more work needed to be done.

1

Preface

Both William Van Alen and Fred T. Ley started their work with tradi-
tional materials, tools, and designs. Each, in his own way, embraced the new
construction technologies that became available to them. They were both on
the forefront of the revolution brought about by steel framed, curtain wall
buildings and their legacy continues to this day. Therefore, the narrative is
not only about two exceptional men, but of an entire industry that was trans-
formed from masonry to steel and reinforced concrete over the course of the
four decades from 1890 to 1930. This was a period of intellectual, artistic, and
political ferment, all of which contributed to the architecture and construc-
tion of the time. It encompassed the Belle Époque, the First World War, and
the Jazz Age. Modern Art, Art Nouveau, and Art Deco all flourished during
these years. The culmination of this for Van Alen and Ley was the Art Deco
masterpiece known as the Chrysler Building.

Since neither man left any significant archive of papers, it has been neces-
sary to fill in the broad outlines of their lives with extensive research in con-
temporary newspapers and periodicals, as evidenced by the chapter notes
provided. Remarkably, many of the buildings that they created are still extant
and in use, in some cases more than 100 years after being constructed. Others
are lost forever, without even a photograph to document them. I have pro-
vided as complete a catalog as possible of the work of William Van Alen and
selective catalog of the more important work of Fred T. Ley's company as
appendices to the book, for those who are interested in seeking out these
buildings.

It is my hope that this book will inspire you to look at these buildings
in a new light, and to better appreciate the contributions of these two men
as participants in this revolution.

1

The Dreamer
and the Builder

When one of the most creative architects of his generation is commissioned by a wealthy industrialist to design a building that will be the tallest in the world, the owner expects to get something special. When he gives the contract to a builder who has a reputation for completing difficult jobs on time and on budget, he expects that design to be executed perfectly. In the fall of 1928, when Walter P. Chrysler commissioned William Van Alen to design the structure and Fred T. Ley to build it, Chrysler got his eponymous Art Deco skyscraper.

The building that Van Alen and Ley would produce, with its soaring tower emerging from a stepped base and capped by a shining stainless steel spire, has become an anchor of the New York skyline. Alternately praised for its originality and damned for its Art Deco excess, it has endured and has found a special place in the hearts of all New Yorkers. In a poll of more than one hundred architects, builders, critics, and scholars taken by the Skyscraper Museum in 2005, it was named as their favorite New York building. Ninety percent of those polled included it in their top ten.[1] Those responsible for creating this building were no ordinary men.

Whether you love it or you hate it, the Chrysler Building at 42nd Street and Lexington Avenue in midtown Manhattan, with its stainless steel cap and spire, is a unique element of the New York skyline. A monument to the Jazz Age, it was finished just as that age was coming to an end. Yet it endures as a working building, filled with bustling offices and shops, just as it was when it opened in early 1930.

Walter P. Chrysler, the owner, William Van Alen, the architect, and Fred T. Ley, the general contractor of New York City's latest skyscraper project, met as a team for the first time during the first week of November 1928. The meeting

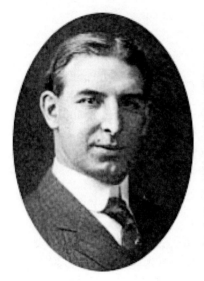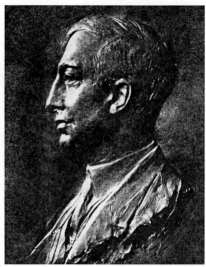

Left: **Fred T. Ley, ca. 1909 (McPhee).** *Right:* **William Van Alen, from a bronze plaque by Joseph P. Pollia, ca. 1930 (Pencil Points).**

took place in Walter Chrysler's office at 347 Madison Avenue, just a few blocks away from the building site. Chrysler, Van Alen and Ley were all self-made men, who had risen from the working and middle class to reach the peaks of their professions. Still, they were very different individuals, each of whom would bring his own unique skills and personality to the task ahead of them.

Chrysler was a hardnosed automobile manufacturer and deal maker. Van Alen was an École des Beaux-Arts educated architect who had introduced many of the elements of modern building design and who dreamed of design-ing great buildings that reflected his own unique vision. Ley was a builder who had a reputation for getting the job done faster, safer and less expensively than anyone else in his field.

At 809 feet tall, the 68-story skyscraper that Walter Chrysler planned to build on the corner of 42nd Street and Lexington Avenue was to be the tallest building in the world, 17 feet taller than the Woolworth Building which had held the record for the previous 15 years. To accomplish this feat, these three men would have to work closely together for the next year and half, with Van Alen and Ley needing to develop deep levels of cooperation and trust, espe-cially because construction was going to start before the design was finalized. This was a situation that both Walter Chrysler and Fred T. Ley had become familiar with during their careers. The sooner construction was started the

sooner it would be done and the sooner the project would start to pay, but the uncertainty only increased the pressure on William Van Alen.

Born in 1875, Walter Percy Chrysler was the son of a railroad engineer. After finishing high school, he had gone to work as a sweeper in the Union Pacific Railroad maintenance shops in Ellis, Kansas. He worked his way up as a mechanic and manager on a succession of railroads, until switching to the automobile industry and taking the job of general manager at the Buick plant in Flint, Michigan, in 1911. He brought to the Buick Division of General Motors the manufacturing methods used in the railroad shops, including the concept of keeping each worker supplied at his work station with all the materials and parts he needed so that he never had to leave his place to replenish them. This sped up production and helped revolutionize the way automobiles were built. He also learned the art of the deal, eventually founding the Chrysler Corporation and building it into the third largest automobile company in America during the 1920s. In 1928, he was 53 years old and fresh from his acquisition of the Dodge Corporation. The building he wanted to have erected in mid-town Manhattan was intended to be a real estate business for his sons to run, as well as a monument to himself. He was financing its estimated $14,000,000 cost out of his own pocket. While the Chrysler Corporation would be one of the many tenants in the building and there would be a Chrysler automobile showroom on the ground floor, it was not going to be the Chrysler Corporation Building. It was going to be the Walter P. Chrysler Building. To emphasize this, the legal entity that was formed to own and manage the building was called the W.P. Chrysler Building Corporation. As the holder of the purse strings, he was the ultimate decision maker and would play a hands-on role throughout design and construction.[2]

The architect, William Van Alen, was born and still lived across the East River in Brooklyn, New York. He was a tall man, six feet in height with blue eyes and thinning, light brown hair.[3] His father, who a owned a small company that manufactured cast iron stoves, had died when William was only 14.[4] Two years later, in 1898, William went to work as an office boy and later became a draftsman for Clarence True, at that time a major architect-developer of row houses on the Upper West Side of Manhattan.[5] After laboring for years at the drafting tables of several architectural firms, Van Alen won the prestigious Paris Prize of the Society of Beaux-Arts Architects in 1908 when he was 26 years old. The prize enabled him to study for three years at the École des Beaux-Arts in Paris, France, and to experience the pre–Great War cultural ferment in that city. On his return in 1911 he established his own architectural

practice, vowing to produce innovative designs and declaring "none of the old stuff for me."[6] Over the next decade, alone and in partnership with others, he developed a reputation for his highly original and innovative designs of high rise buildings, restaurants, retail stores, and private residences. He had been retained by the real estate speculator William H. Reynolds to create a preliminary design for a slightly shorter skyscraper to be built on the corner of Lexington Avenue and 42nd Street, but when Reynolds sold the lease on the land and the building design to Walter Chrysler, there was no guarantee that Van Alen would continue as the architect. Under the terms of their contract, it was Reynolds who owned the plans, not Van Alen. It was not until November 5, 1928, that Walter Chrysler formally gave Van Alen the commission and demanded a new design for a building that would not only be the tallest in the world, but that would reflect Chrysler's own personal vision. Van Alen accepted the job without asking for a written contract, an oversight that would later come back to haunt him.

The builder, Fred T. Ley, came from Springfield, Massachusetts. His father was a cigar maker and, in his spare time, also a noted bass singer and choirmaster. Fred left school at the age of 15 and went to work in the Springfield Department of Highways and Bridges, where he learned to survey and progressed to the position of assistant engineer.[7] When he was 20, he set up his own contracting company. This eventually expanded to become one of the largest general contractors in the country, with offices in New York, Springfield, Boston, and South America. By 1928, the 56-year-old Fred T. Ley had been building in the New York area for 13 years and was known for his ability to build quickly and at low cost, which he did by virtue of his superb organizational skills and attention to finances. He brought to construction the same kinds of organizational concepts that Walter Chrysler had brought to manufacturing, and, like Chrysler, he was not afraid to get his hands dirty. His motto was "No job too big or too small," which was appropriate for the endeavor he was about to embark on. Without going out to bid, Walter Chrysler gave him the contract as soon as he closed the deal for the building lot on October 15, 1928. Fred T. Ley immediately engaged the largest demolition contractor in New York, Albert A. Volk, and set him to work on taking down the existing, low-rise buildings on the site.[8] By the time Van Alen was confirmed in his position as architect and was starting to draw his first sketches, Fred T. Ley had already reduced 405 Lexington Avenue to a hole in the ground and was ready to start excavating for the footings for the massive columns that would support the immense weight of the skyscraper to be.

William Van Alen and Fred T. Ley were both participants in a revolution in architecture and construction that began with three significant innovations. The first was the invention of the "basic" Bessemer steel process in 1873, which allowed the mass production of high quality steel at reasonable cost. This made steel an economically viable building material. The second was the development of "curtain wall" construction. This is generally attributed to the Chicago architect William Le Baron Jenny who first fully utilized it in his Home Insurance Building in that city between 1883 and 1885. Curtain wall construction shifted the load of the upper stories from the outer walls of the building to an iron or steel frame, on which the wall panels for each floor rested. This eliminated the need for massive masonry walls at the base and allowed for greater height and the increased use of glass in the exterior walls. The third was another new material, steel reinforced concrete. By embedding inexpensive steel reinforcing bars in the poured concrete, tensile strength was added to the compressive strength of plain concrete. Reinforced concrete construction was stronger, more rigid, and more fireproof than traditional construction methods. It was also faster and more cost effective to construct with, because floors and walls could now be cast in place rather than laid down one brick or tile at a time.

This revolution freed William Van Alen from the structural limitations of masonry walls and enabled the development of new, vastly simplified styles, but it required new expertise in the use of iron and steel, especially in specifying the dimensions of the columns and beams. From Fred T. Ley's perspective, the new materials and techniques enabled lower cost and more rapid construction, but required new trades, new suppliers, and especially, new ways to organize the construction process.

When the three men met, Herbert Hoover had just beaten Al Smith for the presidency by a landslide, Franklin Delano Roosevelt had won the race for governor of New York State, and Gentleman Jimmy Walker had been re-elected mayor of New York City.[9] The Jerome Kern musical, *Show Boat*, was playing at the Ziegfeld Theater on Broadway, and the country was entering the buildup to the last Merry Christmas season of the Roaring Twenties.[10] In less than a year, the stock market would crash and the economy would begin its long slide into the Great Depression. The Dow Jones Industrial Average, which stood at around 290 at the time that the three men met, bottomed out at 41 on July 8, 1932.[11] There were no intimations of doom at that first meeting, however. In November 1928, the economy was booming and plans for new skyscrapers were being announced almost daily. Van Alen's former partner,

H. Craig Severance, was designing a rival building for George Ohrstrom and the Bank of Manhattan. It was to be built at 40 Wall Street, and Severance also intended it to be the tallest in the world. What was different about Van Alen's project was that it was being funded not by speculation and leverage, but by the deep, cash-filled pockets of Walter P. Chrysler.

At this first of many weekly meetings of the construction team, the most important question was the location and size of the footings for the columns that would support the immense weight of the building. It was impractical to dig down to bedrock across the entire site. Instead, Fred T. Ley planned to have his excavation subcontractor, the Godwin Construction Company, excavate to a solid base only where the columns were to go. Until that was decided, it was impossible to proceed. Van Alen had already produced drawings for Reynolds, albeit for a smaller building, and he decided to stay with the same basic design, including the column spacing. The column bases would be increased in size to take the load of the proposed 68-story tower, but kept in the same position. Excavation could proceed while Van Alen worked out the details of floor plans and exterior design.

Apparently Fred T. Ley and William Van Alen hit it off well at this initial meeting, because as the project went forward there were no recorded conflicts between the two of them. Van Alen produced the designs while Fred ordered the steel, brick and concrete and hired and supervised the subcontractors and work crews who turned those designs into reality. In fact, this was not Fred T. Ley's first "tallest building." Back in 1910 he had built the tallest building in Springfield, Massachusetts, the Kimball Hotel, on Chestnut Street. It was 125 feet tall on the front elevation, equal to the height limit that the state legislature had set in the city after the Massachusetts Mutual Insurance Building was erected to that height in 1908.[12] That limit stayed in place until the 1950s. However, the Kimball was built on a hillside, and its walk-out basement in the rear elevation, which was downhill from the street, added another ten feet to the free height, making it technically the tallest building in Springfield.

After that first meeting, construction moved rapidly. Walter Chrysler wanted the building ready for tenants by May 1, 1930, the first of May being the day on which leases traditionally expired in New York City. The footings were completed by March 13, 1929, and the first columns were set on them by April 9. Van Alen's design called for a base that measured about 200 feet along Lexington Avenue using the full frontage from 42nd to 43rd Streets, and about 170 feet along 42nd Street. This base rose ten stories from the street with two courtyards cut out of it on the 6th floor. The 11th to the 30th floors

were set further back. Out of this relatively low base, the planned tower would rise straight up from the 31st to the 68th story and be topped by a crystal dome.[13]

The lowest members of the central columns that had to support the full weight of the tower weighed 35 tons apiece. When the building was complete, each of them would support 3,700 tons of the structure.[14] The steel members were fabricated in a shipyard in New Jersey from steel shapes that had been rolled in Pennsylvania, and brought to the site as needed in the exact order in which they were to be erected. It was a logistical problem perfectly suited to Fred T. Ley's organization. As the building progressed, the steel erectors would achieve a speed of four stories per week, a rate that was unheard of at the time.

The remarkable partnership between these three men, Walter Chrysler, William Van Alen and Fred T. Ley, was not simply fortuitous. Walter Chrysler had built his automobile company and his fortune in large part due to his ability to find the right man for the job he wanted done. He chose William Van Alen as his architect because Van Alen's designs were not only avant-garde, they were buildable at reasonable cost. He chose Fred T. Ley as his builder because of Ley's reputation for speed, economy, and safety, and his decades of experience in building large scale, steel frame structures.

The life of Walter P. Chrysler has been well chronicled, most notably in his autobiography, *Life of an American Workman*, co-authored by Boyden Sparkes, and the more recent biography, *Chrysler: The Life and Times of an Automotive Genius* by Vincent Curcio.[15] On the other hand, in spite of having the successor organization to the Society of Beaux-Arts Architects, the Van Alen Institute, named after him, William Van Alen is little known outside of architectural circles, and Fred T. Ley has largely been forgotten. Yet without William Van Alen and Fred T. Ley, there would be no Chrysler Building as we know it. It is to them that we owe this icon of the Jazz Age.

2

The Builder
Lays a Foundation

Frederick Theodore Ley grew up in an entrepreneurial family, living in rapidly growing New England cities. He was born on April 22, 1872, in Springfield, Massachusetts, the oldest son of Frederick W. Ley and Martha (Hallenstein) Ley.[1] As with many sons who share their father's first name, Fred always used his middle initial and was known as Fred T. Ley for the rest of his life. Four younger brothers and sisters, Harold, Hendel, who was called Annie, Leo and Emma, followed him.[2] The five Ley children were close, and the three brothers would work together for most of their lives.

Fred T.'s father, Frederick W. Ley, was born near Cologne in the Prussian Rhineland, around 1848, the son of a schoolteacher who emigrated to the United States in 1860 to escape the political repression that followed the failed revolution of 1848. He left his wife and daughters in Germany but brought his two sons with him. Frederick W. was 12 years old at the time. They first settled in New York City. Frederick W. was too young to be drafted during the Civil War and he did not choose to enlist. After the war, in 1869, when he was 21 years old, Frederick W. moved to Springfield, Massachusetts, where he found work as a cigar maker for the W.H. Wright Company.[3]

The W.H. Wright Company, located downtown on Main Street, was the largest cigar maker in the city, employing 30 men and ten women and selling about one and a half million cigars a year. Springfield was situated just north of the extensive shade tobacco fields in Connecticut, and the cigars were made mostly from Connecticut Valley tobacco with some Havana leaf, imported from Cuba, mixed in. The cigars were shipped all over the country.[4]

In Springfield, Frederick W. Ley met and married Martha Hallenstein, the American born daughter of German immigrants, in 1870.[5] Two years

later, in 1872, with the help of his wife's mother, Hendel Alexander Hallenstein, Frederick W. was able to buy a house in a fashionable neighborhood at 37 Dwight Street in Springfield for $10,000, shortly before his first child, Fred T., was born.[6] Mrs. Hallenstein took in German borders to help pay the bills. The address was close to the downtown business area so Frederick W. could walk to work. The horse-drawn street railways were only two years old at the time, and had not yet established a reputation for reliability, so much of the working population in the city was concentrated within convenient walking distance of their places of employment.

When Frederick W. Ley arrived in Springfield, it was a bustling city of almost 25,000 people.[7] The city had benefited greatly from the Civil War, which not only was responsible for a huge increase in employment at the federal armory, but also resulted in the growth of independent small arms manufacturers and their suppliers, as well as factories for swords, bayonets, uniforms and railroad cars. These included the Ames Manufacturing Company in Chicopee, which produced most of the swords used by the Union Army; Smith and Wesson, which produced side arms; and, the Wasson Company, which produced railroad cars and gun carriages. With its position on the Connecticut River at the intersection of major north-south and east-west railroads, the city was a transportation hub for troops and supplies. Its population had increased by 65 percent between 1855 and 1865.

As a result of this increase, the city government was forced to improved its infrastructure, installing water mains and a trunk sewer. These improvements, along with the skilled labor that had been attracted to the city by jobs in the munitions factories, positioned the city to become a major civilian manufacturing hub when the hostilities ended. However, the transition did not take place immediately, and the early 1870s saw a general recession as factories made the shift to peace time production and struggled to absorb the returning soldiers into the workforce. Many of these men, having joined the army as teenagers, had no experience other than military service, and some of them suffered from what today we call post-traumatic stress disorder. Both of these conditions were barriers to their employment in skilled trades.

In addition to his day job as a cigar maker, Frederick W. Ley was a well-known vocalist. He was considered to be the foremost basso in western Massachusetts and was in much demand as a soloist. He was a member of the Orpheus Club, which was an exclusive all-male choral ensemble in Springfield and a member of the chorus of the Springfield Conservatory of Music.[8] The Conservatory was a largely amateur group that performed and promoted

classical music in the city. They specialized in the operettas of Gilbert and Sullivan, but performed the works of other composers as well. In May of 1875, Frederick W. sang an aria from Mozart's *The Magic Flute*, possibly Sarastro's "O Isis und Osiris," as a part of the Conservatory's musical program.[9] These musical events, which often included visiting performers of national status backed by local groups, were an important part of the social life of the city in an era before radio and television, and attracted the upper crust of city society. Although he was only a cigar maker by day, Fred's vocal talents gave him the opportunity to get to know these industrialists, politicians, and bankers, contacts which would be important to him and his family.

Frederick W. Ley also sang as a bass soloist in the choir of the North Congregational Church in Springfield, of which he was a member.[10] This church was located on the corner of Salem and Mattoon Streets and the building, which was completed in 1873, still stands. Today it is the home of the Hispanic Baptist Church.[11] As his experience with sacred music grew, he progressed to the paid position of choirmaster, which would also have a significant influence on him and his family.

In February 1879, when Fred T. was seven years old, his father, Frederick W. Ley, had accumulated enough capital to leave W.H. Wright and open his own cigar factory at 43 Howard Street. This new factory specialized in pure Havana cigars, which used tobacco imported from Cuba. They were a step up in quality from the ones made from local tobacco by W.H. Wright.[12] Two months later, in April, he opened a retail store at 115 State Street, just a couple of blocks away, to sell his cigars, along with loose tobacco and pipes.[13] These businesses provided a solid middle class life style for his growing family, but the Ley's were far from affluent.

In 1882, Frederick W. was offered the position of choirmaster for the Piedmont Congregational Church in Worcester, Massachusetts, about 50 miles east of Springfield. He closed his factory and retail store and moved the family to that city. Piedmont Congregational was a relatively new church, which had been founded in 1872 to serve the growing population in the southern part of the city of Worcester, which was also expanding as a manufacturing center in the post–Civil War era.[14] Fred T. was only ten years old at the time, and the move meant changing schools and adjusting to a new city, but it also accustomed him to the idea that it was important to go where the money was. While in Worcester, Frederick W. Ley continued his singing career, appearing in the cast of a number of opera productions.[15] The youngest member of the Ley family, Fred T.'s sister Emma, was born in Worcester on August 2, 1885.[16]

The job at the Piedmont Church lasted until 1886 when Frederick W. Ley received a more lucrative offer to take over the choir of the Hope Church at the corner of Winchester and State Streets in Springfield.[17] In March of that year, he brought his family back to that city and also took a day job as a supervisor for the Springfield Cigar Company.[18] The family moved into a house at 133 Sherman Street, which Frederick W. had bought from H.M. Cutler for $3600.[19] It was smaller than the house on Dwight St. that they had lived in earlier, but they no longer took in boarders.[20] The new address was only a few blocks away from the church where Frederick W. worked.

While his father pursued his music, Fred T. Ley attended public grammar schools in Springfield and Worcester. The family was not poor, but as his brother Harold recalled, "My father was never a money-maker. I doubt if he ever made more than 30 dollars a week in his life! The family had only enough income to 'get by,' so it behooved us all to get out and earn money just as soon as we were able."[21]

The three Ley boys did odd jobs, mowed lawns, shoveled walks and picked berries to earn what they could. In addition, Harold had a paper route and Fred T. worked as a street lamp lighter, lighting the gas lamps every evening and turning them off in the morning. All of their earnings went to help support the family.[22]

This early focus on learning a trade, working hard, and earning money was a major factor in shaping Fred T. Ley's career. As a builder, he would always be looking for ways to make the job pay, not through cutting corners, but by paying attention to details and doing things faster and more efficiently than his competition.

On July 12, 1886, when he was 14 years old and just arrived back in the city from Worcester, Fred T. enrolled in a four-week-long "industrial school" which was held in the basement of Springfield High School and taught by Mr. George B. Kilbon. The purpose of this industrial school was to prepare the boys for the workplace by teaching them how to use their hands. As we will see, this was the same philosophy that lay behind the Pratt Institute in New York, which William Van Alen would attend many years later. The first lesson given to the boys was on how to nail wooden planks together to make boxes. They started with thick pieces of wood and gradually progressed to thinner and thinner pieces as their skills improved.[23] That sort of training could lead to a factory job or one as a skilled laborer, but Fred T. had higher ambitions than those. That fall, he enrolled in Springfield High School but left after his first year to get a job that paid.[24]

Although they did not have much money, the Ley family was acquainted with the more powerful families in the city through Frederick W. Ley's role as a soloist and lead singer in many of the musical performances that made up a significant part of the city's social life. Probably through these connections, at the age of 15, Fred T. Ley entered the employ of the city engineer, Charles M. Slocum, in the Department of Roads and Bridges. There he learned to survey land and to manage projects. He also picked up the basics of civil engineering. In addition to learning new skills, Fred also made important contacts. He became acquainted with and worked alongside of the men who influenced how city contracts were awarded. His contacts in the Water Department would prove especially valuable a few years later when the city decided to upgrade its water system, first by installing new filters at its reservoir in Ludlow and then by creating an entirely new water supply system. Fred T. Ley soon acquired the title of assistant engineer.[25]

Although a 15-year-old boy with the title of assistant engineer would be unusual today, a century ago, anyone could work as an engineer without a license or other formal proof of competency. The first engineering licensure law was not enacted until 1907 when Wyoming began the practice. Like lawyers, would-be engineers in the late 19th century learned on the job by working and studying with established professionals. In this way, Fred T. Ley learned enough engineering to carry out his first independent jobs, but his real talents lay in management. In the years ahead he would hire the best engineers and supervisors he could find as his company expanded.[26]

While Fred T. Ley was busy learning the basics of civil engineering, tragedy struck the Ley family. On February 20, 1888, while his father, Frederick W. Ley, was on his way to sing in a concert given by the Hampden County Musical Association with members of the Boston Symphony Orchestra in the old Springfield City Hall, he slipped on the icy steps. The fall severely injured Frederick W.'s back, an injury which would eventually result in his losing the ability to walk.[27] For almost a year, with the support of his family and friends, including his oldest son, Fred T. Ley, he struggled to maintain his health and his occupations. However his condition worsened and he finally decided to travel abroad in search of a cure.

On January 9, 1889, Frederick W. Ley sailed from New York City on the ship *Umbria*, nominally as chaperone to the young Thomas Cushman, a popular tenor from Springfield, who was going to study singing in the conservatory of Fraulein Lucy Meyer in Berlin, Germany.[28] The trip was financed by contributions from Frederick W.'s friends, including William E. Wright, who

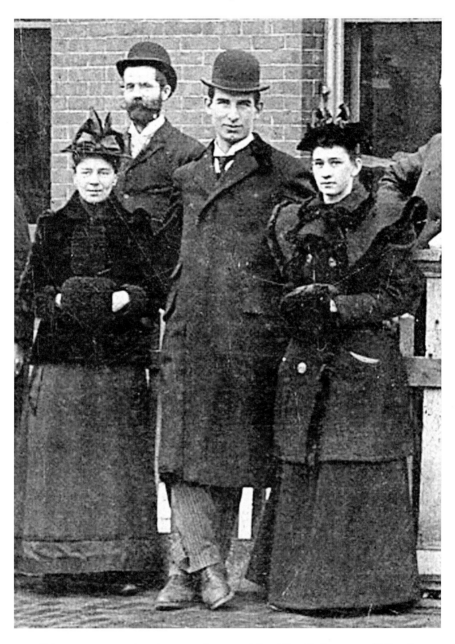

Fred T. Ley, Assistant City Engineer, between Miss Alice Hathaway and Miss Grace Parmenter, with Frank Holden in the rear, 1892 (courtesy Springfield Archives at the Lyman & Merrie Wood Museum of Springfield History).

was a partner in the firm of MacIntosh & Company, a wholesale shoe company in Springfield where Harold Ley worked as an errand boy. The role of chaperone provided a convenient excuse for Frederick W. to accept the money.[29] In later years, when his construction company was flourishing, Fred T. Ley paid all of his father's benefactors back.[30] Frederick W. delivered Mr. Cushman to Berlin, and stayed there for three weeks. He then proceeded to Aix-la-Chapelle, also known as Aachen, to bathe in its hot springs with the hope that they would help his condition. After six weeks at the spa he went on to visit his mother who had returned to live in his boyhood home outside of Cologne, for two more weeks. The time at the baths in Aachen seemed to help and on his return, Frederick W. expressed the hope that he would soon be back as choirmaster.[31] Unfortunately, the improvement did not last and the injury proved permanent.

By October of 1889, Frederick W. Ley's health had deteriorated so much that he had to resign from his position as the choirmaster at Hope Church.[32] His family and friends raised $1,000 to buy a small tobacco store and pool hall at 493 Main Street in Springfield for him to operate, which he did for the next nine years. In this he was assisted by his son Harold who worked with him in the evenings and brought him home at night.[33]

Fred T. and his brother Harold did their first significant real estate deal in 1890. They bought an apartment house with 12 units on Harrison Avenue in downtown Springfield. They each put down $500 in cash and took out a mortgage for $18,500 for a total cost of $19,500. Leo operated the building while Fred was the silent partner. This was the sort of leveraged deal that Fred T. would become expert at over the years. It also indicates that his influence with the bankers was already established, given that they were willing to lend a substantial amount to an 18 year old with only a 5 percent down payment.

Soon after taking possession, the brothers learned that one or more of the apartments were being used for brothels. They quickly evicted the ladies involved and cleaned up the premises. Five years later, they sold the building for $31,500, or a profit of $6,000 each, the interest they had paid on the mortgage being covered by their rents. This was a substantial gain on their cash investment, and the deal established their credit in the real estate market. It also led to many more profitable real estate investments over the years.[34]

Before long, Fred T. Ley was using his surveying skills, which he had learned in his position in the city engineer's office, to earn extra money after work by laying out streets and lots in the suburban developments which were

springing up with the extension of the horse drawn street railway system. By the time he was 19, in 1891, Fred T. was earning $1,800 a year, a substantial sum at the time and equivalent to about $45,000 in 2013.[35] Only $875 of this came from his city job, with the rest coming from his independent work.[36] While in the city engineer's office, he surveyed the routes of the electric car lines that the Springfield Street Railway Company began constructing in 1889 to replace the old horse car routes, a project that will be discussed in more detail in Chapter 4.[37] By 1892, when he was 20, he had acquired his own horse and wagon, which, at times, he rented to the city.[38] A photograph of the city engineer's staff taken in that year shows Fred T. Ley to be a tall, dapper, clean-shaven young man wearing an expensive looking overcoat and a bowler hat.[39]

Fred T. Ley remained in the city engineer's office until 1893, when he finally struck out on his own. This was not the best of times to be starting a business, because the panic of 1893 had started in February. Banks and railroads were failing, credit became difficult to obtain, and the country was falling into a depression. Fred, however, saw opportunity in the falling labor rates caused by widespread unemployment. He was not in debt and had some savings from his years working for the city. His first independent construction project was a sewer in Plymouth, Massachusetts. It was a small job, involving mostly excavation and pipe laying, but he made a profit of $1,000 on it. This would be the equivalent of $28,000 today. It was an impressive enough amount to persuade his brother, Harold, to leave a good job at the Massachusetts Mutual Insurance Company and join Fred T. in his new enterprise.[40]

About this time, Fred T. Ley was hired as a surveyor to lay out the property of the Indian Orchard Company in preparation for the building of the mills in this northeastern suburb of Springfield. Originally designed as textile mills powered by the Chicopee River, which was dammed at the end of Oak Street, many of the buildings still stand and are in use as the home of artists' studios and small businesses. Fred T. Ley also started building and selling small houses. These early jobs taught him how to estimate the cost of projects so as to submit successful but profitable bids.[41]

The Ley brothers continued dealing in real estate. In 1894, working through the T.M. Grainger Real Estate Agency to buy a farm from Mr. A.W. Lincoln for $800 and to sell a building lot on Hall Street to the agency for $600.[42]

Soon afterwards, Fred T. Ley got his first look at the type of construction that he would one day use to build skyscrapers. Early in 1894, construction began on the first steel skeleton building in Springfield, and possibly in New

England, at 1570 Main Street, at the northwest corner of Worthington Street. Known as Whitney's Building, it was constructed by Andrew Whitney, a real estate developer from Fitchburg, Massachusetts.[43] The six-story building made no attempt to suggest masonry construction and had only a very small amount of applied architectural detail. In this, it was reminiscent of the designs of the Chicago School of Architecture, led by Louis Sullivan, who first introduced idea that a building should reflect the frank expression of its metal construction in its outward appearance.[44] However, it is likely that Whitney did not have such aesthetics in mind. To him it was a strictly utilitarian building, and he designed it with his intended uses as the driving force.

Steel framed, curtain wall construction had been pioneered by William Le Baron Jenney in Chicago with his Home Insurance Company Building in 1885. That building is generally acknowledged as the first modern skyscraper. The appearance of a building of similar construction in a small New England city, only ten years after Jenny's introduction of the concept, was remarkable and controversial. The Whitney Building was started in 1894 and immediately drew protests from its abutters, who claimed that the building was encroaching on the sidewalk. The building inspector, A.P. Leshure, was convinced that the walls were too thin to support the weight of the upper floors, and that the building was unsafe. The walls were thin, but because they were supported by the steel frame and did not have to bear the weight of the upper stories, as in a masonry building, they were perfectly safe. Still, on more than one occasion, Leshure threatened to order the building to be torn down. It was not until Whitney called in the state building inspectors to give their opinion that his design was approved. The building was unusual in several ways other than its curtain wall construction. The outer walls actually sloped inwards by an inch for every ten feet of rise.[45] The third floor was not installed, so the second floor was 20 feet high and had no partitions. This created an open space 100 feet by 90 feet, with an unobstructed bay 100 by 50 feet between the wall and the slightly off-center columns that ran down the middle of the building.[46]

This space was used alternately for basketball courts and a "polo" ring. Polo was a form of hockey played on roller skates that was very popular in the 1890s. The regulation playing area was 80 by 40 feet, which fit easily into the dimensions of the Whitney Building.[47] The inclusion of basketball courts is interesting, as the game had only been invented three years earlier by James Naismith at what is now Springfield College. It speaks to the rapid increase

in popularity of the newly invented game. The upper stories of the building could also be reconfigured to create a theater.[48]

The steel for the building was fabricated by the Springfield Iron Works.[49] Construction proceeded slowly, in part due to the new design which required new skills to erect and in part due to the obstructionism of the city government. Perhaps the most significant factor, however, was that there was no architect. Andrew Whiting did the design and engineering himself, adjusting it as he went along to make sure that the frame was strong enough. The result was a true "vernacular" building with no connection to classic architectural styles. For that reason, it attracted severe criticism from the Springfield architect Eugene Gardner, who called it "provincial."[50] The building was finally completed late in 1897. The first tenant was an Italian restaurant located on the ground floor, which catered to the city's growing immigrant population.

Young Fred T. Ley must have watched with interest as the steel skeleton was erected and then clad with stone. He probably also followed the controversy that the building caused and learned some lessons about dealing with abutters and local governments. He would go on to become a leader in the field of steel construction, culminating in his greatest work, the Chrysler Building.

On September 2, 1896, Fred T. Ley landed his first big waterworks contract. It was to construct a new dam at a site called "Fomer" in Holyoke, creating a reservoir now known as Ashley Ponds. The very next day he placed an advertisement for laborers to begin work on the dam immediately. He offered wages of $1.50 to $1.75 a day and had already arranged with local residents to board the workmen for $3.00 a week, which, assuming a six-day work week, would net the men at least $6.00 a week. Preference was given to residents of Holyoke.[51] The relatively high wages, rapid commencement of construction, and attention to detail would become hallmarks of Fred T. Ley's company.

Not every bid went this smoothly. The following year, Fred T. Ley & Company lost out on a $1,600 contract to transport pipe for the Westfield waterworks.[52]

Fred T. Ley's interests were not completely confined to his business. He joined the Masonic Lodge of Springfield and the Bicycle Club, both of which were important social organizations in the city.[53] In 1898 he served as president of the Bicycle Club and supported its decision to sponsor a team of professional riders on the national bicycle track circuit.[54] He took up whist and billiards and participated in tournaments in both.[55]

One of Fred T. Ley's more interesting adventures was his naval service. He joined Company H of the Massachusetts Naval Brigade, soon after it was established in 1892 as the maritime equivalent of the state militia. He rapidly rose to the rank of Gunner's Mate and became an expert with the naval six-inch rifled gun and qualified as a sharpshooter.[56] The Naval Brigade was as much a social organization as a military one, and it provided its members an opportunity to take a training cruise each summer that was as much a holiday as a serious military exercise. In 1893, they sailed on the cruiser USS *San Francisco*.[57] But in 1898, things turned serious. Following the sinking of the battleship Maine in the harbor of Havana, Cuba on February 15, 1898, tensions between the United States and Spain built to the breaking point and Congress declared war on April 25. One month earlier, on March 5, Fred T. Ley had returned from a short trip to Europe, during which he visited several countries, and probably his grandmother, who was still living outside of Cologne.[58] By the time that war was declared, Fred T. Ley had been elected to the rank of ensign by Company H and received his commission, attesting to his leadership ability and popularity.[59] On April 17, during the buildup to the declaration of war, he was ordered to the Brooklyn Navy Yard, along with a detachment of the company. He was to serve as a watch officer and captain's clerk on the auxiliary cruiser USS *Prairie*. This was a fast steamer, formerly call the *El Sud*, which the Navy had purchased and was fitting out for military use. The contingent arrived in Brooklyn on May 7, in time to help out with the final details of the fitting out. For some reason, perhaps because of his father's worsening health, Fred T. Ley did not sail with the ship when it departed for coastal patrol off New England on May 13, but returned to Springfield. He resigned his commission in the autumn of 1898, citing the pressure of running his business. At the time, he was in the midst of building the Monson and Palmer Street Railway.[60]

In addition to the street railways, Fred T. Ley had acquired a prime piece of downtown real estate at the corner of Dwight and Worthington Streets in Springfield where he intended to erect a four story business block.[61] Shortly afterwards he also acquired a tract of land off Belmont Avenue for $3,250.[62] This tract would later be developed into the street known as Leyfred Terrace.

An interesting insight into Fred T. Ley's business practices is revealed by a story from around this time. Apparently, Fred set up an arrangement with Richard's Market in Westfield whereby his laborers on a road grading project in that city could obtain provisions by presenting a numbered disk. This was to make sure that the men were using at least a portion of their

wages for food rather than squandering it on other things. One George Washington Johnson, who was not employed by Fred, found out about this arrangement and produced his own number which allowed him to draw unauthorized provisions for several days before he was discovered and arrested.[63] This concept of assigning a number to each laborer as a means of recognition was necessary when many of them were illiterate and names were more fluid than they are today. Fred would refine the concept over the years, using it extensively during the construction of Camp Devens during the Great War.

Fred T. Ley's one flirtation with politics occurred in October 1898, when the Democratic conventions to select state representative candidates for the Springfield City districts were held and he was nominated as the candidate for representative from the 4th district. The next day, Fred declined the nomination, claiming that he had notified the party leaders before the convention that he would not run, due to the demands of his business.[64]

Frederick W. Ley died on November 18, 1898. He was waked at home and buried on November 20 in Oak Grove Cemetery in Springfield.[65] Fred T. Ley now took on the full burden of supporting his mother and sisters. He had founded his own contracting company in 1894, which he listed in the 1897 city directory simply as "electrical road contractors."[66] However, Fred T. Ley soon expanded the scope of his business and his advertisement two years later in the 1899 edition of the same book stated that the company was a contractor for "Electric Roads, Water Works, Sewerage Systems, Macadam Roads, and Stone Masonry." He also offered steam rollers for rent, which indicates that he was investing capital in the business. The company office was located in the family home at 133 Sherman St. in Springfield and had a telephone, 721–3.[67] These were the humble beginnings of what would become one of the largest construction companies in the country.

3

The Dreamer
Begins to Dream

William Van Alen was also born into an entrepreneurial family, but one that was more affluent and more firmly established than that of Fred T. Ley. He was born on August 10, 1882, in the Williamsburg section of Brooklyn, New York, ten years after Fred T. Ley had entered the world in Springfield, Massachusetts and one year before the opening of the Brooklyn Bridge.[1] His lineage was Dutch, but his family had been in the New World for generations. His ancestor, Pieter Van Halen, had emigrated to Albany, New York, from Utrecht in the Netherlands, in 1658.[2] Ten years later, in 1668, Pieter received a grant of land in Kinderhook, New York, southeast of Albany in what is now Columbia County. The family prospered and William's father, Jacob Van Alen, a fifth-generation descendant of Pieter, moved from Cold Spring, New York, where his family had established a seat, to the Williamsburg section of Brooklyn, where he was close to the business center of Manhattan. In 1886, when William was two years old, Jacob founded the New York Stove Works, a manufacturer of cast iron kitchen ranges, in Peekskill, on the Hudson River, in upstate New York. In the mid–19th century, Peekskill was a center for stove making because magnetite ore, which was especially suitable for making cast iron, was mined in the vicinity. Over time, more than 20 iron mines, primarily producing magnetite ore, were opened in the Hudson Highlands, just to the north of Peekskill. The town was convenient to the Van Alen family seat in Cold Spring and also to Jacob's Williamsburg home since the factory was just a short ride upriver from New York City on the New York Central Railroad's Hudson Division.

Unfortunately, on July 22, 1897, Jacob was struck and killed by a Long Island Railroad train as he was returning home from sailing his yacht on Jamaica Bay, orphaning the fourteen-year-old William and his younger sister

Eleda. Whether this was an accident or Jacob had committed suicide because of the failure of his company is impossible to say, but with Jacob's death at age 45, the family's fortunes declined rapidly and they lost the stove factory. William Van Alen attended public schools, but dropped out in 1898 when he was 16, one year after his father's death, and, like Fred T. Ley had done, went to work. The following year, Van Alen's mother, Eleda Squire Van Alen, remarried. Her second husband was M.H. Christopher, a hardware merchant in Brooklyn.[3]

William Van Alen's first job was as an office boy and later draftsman for the architect Clarence True, who was a major architect-developer of row houses in the West End section of Manhattan.[4] Row house is the New York term for a series of side-by-side single family houses joined by common party walls. In England these are called terraced houses and the more modern term is town house. The West End, an area that encompassed Manhattan between Central Park and the Hudson River from 59th Street on the south to 110th Street on the north, had lagged behind Fifth Avenue and the East Side in development, due to its lack of transportation infrastructure. But when the elevated railroad line along 9th Avenue was extended to 116th Street, beginning in 1879, the developers followed. Originally envisioned as a neighborhood of small, detached, single family "cottages," it was quickly transformed into an upscale residential area. Luxury apartment buildings such as the Dakota, which opened in 1884, and the Osborne, completed in 1885, alternated with attached single family row houses and detached mansions.[5] The most noticeable characteristic of the neighborhood was the design of the row houses, which were distinct from each other and often echoed Northern European themes. It was a significant departure from the uniform brownstone row houses which had previously dominated the city. It was in the design of these new row houses that Clarence True made his reputation and his fortune.

The work he did for Clarence True began Van Alen's architectural apprenticeship. During the 19th century, there were few schools of architecture in the United States. It was not until 1865 that the first had been established at the Massachusetts Institute of Technology. When the first school of architecture in New York City was founded at Columbia University in 1881, it was only the fourth in the entire country. Therefore, the standard career path for most aspiring architects was to serve an apprenticeship with an established architectural firm rather than to attend a specialized school. Beginning by copying drawings, they learned by doing, gradually coming to understand

proportion, decoration, and a smattering of structural engineering. As they gained experience, they would be allowed to design the more routine aspects of commissions. It was not unusual for them to move from one firm to another, broadening their experience, until they were ready to go into practice on their own or with a partner. This was the path that William Van Alen followed.

Clarence Fagan True was the first of several mentors who influenced Van Alen's later style. In architecture, as in many fields of art and science, there is often a line of teachers and students which may extend over centuries and through which the history of the field can be traced.

Clarence True had learned his profession in the office of the architect Richard M. Upjohn. Upjohn was noted for his neo-gothic designs, including the Connecticut State Capitol in Hartford. He was the son of Richard Upjohn, Sr., who designed Trinity Church in Manhattan, a Gothic-Revival masterpiece, which was completed in 1846.[6] The Gothic-Revival school of architecture, of which the Upjohn's were leaders, featured high pitched roofs, spires, and narrow widows with pointed arches. While True did not continue in the neo-gothic style in his own later work, he did draw inspiration from other northern European sources, especially Dutch and German themes.

True set out on his own in 1884 and struggled for a few years, until he found his niche. In 1890, he discovered the West End and received a commission for ten houses on West 89th Street. This was followed in the same year by another 12 houses for a variety of developers, done mostly in the northern European Renaissance style. These designs introduced True's signature "low stoop." Since the mid–19th century, Manhattan row houses had been built with a high stoop, or external entry staircase, to reach the first, or parlor, floor which was about a half story above the street, separating it visually from, and providing more light and air to, the service areas, which were only slightly below street level. True lowered the parlor floor, reducing the number of steps to the entrance, and relegating the service areas to a more basement-like setting. This was enabled by improvements in domestic lighting, especially electric lighting, which was being introduced during this period.

Toward the end of the 1890s, about the time that William Van Alen joined his staff, Clarence True had become successful enough to begin acting as a developer, financing and building houses on his own. His designs featured stepped gables, light colors and large round corner bays. A group of houses that True designed still stands at the southwest corner of 80th Street and

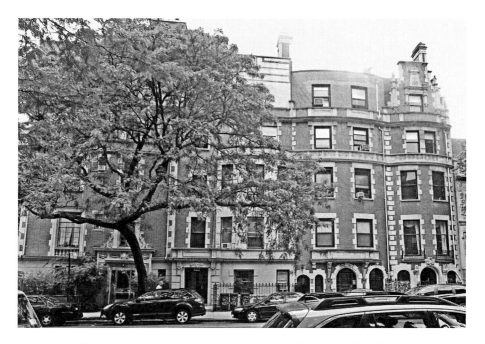

Group of Clarence True–designed row houses, 90th Street and West End Avenue, New York City (photograph by the author).

Riverside Drive. The end house of this group presents a curved facade of brown brick going around the corner, and its windows and doors are set off by contrasting quoin-like white stone blocks. The second house is faced in white stone, and the third is red brick with white stone quoins and window surrounds. The group of houses presents contrasting facades that are still harmonious. The concept of the curved corner facade was one that Van Alen would transform and adapt to new building methods later in his career.

True created a plan for developing the entire block of 92nd Street between West End Avenue and Riverside Drive. The design included a row of houses on the south side set back from the street in a soft arc, reminiscent of a London crescent. That plan proved to be overly ambitious, and he was able to build only the gabled, dormered group standing at the northwest corner of 92nd Street and West End Avenue. The corner building features a street floor facade of broad brown and white horizontal stripes, surmounted by three stories of brick with decorated masonry bays, a slate roof with dormers, and a gabled end on the 92nd street side. It was used as an external set in Woody Allen's film *Deconstructing Harry* and is still lived in.

25

In 1899, the architectural magazine, *The Real Estate Record and Builder's Guide*, called Clarence True's seven-house red brick group in the Flemish style at the northwest corner of 90th Street and West End Avenue, which Van Alen may have worked on, "the best design that has ever left his boards."[7] This group consists of three houses on West End Avenue and four more on 90th. Most of them are red brick with white masonry accents, but there are two in which the facade is all white masonry, one on each frontage, to break up the row. This design is interesting because, while each house is unique, the facades are all consistent with each other, again achieving harmony with diversity. This is in sharp contrast to the monotonous brownstone row houses just across West End Avenue from them. Clarence True's houses are still in use.

Architecture, and more importantly, real estate development, was good to Clarence True. By 1900, he was living in a house in the upscale suburb of Mamaroneck, in Westchester County, New York, with his family of five plus a butler, a cook, a coachman and a housemaid.[8] This lavish lifestyle was supported by a large staff of draftsmen and junior architects like William Van Alen who labored in his New York office for very little pay.

In Clarence True's workshop, William Van Alen would have learned the basics of drafting by copying the elevations and plans of the architects, and the fundamentals of residential building design, including proportion, style, and masonry construction. He would have probably learned nothing about high rise building construction, or the more formal aspects of architecture, but he was introduced to the community of architects and could see what opportunities might lie ahead for him.

We will never know if William Van Alen aspired to become an architect when he first went to work for Clarence True, but he soon decided that architecture was his calling and began to advance his education by taking drafting classes at night at the Pratt Institute in Brooklyn.

The Pratt Institute had been founded by Charles Pratt in 1887 to realize his dream of creating a school where "artisans could learn the skills needed to make a living with their artistry," a goal that resonated with the young William Van Alen. Charles Pratt's life itself was an inspiration to the young architect. One of 11 children, Pratt was born in 1830, the son of a Massachusetts carpenter. He managed to scrape a few dollars together and spent three winters as a student at the Wesleyan Academy in New Market, New Hampshire. He is said to have lived frugally, at times spending only a dollar a week, while devoting himself to his studies. After leaving the Academy, Pratt went

to Boston where he joined a company specializing in paints and whale oil products. He later moved to Brooklyn, New York where he worked for a similar company and expanded that firm to create the Astral Oil Company. When Astral split into separate entities for paint and oil, Charles Pratt gained control of the oil segment of the business and turned it into the most successful such company in Brooklyn. Eventually the company was acquired by John D. Rockefeller's Standard Oil Company, making Pratt a rich man.

Charles Pratt's fortunes increased and he became a leading figure in Brooklyn, serving his community and his profession. A philanthropist and visionary, he supported many of Brooklyn's major institutions including the Adelphi Academy and the building of Emmanuel Baptist Church. However, he always regretted his own limited education and dreamed of founding an institution where pupils could learn trades through the skillful use of their hands. The Pratt Institute was the realization of this dream.[9] Although there is no record that William Van Alen earned a degree or certificate there, today Pratt is proud to claim him as an alumnus.[10]

Throughout his life, William Van Alen was constantly learning and expanding his architectural repertoire. Around 1902, while still studying at the Pratt Institute, Van Alen left Clarence True in search of greater opportunities and was hired by the minor architectural firm of Copeland and Dole, but shortly afterwards moved to the larger firm of Clinton & Russell.[11] This was a prominent architectural partnership that had been founded by Charles W. Clinton and William Hamilton Russell in 1894. In contrast to Clarence True's concentration on residential row houses, Clinton & Russell specialized in commercial buildings. Many of its designs were for commissions related to the extensive real estate holdings of the Astor family.

During Van Alen's tenure as a draftsman and junior architect with the firm, their designs included the Wall Street Exchange Building at 43–49 Exchange Place, an Italian renaissance style structure with a limestone faced base that rises into a red brick tower, and the Beaver Building, a highly decorated triangular building at 82–92 Beaver Street.[12] The Beaver Building is reminiscent of Daniel Burnham's Flatiron Building, uptown at 22nd Street, which had been built one year earlier. Working on these buildings, Van Alen learned to design modern steel framed curtain wall structures, the basis of the modern skyscraper.

A different Clinton & Russell design from this period that Van Alen may have worked on was the 71st Infantry Regiment Armory at Park Avenue and 34th Street. This is an Italianate design encrusted with medieval towers

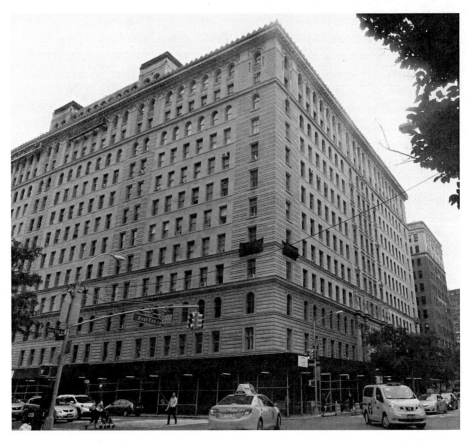

Apthorp Apartments, 390 West End Avenue, New York City (photograph by the author).

and battlements, which was typical of military architecture at the time. The armory was razed in 1976.

Van Alen also probably worked on two Clinton & Russell residential structures that are now listed as official New York City Landmarks. These are the Langham Apartments, a towering building on Central Park West between West 73rd and West 74th Streets, begun in 1905 and the Apthorp Apartments at 390 West End Avenue, begun in 1906. Both buildings utilized steel frame construction.

Upscale apartment buildings like these were a relatively new idea. Tenements, in the sense of multi-family dwellings occupied by people who cannot afford to own a private house, have existed since at least early Roman times.

However the concept of the apartment was not invented until the turn of the 18th century. Louis XIV of France, the Sun King, who ruled from 1643 to 1715, transformed the culture of the French court from one in which the king and his courtiers lived in public, even eating and sleeping in the presence of others, to one which kept public appearances and private activities separate. He remodeled the palace at Versailles to create suites of rooms that were set apart for the private lives of each resident, hence the term "apartment."[13]

In 19th century America, it was considered somewhat disreputable to share a residential building with strangers, because it reduced privacy and provided opportunities for unrelated persons of both sexes to meet unsupervised in the common areas. The first building in New York City specifically designed to house several affluent families who did not want to maintain stand-alone mansions was not built until 1869. It was called the Stuyvesant and it was located at 142 East 18th Street on Irving Place. It was the first building in America to be referred to as an apartment house.[14] In spite of dire predictions, it fulfilled a real need and its success resulted in the proliferation of such buildings in the city. By the beginning of the 20th century, apartment house developers were in a race to build ever larger and more luxurious buildings.

The Langham Apartments were designed by Clinton & Russell in 1904 for Abraham Boehm and Lewis Coon, the owners of the lot. At 135 Central Park West, they occupy the entire frontage from 73rd Street to 74th Street and are just one block north of the Dakota. The estimated cost of the building was $2,000,000. The design was done in the French Second Empire style and capped with a slate and copper mansard roof. There are 13 stories with four large apartments on each floor. The building features a subterranean carriage drive and originally had period rooms, including ones with Elizabethan, Modern French Renaissance, and the neoclassical 18th century Adam style themes. The original apartments had peculiar layouts and did not have private bathrooms, but shared common baths on the hallways. The building did not have an enclosed courtyard, but light and air were provided by three open courts at the rear of the building. Construction began in 1905 and was completed by 1907. The building, now extensively renovated, is still in use.[15]

The Apthorp, which was built on land owned by William Waldorf Astor, covers an entire city block at 2211 Broadway between 78th and 79th Streets and West End Avenue. It is a 12-story Italian Renaissance Revival apartment

building that surrounds an interior courtyard. It has a three-story porte-cochere, or carriage entrance, leading to a formal garden with two fountains. Although it is essentially a massive, rectangular, 12-story block, the rusticated three-story base and much architectural detailing serve to lighten the design. It was one of the first New York City apartment houses to be built around a landscaped courtyard, setting a new standard for upscale apartment houses, by creating a private, secure common outdoor space for the residents. The layout of the apartments was improved over that used in the Langham, the architects having learned from that earlier project. William Astor was personally involved in the design of the building, incorporating ideas gathered from his extensive travels in Europe. The Apthorp was briefly the largest apartment building in the world and is now a condominium building and still a highly desirable address on the Upper West Side.[16] It was considered to be much more opulent than the restrained and extremely elegant Langham.[17]

Other projects which Van Alen may have worked on included the U.S. Express Company Building at 2 Rector Street and the Consolidated Stock Exchange Building, 61–69 Broad Street, a neo-classical temple of finance which has since been razed.[18] Each of these projects exposed Van Alen to a different aspect of architectural design and engineering.

Unlike Clarence True's houses, which had traditional exterior bearing walls of brick or masonry, the Clinton & Russell buildings were of modern fireproof curtain wall design, with the exterior sheathing hung on a steel frame that also supported the interior floors and partitions. The steel beams and columns were covered in terracotta tiles to insulate them from the heat of a fire so that they would not warp or melt, thus making the frame fireproof. This type of construction had been pioneered by William Le Baron Jenney in Chicago with his Home Insurance Company Building in 1885, which is generally acknowledged as the first modern skyscraper. During the following years, the concept was further developed by Louis Sullivan, who was the leading Chicago architect of the time, and a vocal proponent of modern architecture. As discussed in Chapter 2, this method was used as early as 1894 for the Whitney Building in Springfield, Massachusetts, which was not tall enough to be considered a skyscraper.

Until Jenny produced his designs for the Home Insurance Building, the height of buildings had been constrained by the fact that the thickness of a bearing wall at its base had to increase in proportion to the height of the wall in order to support the increased weight of the building above it. As a result,

in a tall building, the area of the ground floor, which generally had the highest rents, was reduced, as was the amount of light that could penetrate the deep window openings. By using a steel framed skeleton, which supported the walls of each story independently, as Jenny and Sullivan did, the exterior walls could be reduced to thin cladding, maximizing the floor space and reducing the cost of the building. This design, combined with elevators to provide access to the upper stories and fireproof construction to ensure the safety of the occupants, allowed the architect to conceive buildings of theoretically unlimited height. It was while working for Clinton & Russell that Van Alen learned this technique and applied it to the first projects to which he is known to have made a significant contribution.

Perhaps the most notable building that William Van Alen worked on when he was with the firm of Clinton & Russell was the Hotel Astor in Times Square. With its elaborately decorated public rooms and its roof garden, the Astor Hotel was perceived as the successor to the Astor family's Waldorf-Astoria Hotel. That hotel had been built on Fifth Avenue between 33rd and 34th Streets in 1893 and was designed by architect Henry J. Hardenbergh. Although still elegant, by 1905, it was dated and the Astors felt the need for a newer hotel further uptown. The original Waldorf-Astoria hotel was demolished in 1929 to make way for the Empire State Building.

Plans for the new grand hotel were conceived in 1900 by William C. Muschenheim and his brother, Frederick A. Muschenheim. The acute intersection of Broadway and Seventh Avenue between 42nd and 44th Streets was then known as Longacre Square and stood beyond the fringe of metropolitan life. A working class neighborhood and manufacturing district, it was the center of New York's carriage-building trade. The Muschenheim brothers became the proprietors for absentee landlord William Waldorf Astor, from whom they leased the land on which the hotel would be built.

The 35,000 square foot Hotel Astor was built in two stages, the first in 1905 and the second in 1909 and 1910, after Van Alen had left to study in Paris. Both stages were designed by the architectural firm of Clinton & Russell in the same Beaux-Arts style. Upon completion, the hotel occupied an entire city block. The reported total cost of the project was $7 million. Clinton & Russell had previously designed a number of Astor commissions. Here they developed a very Parisian "Beaux-Arts" style complete with a green-copper mansard roof. Its 11 stories contained 1000 guest rooms, with two more levels underground for its extensive "backstage" functions, such as the kitchens and wine cellar. His work on this design may have helped Van Alen in his quest

to win the Paris Prize of the Society of Beaux-Arts Architects, as can be seen by comparing the design of the Astor Hotel with that of his winning entry of a design for a theater, executed in 1908.

In 1904, Adolph S. Ochs, the publisher of the *New York Times*, moved his newspaper's operations to a new office tower between Broadway and 7th Avenue where they met at the southern end of Longacre Square. Ochs then persuaded the mayor of New York City, George B. McClellan, Jr., the son of General George B. McClellan of Civil War fame, to build a subway station there and rename the intersection Times Square. The Astor, with its roof garden and restaurants, was an important element in the growth of Times Square and its character as an entertainment center. It provided a base for suburbanites and other out of town visitors who were attracted to the theatre district which would soon occupy magnificent new auditoriums along 42nd Street. Electric lighting on the theater marquees transformed this strip of Broadway into the "Great White Way."

According to architect and critic Robert A.M. Stern, the Astor Hotel set the pattern for "a new species of popular hotels that soon clustered around Times Square, vast amusement palaces that catered to crowds with scenographic interiors that mirrored the theatricality of the Great White Way."[19] These included the nearby Knickerbocker Hotel which was constructed by other members of the Astor family two years later, although that property was converted into commercial office space within a few years. The Hotel Astor was razed in 1967.

Although most of Van Alen's work for Clinton & Russell went uncredited, he was acknowledged as the architect behind the design of the headquarters of the Whitney Central National Bank of New Orleans on St. Charles Avenue in that city. The Whitney Bank held a competition in 1904 to select the architects for the building and Van Alen's design won the commission for Clinton & Russell, in spite of its unorthodox look. This, his first credited design, was for an unusual, tall but narrow office building with the banking offices on the ground floor. According to the architect Francis Swales,

The site was a long shallow lot with an end too wide for one and too narrow for three of the bays [of the design] composed for the longer facade. Academic theory in design was going strong in those days and the lower stories were in the popular classical fashion. To place a classical pilaster in the middle of a facade, and divide the front in two, was a gross affront to the precepts of the schools—so unlike the conservative and tactful firm of Clinton & Russell that wherever the competition was spoken of the corollary was the question "Who was the designer?" … Young Will Van Alen was the culprit.[20]

Although the pilaster was removed from the design before construction, this design helped to establish Van Alen's reputation for creativity and unorthodoxy, characteristics that he would develop through studies at the École des Beaux-Arts in Paris. With this design, William Van Alen could finally claim the title of architect.

4

The Builder of Trollies

When Fred T. Ley started his construction company in 1894, he listed himself in the Springfield, Massachusetts City Directory as an "electric road contractor." Having learned how to survey, supervise grading and track laying, and string electrical wire while working on the electrification of the Springfield Street Railway, he was now getting into the business of building entire street railways as a general contractor. In 1894, electric street railways were the transportation industry of the future. They were being built, not only in every city of any size, but between cities and towns. There was plenty of work for any contractor with the necessary expertise. Moreover, while the capital needed by the street railway companies was substantial, the capital requirements for the contractor were minimal. Since most of the work was done by hand and with horses, it was more important to be able to recruit and organize laborers while avoiding labor unrest than to invest in expensive machinery. These were Fred T. Ley's strengths.

To understand the significance of electric street railways it is helpful to know something about the evolution of public transportation in the 19th century, as evidenced by developments in Springfield, Massachusetts. The history of public transportation in Springfield began on June 20, 1844, when Horatio Coomes, of Longmeadow, advertised an omnibus route running from downtown Springfield to the mill towns of Cabotville and Chicopee Falls, which were north of the city. An omnibus was simply a large horse-drawn coach, but unlike a hired carriage or a hack, an omnibus ran on a regular route and schedule and would accept any passenger who could pay the fare, hence the name "omnibus," which means "for all" in Latin. The first omnibus in Springfield was called the "Accommodation" and it probably held around 20 passengers on two facing benches inside. In good weather, another ten might ride on the roof. It took half an hour to travel the four miles from Chicopee

Falls to Cabotville and another half hour to get to downtown Springfield. The route was scheduled to arrive in Springfield in time to meet the trains on the Massachusetts Central Railroad and the steamboat from Hartford, Connecticut. Having picked up new passengers, the omnibus then returned to Chicopee Falls. It ran three times a day, starting at five in the morning and ending with the last run at 3:30 in the afternoon.[1] The service attracted a ridership and, two months later, on September 1, Mr. Coomes announced that the omnibus on Main Street was so successful that he planned to start running a second one.[2] Profits were elusive, however, and the enterprise did not survive its first year.

Others took up the challenge and by 1858 there were three separate omnibus routes in the city. One ran north and south along Main Street. Another went east, up the hill on State Street to the United States Armory and then south along Walnut Street to the Armory Watershops on the Mill River. The third went south to Longmeadow. This was originally a farming community, but with improved roads it was starting to attract Springfield businessmen who wanted to have residences away from the noise and dirt of the city. The omnibus, and later the street railways, accelerated that trend.[3] Due to the limited number of passengers than an omnibus could carry, operating margins were thin and the lines struggled to maintain a large enough ridership to pay the bills. The lines changed ownership several times. These economics changed with the outbreak of the Civil War in 1861. With the huge expansion of the Federal Armory and the other war related industries in the city, workers were recruited from further away and the omnibus lines prospered by bringing them to and from work. Tickets cost 6 1/4 cents each, and were sold in books of five for a quarter.[4] The demand for public transportation became so great that some of the leading businessmen began to talk about building a horse-drawn street railway system.

By this time, street railways were fairly common in large cities, including Boston and New York. Because the cars ran on rails, the same size crew and team of horses could pull much larger loads, resulting in lower operating expenses at the cost of a higher initial capital expenditure for laying the rails. The street railways also gave a smoother, faster ride. On the evening of March 16, 1863, at the height of the Civil War, Mr. H.A. Fuller, the state senator representing Springfield, presented a petition to the Massachusetts State Senate for a charter to incorporate a horse-drawn street railway company in Springfield. At that time, all new corporations required a charter issued by the state legislature. The proposal was supported by a second petition from

Mr. Henry Alexander and 375 other Springfield residents.[5] In addition to Fuller and Alexander, the principal members of the corporation were Chester Chapin, George Bliss and D.L. Harris.[6] The petitioners asked for the right to build street railways on any street in the city, subject to the consent of the city council. At the time, development in the city was concentrated along Main Street, parallel to the Connecticut River, from the railroad depot in the north to the Mill River in the south. The *Springfield Daily Republican* predicted that such a horse-railroad would open up the portion of the city north of the depot as far as Chicopee to development along the axis of Main Street, and Samuel Bowles, the newspaper's editor, heartily endorsed the proposal.[7]

Controversy immediately ensued. The proponents, who were primarily business owners along Main Street, pointed to the economic advantages and the expected increase in property values along the line of the horse railroad. The opponents rightly pointed out that the street railway would be a monopoly, as only one set of rails could be laid in a street and the owners of the rails would set the fares.[8] Since the promoters were also seeking permission to carry freight, there was a concern that they would put private draymen out of business. Some feared that the rails would obstruct private vehicles.[9] When the request for right-of-ways for the horse railroad was taken up by the city council on June 22, 1863, it was not approved, but was sent to a committee for further consideration.[10]

After much discussion and negotiation, the company yielded on the question of carrying freight and agreed that it would only run passenger cars, but the negotiations broke down over the question of how much of the street the company would be required to maintain.[11] The company felt that it should only be responsible for the rails and the paving between the rails. The city council wanted them to maintain the road for one-half of a rod, that is eight feet, three inches, on either side of the center-line of the tracks.[12] In spite of the fact that many of the elected officials in the city had subscribed to stock in the company, no agreement was reached and the charter of the railroad was allowed to expire in 1865. The project was not abandoned, however.

Negotiations continued quietly for the next three years and, finally, a compromise was hammered out. This required the company to maintain the road for a distance of three feet on either side of its tracks. The Springfield Street Railway company was incorporated by an act of the state legislature on February 24, 1868, with a capital limit of $200,000. They renewed their incorporation in 1869, reducing the capital limit to $100,000. The purpose of the capital limitation was to make sure that all funds realized by the sale

of stock were actually invested in physical plant and equipment and not used to reward the promoters of the corporation. This was a very different concept from today's initial public offerings which are valued based on the expectation of future earnings rather than physical assets. The incorporators were G.M. Atwater, C.L. Covill and Chester S. Chapin. Gideon Wells was the clerk of the corporation.[13] All these incorporators were prominent business men in Springfield. The Springfield City Council passed the necessary enabling ordinance for the street railway on June 19, 1868.[14]

On April 13, 1869, the stockholders met and decided that the initial capital needed was $50,000, and that work would begin as soon as that amount was raised.[15] This depended on those who had subscribed to buy the stock actually sending in their payments, and it took some time for the goal to be reached. On September 11, 1869, the company finally began setting up offices in a building above the railroad depot. Frederick Hastings of Northampton was appointed treasurer and clerk replacing Gideon Wells.[16] On September 14, the board of directors called for the payment of the first installment of $20 per share of the capital stock, out of a total share price of $80, to raise funds for the start of construction.[17]

Construction began in late October, with the tearing up of the paving stones on Main Street to allow for the laying of the track. When the track was complete, the paving stones were replaced by macadam.[18] The initial tracks were laid along Main Street from Carew Street to State Street and then turned up State Street to Oak Street.[19] Beyond Oak Street, they continued through today's Mason Square to stables located between Wilbraham Road and Boston Road. By November 20, the railway had reached the State Street corner.[20] The company headquarters, including the horse barn, were relocated to a building at the intersection of Chestnut and Hooker Streets.[21]

The first two cars arrived in November 1869. They were yellow with "Main and State Streets" painted on the sides, and could carry 12 seated passengers and as many standing as could be crammed in.[22]

The horse drawn street railway began its operations on March 28, 1870, running between Carew Street and Oak Street, beginning at six in the morning, with the last car starting at 9:30 at night.[23] Since Fred T. Ley was born in 1872, this was the public transportation system that he grew up with. It enabled his family to live east of Mason Square and still get to school and work in downtown easily.

By the time Fred T. Ley dropped out of high school and went to work for the Springfield City Engineer's office in 1887, technology was catching up

with the horse-drawn street railways. The first electric street car in America had been put into service in South Bend, Indiana in 1882.[24] This was only four years after Thomas Edison had set up the Edison Electric Light Company to commercialize the use of electricity. The electrification of existing street railways across the country soon followed. Electric street railways had many advantages over horse drawn ones, including speed, range, sanitation, and operating cost. Electricity was a relative novelty, however. There were concerns about its safety, and many of the earliest attempts at electrification were unreliable.

On October 4, 1888, the Springfield Street Railway Company met to discuss possible electrification for the first time. By that point, the company had 18.4 miles of track in the city, owned 66 cars and 220 horses, and employed 122 people. There were 96 stockholders and a capitalization of $350,000, on which the company paid an annual dividend of 8 percent. During the previous year the company had carried almost three million passengers. This was a substantial and going concern, but electrification would require a major investment, as well as new agreements with the city and approval by the state legislature. It was not a decision to be taken lightly. The board of directors decided to visit Meriden, Connecticut, where an electric street railway was already in operation, to see what was involved.[25]

The Meridian Street railway, like most of the newly electrified lines, used the Sprague System. Frank J. Sprague was a former navy officer who had done significant work for Thomas Edison at his Menlo Park laboratory, before leaving in 1884 to found the Sprague Electric Railway & Motor Company. Over the next two years, his company introduced two important inventions: a constant-speed non-sparking electric motor and regenerative braking, which used the motors to assist the friction brakes. His motor was the first to maintain constant speed under varying load. Both the motor and the brake were critical to electric railway systems that had to operate over a wide variety of terrain, including going up and down hills. His system also used an improved spring-loaded overhead metal rod, called a trolley pole, attached to the roof of the car to supply power from a single wire suspended over the tracks. Wires carried the electric current to the motor, which was grounded to the metal rails. It was this system which gave the street railways the popular name of trolleys. This system was used on the first large-scale electric street railway system in Richmond, Virginia in 1888, only six months before the Springfield Street Railway Company began considering conversion from horses to electricity.

In November 1889, the stockholders of the Springfield Street Railway Company finally agreed to petition the city to extend the Main Street line from its terminus at Mill Street, up the hill along Belmont Avenue to Forest Park, and to use electricity on that segment as an experiment.[26] The line would draw its power from the United Electric Light Company.[27]

The Blair and Fiske Manufacturing Company, a maker of lawnmowers, had brought electricity to Springfield in 1881. The company needed better lighting so that it could run a night shift. It installed a generator and began experimenting with electric arc lamps. It later installed lights on the factory roof to illuminate an adjacent ice skating rink, attracting the attention of local merchants, who began installing the lights as well. Demand continued to increase, and in June of that same year the Springfield Electric Light Company was incorporated, taking over the electric portion of Blair and Fiske's business.[28] Unfortunately, the new electric company could not handle the financial burden required by the rapid expansion which followed. In 1887, the United Electric Light Company was formed and it purchased the Springfield utility. United Electric Light immediately purchased land for a new generating station, which went into operation in 1889, just as the electrification of the street railways was getting underway.[29]

Objections were immediately raised. The telephone company feared that the overhead wires would create electrical interference in their system, drowning out conversations. Others felt that the wires would be a safety issue. The City Council overruled these objections, and on December 23, 1889, granted permission for the single trolley system from State Street to Forest Park. Construction was started immediately, and the first electric car was run over the line in the summer of 1890.[30]

The street railway industry in Massachusetts went through four phases. The first was a period of expansion from 1890 to 1903. During this period, the mileage of electric railways in the state increased rapidly as older horse-drawn systems were electrified and new systems were built. The Springfield Street Railway was at the leading edge of this phase. The second was a period of consolidation that occurred between 1900 and 1911, during which smaller railways were leased or bought by larger regional systems. During this phase, the Springfield Street Railway would come under the control of the New York, New Haven and Hartford Railroad, and then absorb the smaller lines that surrounded the city. The third was a period of rising costs between 1910 and 1920, when fare and ridership increases could not keep up with higher wages and equipment costs. The fourth was the period of collapse, beginning in

1920, and largely due to competition from automobiles and buses. By 1930, the electric street railway was essentially a thing of the past.[31] It was during the first two phases of this cycle that Fred T. Ley made his first fortune from the street railway industry.

The experimental line constructed and electrified by the Springfield Street Railway Company was so successful that the company petitioned the City Council to allow it to electrify all of its lines in the city, and permission to do so was granted on December 8, 1890.[32]

At this time, Fred T. Ley was an assistant engineer for the City of Springfield, and he became involved in surveying and constructing the new electrical lines. This was completely new technology. It was only two years since Frank Sprague had commercialized it for the first time in Richmond, Virginia. There was a lot to learn. The overhead wires had to be suspended at a uniform height and insulated from the poles. The voltage had to be maintained at a certain level, which dictated how long a stretch of wire could run before it had to be interrupted and a new electric feed attached. Transformers needed to be installed and maintained. Safety features, including circuit breakers, had to be used appropriately, and the tracks needed to be electrically grounded. In addition, many of the streets needed to be regraded to provide a smooth ride and acceptable grades on the hills.

To accomplish all this, a large workforce had to be organized, trained, and supervised. Electric wires and machinery had to be ordered. A deal had to be worked out with the electric company. Fred T. Ley observed and learned. He formed Fred T. Ley & Company in 1892 while still working for the city.[33] By the time he left the City Engineer's office in 1893, he was well grounded in surveying and project management, and something of an expert in the construction of electric street railways. He had also learned to accurately estimate the cost of building a street railway, an important lesson that helped him to win contracts.

Fred had also learned that there were many ways to make money on street railways besides by operating them. The two most profitable were promotion and construction. Construction was an obvious way. The contractor got paid from the proceeds of the sale of stock and bonds before the system started running, whether or not there were any riders in the future. The promoters made their money by purchasing stock in the company at par, often with borrowed money, then selling it at a premium, once the system was operating.

By March 1894, when he was just shy of 22 years old, Fred T. Ley was

ready to take the next logical step, adding to his business of building street railways by becoming a promoter of them. In this way he could participate in organizing new lines that he could then also build. He became involved with a group of businessmen who were proposing to build an electric trolley line, independent of the Springfield Street Railway Company, to the prosperous farm and quarrying community of East Longmeadow, just to the southeast of Springfield. East Longmeadow had just been incorporated as a town, having been split from the town of Longmeadow and was looking for improved communications with the city. If the group was successful in launching the company, Fred would have an equity interest in it and probably get the construction contract. This was the first proposal for the Springfield Suburban Street Railway Company, which would be Fred's first successful business venture, outside of construction.[34] Unfortunately, the construction of the East Longmeadow line was delayed by the need to find a way to cross the tracks of the Connecticut Central Railroad that ran from Hartford to Springfield. The Central Connecticut would not consent to a grade crossing, purportedly for reasons of safety, but also because they already provided passenger service between the two communities on their railroad and didn't want any competition. It would be another six years before East Longmeadow would get its trolley.

The first electric street railway contract Fred T. Ley secured outside of Springfield was for constructing the Hartford, Manchester and Rockville Tramway in eastern Connecticut, in 1894.[35] This was followed in 1895 by construction of a line between Plainville and Bristol, Connecticut, west of Hartford. When that was completed, the company moved its gangs to Westfield, Massachusetts to install the wiring and electrical equipment for the Woronoco Railway.[36] And, in 1897, Fred T. Ley & Company was awarded the contract to construct the street railway down Main Street in Westfield.[37]

More importantly for Fred T. Ley, on November 29, 1897, the Palmer and Monson Street Railway was organized. The town of Palmer was an important railroad junction point where the Boston and Albany crossed the Central Vermont, 13 miles east of downtown Springfield. Fred T. Ley was a promoter and stockholder in this street railway line. He was backed by a group called the A.M. Young syndicate, which was based in New York City. The Young syndicate, working with the United Gas and Improvement Company of Philadelphia, had been buying up street railways, gas companies, and electric companies in New Jersey for several years and had started moving into Connecticut. They created the Connecticut Railway and Lighting company, in

part to secure the right-of-way condemnation rights that allowed railroads to acquire land by eminent domain. The company planned to use the rights-of-way to build both street railways and electric transmission lines. It was said that they intended to put together a continuous street railway line linking Boston and New York.[38]

Not surprisingly, Fred T. Ley & Company got the construction contract for the Palmer and Monson. By June of 1898 it had run lines from downtown Palmer to its outlying villages of Three Rivers, Bondsville, and Forest Lake, connecting them to the central station. The system was extended to Monson to the south and Wales to the north in 1900.

By 1898, Fred had more business than he could handle alone, and was making enough money that he was able to persuade his brother Harold to give up a good job at the Massachusetts Mutual Insurance Company and join him and his other brother, Leo, in running Fred T. Ley & Company. It is an indication of Fred's perspective on the business that he made Harold the president and Leo the vice president, reserving the role of treasurer for himself, the better to control the company's finances.[39] The brothers were stepping into a crowded and competitive field. Long established construction companies in the area included Birnie, Adams and Ruxton (today the Adams and Ruxton Company); Daniel O'Connell; and others. The first contract that the brothers won as a company was for the grading of the street railway from Worcester to Clinton, Massachusetts, on which they netted a profit of $5,000 for six weeks work.[40]

At this time, Fred T. Ley also got one of his early lessons in liability. On a Saturday night in early November, Mr. E.C. Orcutt drove his milk wagon into a trench that Fred's workers had left open while installing a water main in the Holyoke Road in West Springfield. Eighty quarts of milk were spilled and the wagon and harness were damaged. Fred paid the damages.[41] The work of installing the water main continued into the spring of the 1899.[42]

The following year, 1899, the brothers developed Leyfred Terrace, a street of upscale single family homes on land they had recently purchased. It was located on the east side of Belmont Avenue on the hill between downtown and Forest Park in the south end of Springfield. The houses sold for between $3,500 and $4,500.[43] When this was completed, Harold Ley moved to a house at number 18 there. In 1911, Leo Ley moved into a newly built mansion with a distinctive red roof at 46 Randolph Street that was built out of "hollow tile," essentially concrete block, for better insulation.[44]

By 1899, the Springfield Street Railway Company had competed a trolley

line to Indian Orchard in the northeast corner of the city. This neighborhood contained a large manufacturing complex of brick textile mills along the Chicopee River, which Fred T. Ley had helped lay out around 1893. The route went by way of Chicopee and Chicopee Falls. In Indian Orchard it terminated at the end of the bridge across the Chicopee River to Ludlow and did not extend into that town, forcing its residents and workers to walk across the bridge in all weathers to get to the trolley line. In 1902, a newly chartered organization, called the Ludlow Street Railroad Company, asked for a franchise to operate a street railway within the town limits. An ambitious plan showing connections to Springfield, Chicopee and Holyoke was presented. The franchise was granted, but tracks were never laid.[45]

It was around this time that the Ley brothers made a major decision. Up until then, whenever they had a major project underway, either Fred or Harold was personally on the site almost daily to supervise the work. Fred felt that in this way, they could make 11 or 12 percent gross profit as opposed to the normal ten percent, by making sure the work was done efficiently and without waste. This worked, but it limited the brothers to working on only two projects at a time. They ran the numbers, and realized that by doing more projects simultaneously they could make more money, even if the profit margins were slimmer because they would have to hire supervisors and could not be watching every project every day. They also realized that construction was becoming more specialized and that if they were to hire engineers with the required knowledge and experience, they could branch out into many different types of projects. Therefore, they set out to find the best men they could and paid them well, which led to a steady expansion of their business.

On February 2, 1900, Hendel Hallenstein, Fred T. Ley's maternal grandmother and the matriarch of the family died at the age of 81. It was she who had held the family together during the difficult years of Fred's youth by running a German boarding house in the family home, and Fred was grateful to her for her support during the early years of building his company. He laid her to rest beside her son-in-law, Frederick W. Ley in Oak Grove Cemetery in Springfield.

Towards the end of 1900, a new plan to form the Springfield Suburban Street Railway Company to compete with and expand the reach of the Springfield Street Railway, was announced. The initial proposal was to seek franchises to lay 20 miles of track within the city, primarily on streets that did not already have tracks. It was also planned to build the long-delayed line to East Longmeadow and to continue it on east to Hampden. A second suburban

line would be extended out Boston Road where it would connect through Wilbraham with the Palmer and Monson Street Railway, which Fred T. Ley was building. Ground had been broken for the line from Palmer to Ludlow on September 21.[46] The company would be capitalized for as much as $600,000. The promoters promised to maintain a three-cent fare within two miles of the Springfield City Hall.

The main local promoter of the plan was Fred T. Ley, who intended to finance the project and construct the lines. He would benefit by the connection to the Palmer and Monson, and probably was already planning ways to connect both systems with the network of street railways radiating out from Worcester to the east. The proposal was backed by E.H. Barney, chairman of the committee of transportation of the Springfield Board of Trade.[47] However, it was rumored that the real power behind the plan was the A.M. Young Syndicate, which had backed the Palmer and Monson. Earlier in the year, this group had tried to buy up the stock of the existing Springfield Street Railway Company, but it was rebuffed by the shareholders, who wanted to maintain local control.[48]

In spite of the rumors, when the articles of association for the Springfield Suburban Street Railway were published, all of the listed stockholders were from Springfield, and there was no indication of outside influence or control. The stockholders included both Fred T. and Harold A. Ley, both of whom were also on the board of directors. The capitalization of the company was only $80,000, a lot less than the initial proposal, indicating that the plans had been scaled back for the time being. The largest stockholder was Fred T. Ley, who held 474 shares, while his brother held 200 shares giving them a large majority of the 800 shares issued and therefore a controlling interest.[49]

Although they were running a successful construction company, it is difficult to understand how the Ley brothers could come up with the $67,400 needed to purchase their portion of the stock out of their own pockets. This sum was the equivalent of about $1.5 million in 2015. Since the Palmer and Monson Street Railway, which Fred T. Ley & Company was building, was known to be under the control of the Young syndicate, it was probable that they obtained the financing for the Springfield Suburban from them, possibly through bonds guaranteed by the United Gas Improvement Company. Such secretive and complex deals were fairly common at the time.[50]

When the line from Springfield to Palmer was completed, the system, which included the Palmer and Monson, was renamed the Springfield and Eastern Street Railway. It made its first run on September 16, 1901. The trip,

which began on a segment of the Springfield Street Railway, took one hour and 15 minutes to go the 13 miles from Court Square in Springfield to the center of Palmer Village. From there, the special car proceeded to Forest Lake, a park in northern Palmer, for a celebratory picnic.[51] Eventually the Palmer and Monson line was extended north to the town of Ware. The section of the line connecting Ware to Palmer was discontinued around 1919, as automobiles became a favored mode of transportation.[52]

Around the same time, Fred T. Ley became one of the incorporators of the Concord and Clinton Street Railway Company in the eastern part of Massachusetts. This line was projected to extend the Concord, Acton and Maynard line to Clinton which was just north of Worcester, eventually linking that city to Boston via their northern suburbs.[53]

During 1901, Fred T. Ley moved to a luxurious home on the bluff overlooking the Connecticut River, just to the west of Longhill Street, on a cul-de-sac called Buena Vista. The Tudor style house had been built in 1897 for Louis F. Newman. Newman was the general manager of the Forest Park Heights Company, which developed most of the area south of Sumner Avenue after street railway made the area desirable.[54] When Fred T. Ley moved there the house was called Villa Bluff, but, after his marriage in 1903, he and his wife renamed it Bonnie Brae.

His sister, Hendel, was married there in an elaborate ceremony on February 18, 1902. Her husband was Ernest Glantzberg, a local businessman who soon relocated to Boston with his new wife.[55]

By early 1902, Fred T. Ley & Company had completed street railway lines connecting Springfield to Feeding Hills, which is the western part of West Springfield, Massachusetts, and Suffield, Connecticut to the southwest. Both of these lines were under the control of the Springfield Street Railway Company. The first run over the Suffield line was made by a party of dignitaries, including Fred T. Ley, on January 1, 1902.[56] The company also built lines connecting Springfield with Chicopee and Holyoke.

On March 19, 1902, the Springfield City Council considered a formal petition from the Springfield and Eastern to extend their service into Springfield along routes not served by the Springfield Street Railway. Although a through car had been run the previous September for the ceremonial opening, regular customers were obliged to change from one line to the other at the Springfield border.[57]

Also in March, Fred T. Ley announced plans to build a single story block of stores, known as a "monitor block" at the northeastern corner of

Worthington and Dwight Streets. It was designed to house eight stores and expected to cost around $20,000. Fred predicted that the building would be completed within two months. This structure later burned and the site is now a parking lot.[58]

In April 1902, articles of association were published for another new street railway company, known as the Southwick Street Railway, to extend the Feeding Hills line from Agawam westward through Southwick to Park Square in Westfield. Fred T. Ley was on the board of directors of this new company, but he only held 50 shares of stock, with a par value of $5,000. The lead stockholder was Charles H. Parsons of Springfield, who held 134 shares or about 45 percent of the company.[59]

On August 1, 1902, at a meeting held in the office of Mayor Ralph W. Ellis, Springfield's first real estate trust was formed to purchase eight business parcels fronting on Main, Taylor, and Worthington Streets. The purchase price of the property was $400,000, which was the largest real estate deal in the history of the city. The stockholders included Fred T. Ley, Leo Ley, Mayor Ellis, three bank presidents and several industrialists. The property included eight separate buildings: three on Worthington Street, two on Main Street, and three on Taylor Street. It was purchased from the prominent businessman Nathan Bill for $25,000 down with a mortgage of $375,000 held by Bill.[60]

The trust was capitalized for $1,000,000 with 10,000 shares with a par value of $100 per share, but in fact it only sold 12 units of $2,500 each with the Ley brothers retaining three units for themselves. This gave them $30,000 in cash, with the excess $5,000 going towards initial operating expenses. The excess approved capitalization of $970,000, was intended to be used to acquire additional downtown properties, but it was apparently never raised. Fred T. Ley was elected as one of the trustees. At the age of 30 he had established himself as not just a contractor, but also one of Springfield's leading businessmen.

Over the next few years, the Ley brothers, who were the operating trustees, paid off a portion of the mortgage from the rents and bought up some 60 percent of the outstanding shares of the trust at prices as high as $5,000 a unit. Eventually, they refinanced the mortgage with the Five Cent Savings Bank of Boston for $500,000, using the proceeds of the loan to pay a dividend of $17,000 on each investment unit to the remaining shareholders. That meant $153,000 went to the Ley brothers. A few years later, they sold the property for $1,500,000 realizing a profit of over a million dollars on the

deal. The Ley brothers were on their way to serious riches, but they never stopped trying to grow their business.[61]

On March 17, 1903, the board of directors of the Springfield Suburban Street Railway Company, including Fred T. Ley, Harold Ley, Charles F. Grosvenor and A.J. Purinton, petitioned the town of Ludlow for permission to lay tracks into the southern portion of the town and connect them to Springfield across the Chicopee River. A hearing was held on April 6, but agreement was evidently not reached, because the project did not move forward.[62]

It would be another eight years before Ludlow was connected to the street railway system. At a town meeting in 1907, the residents of Ludlow instructed their selectmen to confer with the Springfield Street Railway officials about extending the line into Ludlow. The first discussions took place during the winter of 1907–08, but it took until the summer of 1910 before a deal could be struck. The contract for construction went to the Birnie, Adams and Ruxton Company, not to Fred T. Ley, who was a director of the rival Springfield Suburban Railway Company. The line finally became operational on December 21, 1911.

The Springfield Suburban Street Railway Company completed its line to East Longmeadow in 1902 after building a dry bridge on North Main Street in that town to allow the trolley line to pass over the tracks of the Connecticut Central Railroad. This had required agreements between the railroad, the town, the state, and the Suburban Street Railway Company on the design and financing of the bridge, which was built with abutments made from sandstone dug from the East Longmeadow quarries. The dry bridge survived the demise of the trolleys and was only demolished in the early 2000s after the Connecticut Central abandoned the line through the town.

Another major business venture taken on by Fred T. Ley was the Berkshire Street Railway Company. At the turn of the century, there were already three street railways in Berkshire County. The first to be chartered, in 1886, was the Hoosac Valley Street Railway, which ran north and south along the valley of the Hoosac River between the towns of Adams and North Adams. It was later extended north to Williamstown, east to Clarksburg and south to Cheshire, where it connected to the Pittsfield line. It was electrified in 1889.[63] The Pittsfield Street Railway was the second company to receive a charter, also in 1886, but it was the first to begin operations. It ran from the Boston and Albany Railroad depot in downtown Pittsfield north to Pontoosuc Lake. The company was not very profitable and in 1890 it was succeeded by

the Pittsfield Electric Street Railway company, which electrified the lines in 1891. The new company extended the tracks east to the town of Dalton, south to Lenox, and north to Lanesboro and Cheshire, where they connected with the Hoosac Valley Railroad.[64] The third company to be formed was the Hoosick Railway, which was chartered in 1893, in New York State, and was constructed as an electric road from the start. It initially connected Hoosick Falls, with North Hoosick and Walloomsac, all in New York. It 1897, it was combined with the Bennington Electric Railroad Company of Vermont to form the Bennington and Hoosick Valley Railway, and tracks were laid from Bennington, Vermont, through North Bennington to connect with the Hoosick Valley line at Walloomsac, New York. The line was also extended south to Pownal, Vermont, just north of Williamstown, Massachusetts.[65]

Given this extensive existing network of street railways, it was something of a shock when, in January 1901, the Pittsfield newspapers published reports of a new company called the Berkshire Street Railway which proposed to construct a 55-mile long trolley line extending from Adams south through Cheshire, Lanesboro, Pittsfield, Lenox, Lee, Stockbridge and Great Barrington to Sheffield and the Connecticut state line. The articles of association of the company were signed on December 10, 1900, and filed with the Commonwealth of Massachusetts on January 26, 1901. The corporation had a projected capitalization of $550,000. The principal promoter of the company was Ralph D. Gillett of Westfield, Massachusetts, who was a director of the Woronoco Street Railway, which extended from Springfield to Westfield. The men signing the articles of association included State Senator Thomas D. Post, James D. Sanford, the president of the City National Bank of Springfield, and a number of prominent Berkshire County industrialists. Among these names was Fred T. Ley of Springfield.[66]

The existing street railway companies immediately protested the proposal, but the Berkshire company was able to obtain franchises in all of the towns where it applied for them. It dropped its attempt to include Adams when the Hoosac Valley was granted the right to build south from Adams to Cheshire. On June 11, 1901, the company received its charter of incorporation, and a month later awarded the contract for the construction of 42 miles of electric railway to Fred T. Ley & Company. The line ran from a connection with the Hoosac Valley in Cheshire to the Golf Grounds at Great Barrington. The contract for the rolling stock went to the Wason Manufacturing Company of Springfield.[67]

With Fred T. Ley's normal quick response, construction began on July 17,

only one week after the contract was awarded. The work was started at the northern terminus in Cheshire, and by the end of August activity extended all the way to Great Barrington. The grading was done by men using horse-drawn scoops and wagons along with a lot of pick and shovel work. Bridges had to be built at the many crossings of the winding Housatonic River south of Pittsfield, which slowed down the work, but progress was steady. The rapid rate of construction was the result of a high degree of organization and aggressive management, two characteristics that would become the hallmarks of Fred T. Ley & Company. The management techniques developed in constructing this and the other street railways would contribute to the company's major successes, including Camp Devens in 1917 and the Chrysler Building in 1929.

There was an interesting event early in construction. Both the Berkshire and the Pittsfield Electric Street Railway companies had been granted rights in Cheshire, and under the terms of the franchises, the first company to lay its tracks from Lanesboro to the intersection of the Old Lanesboro and Cheshire Roads was to have the right to build through the center of Cheshire to the Town Hall, with the other company having the right to run over the downtown tracks, although they would have to pay for the privilege. Taking advantage of this clause, Fred T. Ley's workmen laid the required 3,000 feet of track in a single day on August 1, 1901. However the Pittsfield company refused to run its cars over the Berkshire tracks, and it received the right to run its lines along a different route into the center of the town.

Construction continued through the winter of 1901–02, and the first segment, between Park Square, Pittsfield and the town hall in Cheshire, a distance of 10.5 miles, was completed by late spring. The first Wason cars arrived from Springfield on May 17, 1902, and a month later, on June 17, the first trip from Pittsfield to Cheshire was made. The line from Pittsfield to Lee was opened on August 20, the segment from Lee to Stockbridge on September 12, and the final leg into Great Barrington on November 26.

The following August, a grand excursion was arranged for the officers and principal stockholders of the company over the entire Berkshire line. They traveled in a new "palace car" called the *Berkshire Hills*. Among the party, in addition to Fred T. Ley, were officials from the Schenectady Street Railroad in upstate New York and individuals from Newburg and New York City, giving an impression of the wide reach of Fred's connections.[68]

The railway was constructed in a substantial manner. Most of the line was built with rail weighing 70 pounds per yard with a T-shaped cross section,

laid on ties set on 24-inch centers, rather than the lighter 40- to 48-pound rails used on other lines. Around three dozen bridges and trestles were built. The trolleys used a double wire system supported by side brackets throughout the system.[69]

Early in 1903, the New York, New Haven and Hartford Railroad Company, under the leadership of Charles S. Mellan, began to take over trolley lines within its territory. In Massachusetts, the railroad began by acquiring several small suburban street railways around Worcester. Late in 1904, the New Haven began negotiations to take over the Berkshire Street Railway. The deal was closed in February 1905 when the outstanding stock with a par value of $1,000,000 dollars was sold to New York, New Haven and Hartford executives as individuals, since the railroad itself was prohibited from owning the securities by Massachusetts law. The price paid was never reported, but it was widely believed that Fred T. Ley and the other stockholders made a tidy profit on the transaction.[70]

Eventually the New Haven would go on to acquire the Hoosac Valley Street Railway, Pittsfield Street Railway, Pittsfield Electric Street Railway, Hoosick Railway, Bennington Electric Railroad, Bennington & Hoosick Valley Railway, Bennington & North Adams Street Railway, Hoosick Falls Railroad and the Vermont Company. This created a line of light rail that ran from Vermont to Connecticut with connections to New York State.

In 1908, Fred T. Ley & Company was awarded the contract to build a reinforced concrete bridge across the Deerfield River between the towns of Shelburne Falls and Buckland for the Shelburne Falls & Colrain Street Railway Company. This otherwise unremarkable contract resulted in a 400 foot long concrete bridge with five arches, just wide enough for a single track. When the Shelburne Falls & Colrain went bankrupt in 1927, the bridge became overgrown with weeds, but it had been built so sturdily that the town was reluctant to tear it down. A local woman, Antoinette Burnham, came up with the idea to transform the bridge into a thing of beauty, and in the spring of 1929, the Shelburne Falls Women's Club placed loam on the bridge and planted it with flowers. Thus was created the Bridge of Flowers, which is today a major tourist attraction in Shelburne Falls. It is still standing and in good repair 106 years after Fred T. Ley built it. For a period of time, Fred T. Ley & Company used an image of the bridge as a part of its letterhead.[71]

In November 1908, Fred T. Ley, with his brothers Harold and Leo, subscribed for the majority of the stock in a newly proposed street railroad between Waltham and Marlboro in the eastern part of state, taking around

Trolley bridge transformed into the Bridge of Flowers, Shelburne Falls, Massachusetts (photograph by the author).

4200 shares of the 5000 on offer, for an investment of well over a million dollars. The intent of the corporation was to establish a direct trolley connection between Marlboro and Boston to compete with the full scale railroads. The line would connect with the Boston elevated railroad at its terminus in Waltham, if a deal could be struck with that company. It appears that no agreement could be reached with the Boston elevated and that the project never went forward.[72]

Fred T. Ley's last successful venture into street railways occurred in 1909 when he and his brother Harold bought a controlling interest in the Kingston Consolidated Street Railway in Kingston, New York, from August Belmont and John I. Waterbury, the president of the Manhattan Trust Company. The street railway, which was ten miles long, was struggling with its finances and having difficulty maintaining its rights of way. The Ley brothers immediately mortgaged the property and franchise of the company to the Manhattan Trust Company for $250,000 and issued bonds secured by the proceeds of the

mortgage for $75,000.[73] Around $45,000 of this money was used to upgrade the rails, but a fair proportion of it flowed directly to the Fred T. and Harold Ley.[74]

Fred also had an interest in a scheme to build a light railway from Buffalo, New York to the Hudson River called the Buffalo, Rochester and Eastern Railroad. The petition for a franchise was denied by the upstate Public Service Commission of New York in mid–1909, and a re-hearing of the petition was held in January 1910 with the same result.[75] It was probably fortunate for the Ley brothers that the petition was turned down, as street railways generally were entering their period of decline due to increased competition from automobiles and busses.

Electric street railways were good to Fred T. Ley. They made him his first fortune. They taught him how to handle large scale construction projects and how to finance them. They taught him how to structure deals and how to work with state and local governments. Perhaps most importantly, they gave him entrée to circles of powerful businessmen with wide ranging contacts. But the golden era of street railways was a short one. With the introduction of Henry Ford's Model T in 1908, automobiles began to take away their traffic and it was time for Fred T. Ley to move on to other opportunities.

5

The American Dreamer in Paris

During his ten-year apprenticeship as an architect, William Van Alen worked in many different styles, materials, and construction techniques, but he dreamed of greater things than row houses and neoclassical banks. To achieve that, he knew that he needed more formal architectural training. The major influence on American architecture in the late nineteenth and early twentieth centuries was France. Any aspiring American architect who could afford it sought admission to the École des Beaux-Arts in Paris. Many of the most distinguished architects working in the United States were graduates of this school, including Richard Morris Hunt and Louis Sullivan. Those who, like William Van Alen, could not afford to attend the École des Beaux-Arts found practicing architects who taught using its methods and traditions in the United States.

Around 1903–04, upon completing his classes at the Pratt Institute, and while still working for the firm of Clinton & Russell, Van Alen joined the Atelier Masqueray for more advanced architectural studies. This was the first independent architectural atelier, or workshop, in the United States. It was founded by Franco-American architect Emmanuel Louis Masqueray with the encouragement of the Society of Beaux-Arts Architects. This organization was made up exclusively of architects practicing in America who had been trained at the École des Beaux-Arts in Paris. The atelier was a concept adapted from the École des Beaux-Arts. Students would each contribute funds to rent a space and pay a stipend to a practicing architect. This master architect was usually a graduate of the École, and served as the *patron* of the atelier. The architect set the students problems to work on, and they would then meet to discuss and criticize their design solutions amongst themselves before presenting them to the *patron*. The concept was that by trading ideas and talking

about designs, the students would learn from each other while developing styles that were founded on the classics but that reflected their individual personalities.

Masqueray had established his atelier at 123 E. 23rd Street in Manhattan in 1893, to encourage the study of architecture according to French methods. Architect Walter B. Chambers shared in this enterprise. Chambers, like Masqueray, was a graduate of the École des Beaux-Arts. Among other work, he was the designer of the beaux-arts style Lawrence Library in Pepperell, Massachusetts. A colorful and dynamic teacher, Masqueray pleaded with his students to keep things simple. Beginning in 1899, Masqueray also made it possible for women to study architecture with him by establishing a second atelier especially for them at 37–40 West 22nd Street in New York. This was probably the first architectural atelier for women anywhere in the world. As was said at the time, "he has unbounded faith in women's ability to succeed in architecture, particularly as applied to interior decoration, provided they go about it seriously."[1] In 1901, Masqueray was appointed as the Chief of Design for the St. Louis Exposition, which was being planned for 1904. In 1905, after the Exposition ended, he moved to St. Paul, Minnesota, where he established a new practice, but the atelier in New York City carried on his legacy under Walter Chambers.

Although Masqueray was no longer a consistent presence at the atelier when Van Alen studied there, his ideas continued to be taught, with an emphasis on proportion. Masqueray's simple test of proper proportion was, "Does it look well?" He stressed the importance of studying the past, but also encouraged students move beyond it. One of his sayings was that although the Parthenon was a great work of architecture, "it might not make the best design for an office building if a dozen Parthenons were piled one upon another and hung to a steel skeleton." He taught that sometimes it was necessary to break the rules, because that was the "sensible thing to do."[2]

After three years at the Atelier Masqueray, Van Alen moved to another atelier, this one headed by Donn Barber.[3] Donn Barber, also a graduate of the École des Beaux-Arts, was known for his more modern French designs as epitomized by his National Park Bank building at 214 Broadway in New York City, which was completed in 1904. This building broke precedent by abandoning the classical architectural orders and using a colossally scaled arched opening flanked by battered, rusticated piers. On the interior, the steel truss work was exposed, giving the bank something of the elegant industrial look of the Eiffel tower.[4]

Around 1905, Van Alen started preparing himself to enter the prestigious architectural competition known as the Paris Prize. This competition was sponsored by the Society of Beaux-Arts Architects. The Society had been founded in 1896 by a group of American architects who had studied at the École des Beaux-Arts in Paris, and was devoted to spreading the influence of the École in the United States. As noted above, its membership was limited to graduates of the École. The Paris Prize competition was created by the architect Lloyd Warren and was first conducted in 1904. It consisted of a series of tests, each more narrowly focused, to determine the architectural ability of the competitors. A percentage of the participants were eliminated at each step, until only a few finalists were left. The winner received $3,000 for travel to France and living expenses in Paris. The winner was also admitted to the École des Beaux-Arts without having to take the entrance examination, an exclusive privilege granted because the Paris Prize competition was considered to be as exacting, or more so, than the École's entrance examination.[5] The École itself was supported by the French government and did not charge tuition.

The 1908 Paris Prize design for "A Theater" by William Van Alen, atelier Don Barber (Society of Beaux-Arts Architects).

The École des Beaux-Arts, which was the premier school of architecture in the world at the start of the 20th century, was descended from the Académie Royale de Peinture et de Sculpture. This had been founded in 1648 by Cardinal Jules Mazarin, the Chief Minister of France under King Louis XIV, the Sun King. The Académie was a way to recognize outstanding French artists and organize them for service to the state. At that time, architecture was considered to be the application of the arts of painting and sculpture to building and architects were among those named to be members of the Académie. In 1671, Cardinal Mazarin's successor, Jean-Baptiste Colbert, recognized the distinction between architecture and the other arts and established the Académie Royale d'Architecture as a separate body. The distinguished architects who were appointed as academicians conducted an informal school, giving lectures on the principles of architecture, especially proportion and the classical orders. In 1740, the prominent architect Jacques-François Blondel formalized this educational aspect of the Académie by founding the École des Arts, which the Académie officially recognized in 1743.[6] The academies were abolished in 1793 during the French Revolution because of their royalist associations, but the need for architects to serve the new Republic prompted the National Convention to establish the École Special d'Architecture, headed by some of the ex-academicians, within the newly formed Institut National de Science et des Arts. In 1816, after the restoration of the monarchy, Louis XVIII established the École des Beaux-Arts to bring the numerous Écoles Special together. The organization and teaching methods created at that time were essentially the same ones William Van Alen would experience during his studies there almost one hundred years later, reflecting the conservative nature of the École.

In more modern times the influence of the École declined and after the student protests and riots in 1968, it was closed and replaced by a number of smaller, separate architectural schools called Unités Pédagogiques. There are now eight architectural Unités Pédagogiques in Paris and its environs as well as others in various cities around the rest of France.

The École des Beaux-Arts offered studies in architecture, drawing, painting, sculpture, engraving, modeling, and gem cutting. Its architecture ateliers had a profound influence on American architecture in the late 19th century, both through its French graduates who, like Masqueray, came to the United States and established ateliers, and through Americans, like Donn Barber, who travelled to Paris to study at the École. Attendance at the École des Beaux-Arts was an important credential for ambitious young American archi-

tects, although by the early 20th century its leadership was being challenged by new American schools of architecture, especially those at the Massachusetts Institute of Technology and Columbia University.[7]

In 1906, William Van Alen was awarded a *loge* in the Paris Prize competition, meaning that he was selected as a finalist. In this competition, the final phase began with a one-day event where the finalists were each placed in a separate cubicle, or *loge*, and had 12 hours to complete sketches for a building that met the criteria set out in the "program" prepared by a prominent graduate of the École des Beaux-Arts. They then had two weeks to complete their final elevations and plans, which had to conform to their original sketches. This was to prevent the competitors from getting outside help with their designs. The 1906 program was for "a restaurant on the borders of a lake." The winner was Frederic C. Hirons, who later designed the classical George Rogers Clark National Memorial, in Vincennes, Indiana, among the last major Beaux-Arts style public works in the United States. It was completed in 1933.[8]

William Van Alen entered the competition again in 1908 while he was still working for Clinton & Russell and associated with the Atelier Donn Barber. He was 26 years old and time was running out. The École had an age limit of 30 for its students and the course was three years long. This was his last chance to win the Paris Prize, and this time he did. The $3,000 stipend which came with the prize enabled him to travel to Paris and support himself while enrolled in the École des Beaux-Arts.[9] The subject of the final problem of the competition, which had begun with 60 participants, was "a theatre" to be built on a plot 250 by 450 feet with four street facades. The program, or specification, for the competition was written by Julien Gaudet, formerly a professor at the École des Beaux-Arts, who had collaborated with Charles Garnier on the design of the Paris Opera in 1861. Van Alen's design, which was never built, was for "A Grand Opera House."[10] This was done in the French, Beaux-Arts style, in spite of the influence of Donn Barber's more modern designs. Reminiscent of the Paris Opera, it was more austere with an entrance composed of three double doors surmounted by tall, narrow, arched niches, separated by wide columns and flanked by relatively plain walls. The auditorium was covered with a copper-sheathed dome with a lantern that was set off against a decorated rectangular structure containing the flys over the stage.[11] Elements of the design echo certain aspects of the Astor Hotel, which Van Alen had probably worked on a few years earlier.

When William Van Alen arrived in Paris in the late summer of 1908, the

city was experiencing the last years of the Belle Époque. This period of peace, prosperity and cultural innovation under the Third Republic is generally accepted as having begun in 1880 when the first modern celebration of Bastille Day was held. This event symbolically marked France's recovery from two devastating events: its defeat by Prussia in 1870, and the bloody suppression of the Paris Commune in 1871. This was the Paris of Pablo Picasso, Claude Debussy, Marcel Proust and Gertrude Stein. It was also a period known for its gaiety and popular amusements, including the café-concerts, the can-can, and theaters.

But the Belle Époque was much more than the flaneurs, boulevardiers, and grand horizontals. Beginning with Manet in the 1860s, innovative artists were increasingly breaking away from the realistic, academic style of art that was taught at the École des Beaux Arts and celebrated in the Salon. Impressionism gave way to pointillism, which was followed by symbolism and a host of other ism's. In 1908 Pablo Picasso and Georges Braque, who were both living in Paris, were developing cubism. These artists did not exhibit in the official Salon, but held their own exhibitions and attracted their own set of private collectors and patrons, rather than relying on public commissions as the more conventional artists did.

In the realm of architecture, perhaps the most important new movement was the style that came to be known as Art Nouveau. The name was taken from a gallery established by the German art dealer Siegfried Bing in Paris in 1895 called the Maison de l'Art Nouveau, which featured modern art exclusively. By the time of the Exposition Universalle in 1900, the style had become adapted to modern furniture, tapestries, and objets d'art. Its application in architecture can be traced to the 1888 Barcelona Universal Exposition, where modern buildings designed by Lluis Domenech I Montaner were displayed.

This style of architecture was not taught at the École des Beaux Arts, but it was everywhere around it in Paris. Every time William Van Alen rode the new Paris Metro, he passed through the flamboyant Art Nouveau entrances designed by Hector Guimard. Guimard had studied at the École des Beaux Arts but he later became a follower of the great architectural theoretician Viollet-le-Duc. Guimard travelled to Brussels to meet the architect Victor Horta, whose building designs were boldly modern. Horta taught Guimard to use the lines of Art Nouveau and influenced him with his axiom that when imitating plant forms from nature, one should banish the leaf and the flower and keep only the lines of the stem. Using this style, known as the

"Belgian Line," Guimard designed the Art Nouveau Castel Beranger in the Passy neighborhood of Paris, in 1890. At the time, it was one of the few modern style buildings in the city. It is six stories tall, with 36 apartments, each with a different design, and features an elaborate cast iron and copper gate. It is still in use.

In 1896, the Paris Metropolitan Railway Company held a competition for designs for the entrances to its new underground railway. Although Guimard did not win the competition, the president of the company overruled the jury and selected his Art Nouveau designs instead. They involved cast iron forms in the shape of plant stalks, blossoming into flower forms that contained lamps. They supported enameled plaques with the word Metropolitan in a new font also designed by Guimard.[12]

In 1908, when Van Alen arrived in France, the Third Republic was stable and the economy was prosperous, in spite of labor unrest in the Pas de Calais. Clement Armand Fallières was president of the Republic, having been elected in January 1906, and Georges Clemenceau was serving his first term as prime minister, having been selected for that post in October of the same year. Wilbur Wright had arrived in Paris in May 1908, and was conducting demonstration flights of the new Wright Flyer.

William Van Alen took rooms in a modest, five-story apartment building at 16 Rue de l'Odéon, in the 6th Arrondissement, on the left bank, about equidistant from the École and the Atelier Laloux and close to the Odéon Theater and the Luxembourg Gardens.[13] The 6th arrondissement was a favorite neighborhood for both students at the École and artists working independently in the modern styles, although the center of gravity of modern art was already shifting to Montmartre. The 6th was on the edge of the Latin Quarter, and Van Alen's lodgings were only a mile from the Hotel Biron where the sculptor Auguste Rodin had his studio and just across the Luxembourg Gardens from the flat of Gertrude Stein and Alice B. Toklas at 27 Rue de Fleurus.[14]

As an *eleve* at the École des Beaux-Arts, as the enrolled students were called, William Van Alen became a member of the atelier of M. Victor Laloux, a prominent French architect. Laloux had attended the École and won the Prix de Rome in 1878. His most famous work was the Gare du Quai d'Orsay in Paris, a train station that was the principal public structure built in connection with the Paris Exposition of 1900. In 1986 the structure was repurposed as an art museum called the Musée d'Orsay. His atelier was the most popular one with American students at the École, hosting no less than 97 of them over the years. Laloux's atelier was in a lavish 18th century house at 8

Rue d'Assas. The students pinned their drawings onto walls paneled in Louis-Quinze woodwork.[15]

In Paris, the ateliers were central to the architectural training and were scattered along the streets surrounding the buildings that housed the École, which occupied a large campus on the Rue Bonaparte at the corner of the Quai Malaquais. The ateliers provided not only formal training, but social interaction and a sense of camaraderie developed among the students. As recounted by A.D.F. Hamlin in 1908, the year that Van Alen won the Paris Prize:

> The fundamental importance of the plan is always insisted upon; composition is exalted above detail; the presentation or "rendering" is according to well-developed principles and traditions. The student is made to study and re-study his design in all its aspects, to draw and re-draw, constantly revising the design—plan, section and elevation being carried along more or less together through all these revisions. In the daily criticism of the fellow-students as well as the occasional criticisms of the *patron,* it is primarily the artistic considerations that are emphasized. It is a somewhat conventional system and tradition, but a very salutary discipline for the youngster.[16]

Of course, by the time William Van Alen entered the École at 26 years of age with at least one large completed building to his credit, he was no longer a youngster.

At the École itself, William Van Alen could have attended lectures on architectural theory, engineering, materials, and urban planning.[17] However, due to his apprenticeships with Clarence True and Clinton & Russell, and his studies at the Pratt Institute and the ateliers of Masqueray and Donn Barber, he was probably already proficient in many of these subjects and would have spent most of his time in the atelier.

As an *éleve* at the École, William Van Alen participated in the *concours.* These were competitive exhibitions held among the students from all of the ateliers. As in the competition for the Paris Prize, the students were given 12 hours to do preliminary sketches for a project that was set to them, and then had two weeks to complete their finished drawings. For French students, these the *concours* were a critical trial, because the student who most excelled in them would be awarded a fellowship at the French Academy in Rome, the coveted Priz de Rome. As an American, Van Alen was not eligible to win this prize, but he nonetheless did his best to win in the *concours.*

William Van Alen's designs for an establishment for thermal mineral baths and for a city hall both won "first medals" in the *concours.* Francis Swales comments, "His work at the École indicated that the training was pro-

Design for "A Monument Erected on an Island in the Sea" by William Van Alen. Awarded First Second Medal at the École des Beaux-Arts (Society of Beaux-Arts Architects).

viding him with the mental freedom necessary to think independently, instead of merely the usual school-cargo of elements of architecture and a technique of composition by rules. Touches of quaintness and sentiment may be found in his early compositions of ornamental and archaeological design, and one at least of his projects—a design for *A Monument to be Erected on an Island in the Sea*—displays a comprehension of monumental quality and scale seldom found in student design."[18] This design for the monument only won a "first second medal" for Van Alen.

While the École taught that the ultimate expression of beauty in architecture was classical, it also embraced new materials and techniques of construction, including iron, steel, glass, and reinforced concrete.[19] This combination of classical design with modern building methods would become a hallmark of Van Alen's most innovative designs.

In addition to his formal training, William Van Alen was surrounded in Paris by a large number of beaux-arts and neo-classical buildings and monuments to study during his free time. He was only a day's journey by train from Rome, Brussels, and Berlin, with their equally interesting architectural specimens. We know that he befriended a French baron who took him to visit a number of chateaus in northwest France and that he visited the cathedral

cities of England. It would have been natural for him to have exposed himself to the widest possible range of great European architecture while he had the opportunity.

Two letters from Van Alen to Edward Tilton, who was the chairman of the Paris Prize Committee at the Society of Beaux-Arts Architects in New York, survive. The first was written on June 12, 1909, at the start of his second year of study and reads as follows:

Dear Mr. Tilton:—

Just a line to inform you that everything is going on well. I have finished two projects since I wrote you last. I am contemplating a trip to the Cathedral Towns in the southern part of England, after going on loge for the summer project. And expect to be gone at least a month.

Was to the Quatre-Arts Bal on the 9th and had a great time. It was held at the Hippodrome, Place Clichy so we had plenty of room.

If when sending my cheque you will enclose the names of the logists for the prize this year, I will appreciate it very much as I would like to know.

Thanking you for your kindness, in advance, I am,
Very truly yours,
Wm. Van Alen
16 Rue de l'Odéon
Paris, France[20]

This request for the names of the finalists, the logists, in the Paris Prize competition indicates Van Alen's growing awareness of the importance architectural community and the need to know who his future colleagues and competitors might be.

The second letter is dated September 13, 1909, and reports on Van Alen's trip to England.

Dear Mr. Tilton:—

Had a very interesting trip through England. Left here on July 20th after the loge, spent 2 weeks at a chateau in Normandy with a Baron and visited a number of chateaus with him. He knew the people so it gave me a bully opportunity to see some of these places which were wonderfully furnished. The remainder of my time I spent visiting the cathedral towns of England, went as far north as York and as far south as Salisbury. I also visited quite a number of the Halls and Manor Houses.

I am now returning to the summer project, which renders on Oct. 2nd. Was unable to render the last project as I was not well, and was under the doctor's care until I left on my trip. My trip did me an awful lot of good and at present I am very well.

Most sincerely yours,
Wm. Van Alen
16 Rue de l'Odéon, Paris, France[21]

In 1911, Van Alen was awarded the Beaux-Arts *diplôme* and graduated from the École. His three years of training in Paris had a lasting influence on his future designs including his masterpiece, the Art Deco Chrysler Building. The architectural critic Kenneth Murchison later wrote that Van Alen was "the only American student who returned from Paris without a box full of architectural books." His attitude as a young architect was, "No old stuff for me! No bestial copyings of arches and columns and cornishes [sic]! Me, I'm new! Avanti!"[22] When he returned to New York, he went into practice and began to put what he had learned to work.

6

Fred T. Ley & Co.

Between 1903 and 1917, Fred T. Ley used the experience he had gained in managing relatively limited projects to take on ever more ambitious ones and acquire a national reputation as a builder. He grew his company from a small regional contractor specializing in electric street railway construction into a major construction and real estate company with contracts throughout the northeastern United States. He diversified the company by adding expertise in steel and concrete building construction, power plants, bridges and water works. He and his brothers acquired equity interests in some of the company's projects and he made connections with influential financiers in New York and elsewhere. He also acquired a personal fortune that enabled him and his wife to take a place among the social elite in Springfield, Massachusetts.

The year 1903 was a pivotal one for Fred T. Ley. On April 27, he married Miss Mignon Casseday, the daughter of Thomas Casseday, the president of the Bank of Commerce in Louisville, Kentucky.[1] They most likely met in New York City. New York was the most important banking center in the entire country, and Fred made frequent trips there while arranging financing for the electric street railways while Mr. Casseday also regularly visited the city with his family. Fred made it a point to establish both commercial and personal contacts in construction and financial circles wherever he operated, and this may have allowed him to come to know the Casseday family. The match between the banker's daughter and the entrepreneurial contractor proved to be lasting.

By this time, Fred T. Ley had accumulated enough capital to begin making investments outside of the electric railway industry. He backed a group of Springfield inventors who were starting the Independent Store Service Company to manufacture an improved "cash carrier," which was a pneumatic

tube system used for sending money between the sales floor and the cash room in retail stores. The company was located at 275 Main Street in Springfield.[2] With his brothers Harold and Leo, Fred purchased land on the hill above the south end of Springfield and laid out an upscale subdivision which he called Leyfred Terrace. The lots there sold for $1,500 to $2,500 each, a substantial sum at the time.[3] Many of the houses they built there are still standing.

By 1905, even though he was still operating out of an office in his family's house, Fred T. Ley's business had grown so large that he decided to incorporate it, forming Fred T. Ley & Company, Inc. His brother Harold continued to hold the title of president while Fred remained the treasurer, firmly in control of the company's finances.

Fred purchased a large house on a cul-de-sac off Longhill Street in Springfield on a bluff overlooking the Connecticut River. At first, he kept the name of "Villa Bluff," but in 1904 he changed it to "Bonnie Brae." The house had originally been built in 1897 for Louis F. Newman, the general manager of the Forest Park Heights Company which had developed most of the neighborhood south of Sumner Avenue. Around this time Fred also took up the game of golf, annoying his brother Harold, who was always in the office on Saturdays when Fred was out on the course.[4]

A curious incident occurred at Bonnie Brae on January 11, 1905. A young man by the name of Bertram G. Lawton, only 17 years old, broke into the house while Fred T. Ley and his wife were at home. Bertram was masked and armed with two revolvers, and he demanded cash. Unfazed, Fred T. Ley gave Bertram $7, and the boy fled the premises. The robber then ran to a nearby phone booth and called Fred to apologize for the robbery. Unfortunately for Bertram, police inspector John Boyle had already arrived at Fred's house in response to the robbery, and it was he who answered the phone. He got Lawton to tell him where he was and kept him on the phone until an officer could get there and arrest him.[5] It seems that Fred took the entire incident coolly and the fact that a police inspector would respond immediately to his complaint indicates his standing in the community.

It was also about this time that Fred and Mignon Ley started keeping dachshunds at Bonnie Brae.[6] The dachshund was their favorite breed of dog. A friend of theirs recalled that in later life, they kept "serial dachshunds." They would acquire a dog and proceed to overfeed it until eventually it succumbed to its obesity, at which point they would get another and start the process over again.[7]

Fred T. Ley's first son, Frederick Alexander, was born in April 1905 and christened into the Anglican Church by the acting rector of Christ Church Cathedral in a ceremony conducted in Fred's home and attended by some 70 guests, including some from as far away as New York City and New Jersey.

Four projects will serve to illustrate Fred T. Ley's rise as a modern, scientific contractor. These are the Springfield Reservoir filters in Ludlow; the Little River water system; the Hotel Kimball; and, the Coliseum at the Eastern States Exposition. Each project built on its predecessor, helping to establish Fred's reputation and enabling him to build his company's expertise by bringing in skilled engineers and supervisors.

In 1906 Fred T. Ley & Company landed its first major municipal construction project, the installation of sand filters at the Springfield City Reservoir in Ludlow, a town that abutted the city on the northeast. The 445 acre Springfield Reservoir had been created between 1873 and 1875 by damming Broad Brook at Center Street in Ludlow. With an elevation of 400 feet above sea level at its outlet, the reservoir could supply the entire city of Springfield, the highest point of which was a little less than 200 feet lower, by gravity flow. When it was originally constructed, the reservoir was quite shallow and the contractors had not done a thorough job of removing stumps and vegetation. In the summer, the water warmed up rapidly and the high organic content of the reservoir bed made it into a giant petri dish. The water was unfiltered and could become quite foul with algae and sediment.

Since, at the time that the reservoir was originally constructed, the water supply was seen primarily as a public safety and sanitation utility for fighting fires and flushing sewers, rather than as a source of drinking water, this was acceptable, although not desirable. Eventually, as the need for potable water grew, the reservoir was drained, mucked out, deepened, and the bottom covered with sand. This reconstruction improved the water quality, but it was still unhealthy in July and August. By 1900, the city was forced to close the reservoir during the summer months, when the water quality was worst, and use water supplied from local brooks during that time. During the summer of 1905 there was an outbreak of typhoid fever in the city of Springfield that, while not clearly linked to the alternate water supplies, exposed the poor condition of the water supply system.[8] Finally, late in 1905, after 30 years of complaints, the city decided that further improvements were needed and a system of sand filters should be installed.[9]

By this point, Fred T. Ley had learned that the art of the builder begins with the bid. On the morning of November 22, 1905, the Springfield Water

Commission took six contractors on a tour of the Springfield reservoir and invited them to bid on the preliminary excavations for the filter beds. Based on his experience with grading and excavating for street railways, Fred T. Ley submitted a bid before noon, the same day. That afternoon, the commission awarded him the contract based on his low bid of 29 ¾ cents per cubic yard of material excavated, or about $9,000 in all. The contract required that one-third of the work be completed by January 1, 1906, and the entire job be completed by March 1 of the same year. In one of his signature moves, Fred put a gang of 50 men on the job the next day, starting to dig the foundations for the filters. He could do this because of his connections with the labor market and the ability of his supervisors to direct useful work even while the plans were still being finalized. He gave preference to local labor, primarily Italians from the south end of Springfield.[10]

In the late 19th century, Springfield had attracted a large number of Italian immigrants. These came mainly from southern Italy and Sicily. They provided a good pool of unskilled labor and were recruited through labor brokers in the city. This enabled contractors like Fred T. Ley to raise and deploy a workforce rapidly, provided that they could provide adequate supervision. Fred had used Italian labor on his street railway projects, and had a reputation for fair dealing that attracted workmen whenever he needed them.

When Fred had completed the preliminary site work for the filters, he put together an aggressive bid of $12,492.50 for installing the piping and the sand filters themselves and convinced the Water Commissioners that he had the ability to do the rest of job. The contract for the filters was awarded to him over six other bidders.[11] The filter structure is a roughly rectangular earthen embankment enclosing an area of approximately 400 by 500 feet. This is divided into four rectangular compartments. The compartments were filled with sand taken from a hill on the peninsula at the northeast corner of the reservoir. An intake pipe was laid 100 feet out into the deeper part of the reservoir and from this the water was pumped to a structure in the center of the filter. This distributed it over the tops of the sand beds and the water percolated downwards through the sand, which removed particulates, algae, and other impurities. Perforated pipes collected clean water from a gravel bed underneath the sand.

Railroad tracks, Fred's specialty, were laid from the sand hill to the filter beds and dump cars were used to transport and distribute the sand.[12] The job was completed in the early spring of 1906 before the water quality started to degrade in the warmer weather and for the first time Springfield could use

water from the reservoir all summer long. Fred T. Ley completed the project on time and at a profit. These filters continue in use today, with some upgrades, over a century after they were built. Fred's completion of the project on schedule and with no cost overruns impressed the Springfield Water Commission and would shortly prove valuable to him.

Even before Fred T. Ley won the contract for the sand filters, the Springfield City Council decided that improving the quality of the existing water supply system was not enough. They concluded that city had outgrown the water supply from the reservoir in Ludlow. On November 13, 1905, the Council adopted orders directing Mayor Dickinson and the Water Commission to petition the state legislature for the right to build a new, larger capacity water system. They proposed to dam Borden Brook and several other feeder streams in the Little River watershed in towns of Blandford and Russell, which are located in the hills to the west of the city.[13] The dams would create the Cobble Mountain and Borden Brook reservoirs which extended into the adjacent town of Granville. The legislature took this petition up during its next session. In spite of opposition from interests in Westfield, which wanted to retain the water rights for their own town, the enabling legislation was passed on April 11, 1906.[14] There were still some on the Springfield City Council who opposed spending money on a new water system when the Ludlow supply had just been upgraded, but the Council finally accepted the act on June 19, allowing the work to proceed.[15]

The proposed Little River water system was a monumental project that involved building three dams; drilling a tunnel almost a mile long through Cobble Mountain; constructing a water treatment facility including a sedimentation basin and sand filters in West Parish; constructing an underground holding reservoir under Provin Mountain; and creating an aqueduct more than 15 miles long out of 54-inch diameter steel pipe. The aqueduct would have to cross both the Westfield River and the Connecticut River to bring the water to the city. The estimated cost of the project was in the vicinity of $2,000,000.[16] The City Council finally gave its approval for the first two bond issues totaling $540,000 on December 10, 1906, allowing the Water Commission to start preparing specifications and soliciting bids.[17]

The work was divided into six separate contracts. The first of these, Contract No. 1, was for the construction of an access road, which today is known as Gorge Road, a diversion dam on the Little River downstream of the main reservoir, and the tunnel through Cobble Mountain. The diversion dam was needed because the water from the main reservoir was channeled down the

Little River Diversion Dam, Russell, Massachusetts (McPhee).

natural course of the Little River for seven miles before being diverted into the tunnel. It took until July 18, 1907, to write the specifications for this contract and prepare the bid documents. The specifications were issued in a 17 page pamphlet, and called for 19,000 cubic yards of excavation. The dam was to be built of "cyclopean," or large block, masonry on a concrete base. The coffer dams used to temporarily divert the river while the main dam was being built would be made of rubble. The tunnel was specified as being 4,530 feet long, with a slope of 0.4 foot for every thousand feet, or 0.04 percent.[18]

Eleven bids were submitted for Contract No. 1 and, on August 27, 1907, it was awarded to the Culgin-Pace Construction Company of New York City, which submitted the low bid $280,670.

Construction started immediately, but progress was slow and there were several labor disputes. The financial panic which broke out on Monday, October 4, 1907, squeezing the credit markets and causing bank failures, probably did not help. Finally, in early August 1908, after less than one year on the job, Culgin and Pace abandoned the project. At first, they tried to negotiate with Fred T. Ley to get his company to complete the project as a subcontractor.

Fred wanted the contract, but did not want to assume responsibility for the quality of the existing work or for any debts that the original contractor had incurred. He drove a hard bargain and after three days of negotiation had a tentative deal. But after further consideration, Culgin and Pace decided that the terms were not favorable enough to them and backed out of the agreement.

At this point the city stepped in. The Springfield Water Commissioners had three options. They could allow Culgin and Pace to subcontract out the remainder of the work; they could revoke the contract and go out for new bids before letting it again; or they could call on the holder of the performance bond to either complete the project or forfeit the bond. Each of these options had its drawbacks. If the commissioners allowed a subcontract, the city would be liable for any obligations that Culgin and Pace had incurred to date. If they went out for new bids, the work would be halted until the new contract could be awarded. This might take several weeks or even months to accomplish, and what had already been done would be threatened with damage from winter and spring floods. If the Commission deferred to the bond company, they would have no control over who would get the contract.

Upon investigation, the Commission discovered that Culgin and Pace had run up massive debts for supplies and equipment, and that their accounting for expenses was suspect. Those revelations took the option of subcontracting the job off the table. The commissioners opted instead to defer to the bonding company. That company then revoked the contract and immediately re-awarded it to Fred T. Ley & Company on August 27, one year to the day after it had been awarded for the first time. The next day, the Ley company had 150 men on the job. Many of these were men who had already been employed on the project, but Fred declined to re-employ those he called "dissenters." These were the labor agitators.[19] The mortgage on the excavation equipment was held by the Westfield National Bank, and when bank foreclosed on it, Fred T. Ley & Company was allowed to take over the machinery and assume the remainder of the debt.[20]

Fred T. Ley gained this no-bid contract in part because of his close ties with the Springfield city government and business community, especially his banking contacts. The award was also influenced by his efficient work on the Ludlow filters and the knowledge of the Little River project that his company had gained through its negotiations with Culgin and Pace. Because the contract was awarded to him at the price bid by Culgin and Pace, less any payments already made by the city, and the price of materials had fallen since

the original contract had been let, he stood to make a substantial profit on the project.

Meanwhile, on September 10, while Fred was taking over the contract, the Culgin and Pace Company was forced into bankruptcy by its creditors.[21]

An unrelated lawsuit that was filed in 1913 reveals some of the methods used by Fred T. Ley & Company when working in remote areas where local labor was scarce. While working on a contract for installing electrical wiring in the Hoosac Tunnel of the Boston and Maine Railroad, around 1909, the company contracted with one Christine Pipolo to provide labor to them. The contract specified that she would recruit a large number of "her countrymen," that is Italian laborers, in return for the exclusive right to supply the men with groceries and provisions until the work was complete, presumably at a steep markup. Fred T. Ley & Company would provide a shanty and cots for the men to sleep on. Partway through the job, the company found that they could hire enough local men to complete the project, and started laying off the Italians. Ms. Pipolo sued for her lost profits and won. This sort of arrangement was probably fairly common, and helps account for the speed with which Fred T. Ley could put together a large labor force on short notice.[22]

During October, while Fred T. Ley & Company worked to complete Contract No. 1, they were also asked to complete the work on Contract No. 3, which was for the construction of the Provin Mountain underground reservoir. This contract had originally been awarded to the Ficklen-Baker Construction Company of New York City. That company reorganized to become the Baker Construction Company, but was unable to complete the contract. So, as with Contract No. 1, the bonding company, in this case the Bankers' Surety Company of Cleveland, Ohio transferred the contract to the Ley company. The reservoir was built by blasting out about two acres of rock at the top of the mountain to a depth of 30 feet. The hole was then lined with concrete and a steel reinforced concrete roof supported by 300 pillars was built over it. This was without question the largest reinforced concrete structure that Fred T. Ley had ever worked on, up to that point. The purpose of the reservoir was to provide intermediate storage of a full day's water demand for the city of Springfield. At a height of 404.5 feet above sea level, it was 180 feet above the highest point in the city, yet about 600 feet below the level of the Cobble Mountain Reservoir. This meant that the entire system could operate by gravity and provide more than 100 pounds per square inch of water pressure in most of the city.[23]

These two contracts on the Little River system established Fred T. Ley

& Company as one that could succeed on major projects where others failed. Fred completed both contracts on time and water from Cobble Mountain started flowing into the City of Springfield in January 1910.

While working on this contract, Fred T. Ley experienced a personal tragedy. On October 26, 1909, his wife, Mignon, gave birth to a daughter, who they named Barbara. Sadly she died the next day and is buried in the family plot in Oak Grove Cemetery in Springfield. Perhaps as a way of recovering from this event, as well as a respite for Fred from his many obligations, he and Mignon took a six week vacation beginning in February 1910. They cruised to Havana, Cuba, Nassau in the Bahamas, and Palm Beach, Florida before meeting up with friends for some quality time on the golf courses of Pinehurst, North Carolina.[24]

Before he left for this vacation, however, Fred spun off the electrical wiring department of his company, selling it to its manager, Richard A. Turner. At first, Richard A. Turner and Company, Electrical Engineers and Contractors, shared office space with Fred T. Ley & Company in the Phoenix Building on Main Street in Springfield. The elimination of this department signaled the shift in emphasis of the company from electric street railways to concrete and steel construction.[25]

In 1909, while still working on the Little River project, Fred T. Ley also undertook his first major steel-framed building. This was the Boston Arena, an indoor ice rink designed by Funk & Wilcox as an open hall that could also be used for conventions and meetings. The main building was 157 feet wide by 350 feet long with a steel truss supported roof that had a clear span across the width of the building.[26] At the entrance there was a head house where tickets and refreshments were sold and where skates could be rented. This was surmounted by tower which called attention to the arena. The Arena was located on St. Botolph Street, west of Massachusetts Avenue, in Boston and was billed as "the largest skating rink in the world."[27] Ground was broken on October 11, 1909, and the arena was officially opened on April 1, 1910, with an ice carnival held to benefit the Sharon Sanatorium.[28]

On December 6, 1909, while still finishing the Boston Arena, Fred T. Ley submitted the low bid and was awarded the contract to build the Kimball Hotel on Chestnut Street between Hillman and Bridge Streets in downtown Springfield. This location was then an affluent residential neighborhood, located halfway between the transportation hub of Union Station and the civic hub of Court Square. One of the companies bidding against Fred T. Ley & Company was the Thompson-Starrett Company of New York City. This is

the first documented interaction between Fred T. Ley and any of the five Star-rett brothers, Theodore, Paul, Ralph, Goldwin and William, with whom he would develop a professional relationship that would be of great importance to his company in the future.[29]

The Hotel Kimball was designed by the noted Springfield architect Samuel M. Green to be a modern, fireproof, first class hotel, the first one of its kind to be built in the city. Samuel M. Green and Co. was a large architectural and engineering firm that designed buildings all over New England. The hotel covers a lot that is about 114 feet wide along Chestnut Street and 180 feet deep. It is eight stories high on the Chestnut Street side. Because the lot slopes sharply downwards from Chestnut to Dwight, the basement actually serves as the ground floor in the rear, and if measured by its rear elevation, it was the tallest building in Springfield at the time. The building is faced with granite on the first story, which is 22 feet high, and is faced with brick trimmed with limestone above that. The main entrance is on Bridge Street with a second entrance from Chestnut. The hotel contained 309 rooms, a dining room seating 450, and a 22-foot-high banquet hall that could accommodate another 350 guests.[30] Built for William M. Kimball, a successful Springfield businessman and manager of Springfield's Worthy Hotel, the hotel was part of a chain controlled by George W. Sweeney of Buffalo, New York, who also had hotels in Rochester and New York City.

In August 1910, when the building was structurally complete and work was beginning on the interior, Fred T. Ley demonstrated his ability to negotiate with the unions. At that time, there were two separate unions that represented plasterers in the United States, the International Bricklayers and Plasterers Union and the Operative Plasterers Association. The International Bricklayers and Plasterers Union considered Springfield to be its territory, so when Fred T. Ley subcontracted the plastering of the Kimball to the McNulty Company of New York City, McNulty agreed to use the local union. But when the Operative Plasterers Association, which had New York City as part of its territory, found out about this, they threatened to shut down McNulty's other projects in New York unless he used men who were members of their Association on the Kimball. This caused a work stoppage by the bricklayers as well as the plasterers. Fred T. Ley arranged a meeting with the international executive board of the Bricklayers and Plasterers Union and representatives of the Operative Plasterers Association in New York City on Friday, August 26, and offered a compromise. He suggested that each union supply half of the workers. Both sides agreed to this, averting an extended

The Kimball Hotel Building, 140 Chestnut Street, Springfield, Massachusetts (photograph by the author).

strike. The plastering resumed on August 30, with 30 plasterers, 15 from each union, eventually being employed on the project.[31]

There were other minor labor disputes as the work progressed, but Fred T. Ley kept things moving and on January 10, 1911, he took out the following advertisement in the *Springfield Republican*.

THE KIMBALL HOTEL

Will be one of the finest hotels in New England. Springfield will be proud to possess such a hotel.

It will not be so handsome a building just because we built it: the architect, S.M. Green, Inc., would have insisted upon excellence of work, no matter who the contractor might have been.

BUT WE ARE PROUD OF OUR
WORK

S.M. Green, Inc., or any other architect does not have to INSIST on the character of the work we do. If there is an insisting to be done, this office can do it and our men get busy.

FRED T. LEY & CO, INC.
SPRINGFIELD, MASS.[32]

This was the first of many self-congratulatory ads that the company would place about its projects over the years, and it sets out Fred T. Ley's personal approach to contracts well. He always strove for excellence in his work.

The opening of the Hotel Kimball began with a dinner for the stockholders on March 16, 1911, followed by an elaborate banquet for a select group of 75 city businessmen and members of the city government on St. Patrick's Day, and a formal public opening featuring another banquet the following day. The total cost of the project was reported to be around $1,000,000. William Kimball became the hotel's first manager. The hotel was splendid in every phase of its construction and fitting. Solid mahogany floors and chairs with upholstery of hand tooled-leather, bearing the Kimball coat-of-arms, were only part of its elegance.[33] When it opened, the room rates ranged from $1.50 to $3.50 per day.

The hotel later became a part of the Sheraton hotel chain and was known as the Sheraton-Kimball.[34] Among its guests were United States presidents, kings, wealthy American industrialists, and stage, screen, and radio stars. The building changed hands several times between 1964 and 1980. It was converted from a hotel to residential apartments and renamed Kimball Towers. In 1985, the building was again renovated and converted to residential and commercial condominiums, and is still in use today.[35]

As an indication of his rise in the local business community, Fred T. Ley was elected President of the Springfield Board of Trade in 1908 and again in 1909.[36] This was a significant position as the Board of Trade was the predecessor to the Chamber of Commerce. It provided a venue where businessmen could meet and work out deals in private, and it was a significant force in local politics. As president of the Board of Trade, Fred participated in an

extraordinary conference of New England governors held in Boston on September 14, 1908. Attended by all of the New England governors except Governor Cobb of Maine, who was preoccupied by an election campaign, it met at the Algonquin Hotel to formulate plans to develop the business and natural resources of the region. Of greatest concern to the assembled governors were the regulation of fisheries on a regional basis, the development of highways between the states and especially between the major cities, and the harmonization of laws regarding public health and sanitation, especially in the dairy industry.[37]

In 1910, Fred became a member of the board of directors of the Springfield National Bank, in the company of the prominent businessmen George W. Tapley and G. Frank Merriam.[38] He was also a member of the syndicate that formed the Northern Connecticut Power Company, which proposed to remove the dam at Enfield, Connecticut on the Connecticut River, south of Springfield, and develop a hydroelectric power station on the site.[39]

In 1910, Fred owned a 30 horsepower Knox automobile, which was built in Springfield, for his personal use, and his company owned two Cadillac cars of ten horsepower each. This was unusual at the time, when automobiles were a novelty, and was indicative of his growing wealth, as well as his recognition of the value of new technology to his company.[40]

Fred T. Ley also became a director of the Fisk Rubber Co. and the Turners Falls Power Co., and was president of the Napier Saw Co.[41] The Fisk Rubber Company had been founded in 1898 when Noyes W. Fisk of Springfield bought out the bankrupt Spaulding and Pepper Company of Chicopee. Spaulding and Pepper made bicycle tires for the many bicycle manufacturers in that city, but the bicycle business was declining. The Fisk Rubber Company expanded into automobile tires and thrived.[42] Today, Fisk tires are a discount brand, made by Michelin, but for many years they were a leading American company. Their trademark was the iconic "Fisk Boy," a young boy in a nightgown with a tire slung over his right shoulder and a candle in his right hand, accompanied by the slogan "Time to Re-Tire." Fred T. Ley's early association with the Fisk Rubber Company would lead to several important contracts, including the new Fisk tire plant in Chicopee and the Fisk Building in New York City.

Fred later served as president of the Chamber of Commerce in Springfield.[43] That he was able to juggle the rapid and massive expansion of his company and his many outside commitments is indicative of his organizational abilities and energy.

In 1910, while the Hotel Kimball was under construction, Fred T. Ley & Company also constructed an office building for the Fore River Ship Building Company in Quincy, Massachusetts. The Fore River company was a major builder of warships, including battleships. It became a subsidiary of Bethlehem Steel in 1913. The office building was a four-story steel and concrete structure with large expanses of glass. The building still stands at 116 East Howard Street in Quincy, but is abandoned and derelict today.[44]

It was during this period of rapid expansion between 1910 and 1915 that Fred and his brother Harold worked out a detailed system of tracking costs on a daily basis which contributed significantly to the profitability of their company. They developed a series of forms on which they could record all costs related to a project including materials actually used and workers' time charged. Any overruns were quickly identified and corrected. As Harold Ley put it, "If you *stop your losses*, your profits will take care of themselves."[45] The system, along with the forms used, was published by Halbert P. Gillette and Richard T. Dana in their 1922 book, *Construction and Cost Keeping*.[46]

In 1911, Fred T. Ley was elected a director of the Springfield National Bank and was noted as having substantial holdings of the bank's stock. His name appeared prominently in an advertisement touting the stability of the bank.[47]

In early April 1912, Fred T. Ley took a trip abroad. With his wife, his son, Frederick Jr., his mother, and his sister Emma, he sailed to Cherbourg, France on the ship SS *La Provence*. On the trip over, they passed the RMS *Titanic* on its fatal maiden voyage to America and the *La Provence* exchanged messages with it warning about icebergs. When the *Titanic* sent out its distress calls on the night of April 14, the *La Provence* was over 600 miles to the east of her, and so did not participate in the rescue efforts. In Europe, the Ley family toured France, Switzerland, and Italy. Unfortunately, in Davos, Switzerland, Fred's sister Emma, who was single, contracted an infection and died at the age of 25. She was cremated in Europe and her ashes were buried in the family plot in Oak Grove Cemetery in Springfield. They returned from Naples on the SS *Prinzess Irene* of the North German Lloyd line, arriving in New York on June 1.[48]

During 1912, Fred T. Ley & Company handled more than $3,000,000 in contracts and employed more than 3,000 men with a weekly payroll in excess of $45,000. Among the buildings they erected that year were the Faith Congregational Church, now Faith United, of which Fred T. Ley was a member, and the Wyman-Fenton Building at the corner of Deme and Hancock Streets

Faith Church, 52 Sumner Avenue, Springfield, Massachusetts (photograph by the author).

in Boston, which was the first large office structure to be built on Beacon Hill.[49]

The company erected its own building, called the Fred T. Ley Building, at the corner Worthington Street and Dwight Street in Springfield in 1913. A succession of contracts for large buildings in Springfield followed, including the Springfield YMCA in 1913 and the Main and Liberty Building in 1914. The company began building the Frederick Wilcox Chapin Memorial Building at Springfield Hospital in 1914. This modern, for the time, brick and steel building contained 46 private rooms, an operating suite and X-ray facilities. It was named for Dr. Chapin, a trustee of the hospital who had died in 1910. It was the first of three buildings which, when completed in 1930, made up the Springfield City Hospital, and are still in use as a part of the Baystate

YMCA Building, 110 Chestnut Street, Springfield, Massachusetts (photograph by the author).

Medical Center.[50] In 1915, they constructed the Third National Bank Building in downtown Springfield, now called the Harrison Place building.

The company also built the Hampden Steam Plant in Chicopee, and water power plants, including one for the Turners Falls Power Company, the Connecticut River Company plant in Shelburne Falls, and plants for power development for the Eastern Connecticut Power Company in New London.[51]

In February and March 1913, the Leys travelled to Kingston and Port Antonio, in Jamaica, before going on to Panama where Fred got to inspect the work on the canal, which was then under construction. The Ley family went abroad again in March 1914, touring England and Germany with a number of other couples from Springfield and returning home on the two-year-old SS *Imperator*, the second largest passenger ship in the world, on April 4, only four months before the outbreak of the Great War.

This was a prosperous and busy time for Fred T. Ley. His company had become a major regional general contractor with a core group of skilled

Chapin Building at Bay State Medical Center, Springfield, Massachusetts (photograph by the author).

engineers and superintendents who were trained in his methods and who could oversee its many projects even when Fred was absent on his travels, but bigger things were yet to come. After completing the Hotel Kimball, Fred T. Ley's next major coupe was the construction of the Coliseum for the Eastern States Exposition.

Third National Bank Building, 1392 Main Street, Springfield, Massachusetts (photograph by the author).

The Eastern States Agricultural and Industrial Exhibition was the brain child of Joshua L. Brooks, an industrialist who had founded the J.L. Brooks Banknote and Lithographing Company in Boston in 1888. He moved the business to Springfield two years later and became a leader of the Springfield Board of Trade. He wanted to bring to the farmers of New England the same innovations in science and management that had revolutionized manufacturing. To do this, he saw the need for a venue where the farmers could be exposed to the newest agricultural ideas, machinery, and products. The concept of an annual Exhibition was born, and a company to carry it out was incorporated on May 27, 1914, with Joshua Brooks as president.[52]

Progress was slow at first, but in January 1915, plans for the establishment of the Eastern States Agricultural and Industrial Exposition began to be realized with the issue of $200,000 worth of stock to finance the necessary construction and operating costs. A large site was acquired in the town of Agawam, just across the Connecticut River from Springfield. It was located on low ground on the north bank of the Westfield River, just upstream from its confluence with the Connecticut. The management of the Exposition also received a letter from the National Dairy Show, which had been held in Chicago for the past nine years, indicating their interest in holding an eastern version of the show at the Exposition grounds.[53] It was originally hoped that the first Exposition could be held in October 1915, but due to the need to build a dike along the Westfield River to prevent flooding of the grounds, the opening was delayed to 1916.[54]

Because of an outbreak of hoof and mouth disease in the western states, the National Dairy Show was not held in 1915, however the organizers of the show, including its president, W.E. Skinner, continued to look for a site to hold an eastern version. Joshua Brooks and the directors of the Eastern States Exposition worked hard to bring the show to the Exposition grounds. They were in competition with New York City, Philadelphia, Boston and other large cities, but Brooks brought a dedication and level of intensity to Springfield's proposal that the other cities lacked. On the day after Christmas, 1915, a delegation, which included Governor David Walsh of Massachusetts, Governor Charles W. Gates of Vermont, and Fred T. Ley's brother and business partner Harold Ley, travelled to Chicago in a special rail car attached to the Twentieth Century Limited. They were going to meet with the board of the National Dairy Show, in a final effort to get a commitment for the show to come to Springfield.[55] The meeting, which was scheduled for one hour, lasted two days. In the end, the executive committee of the Diary Show voted to

bring it to the city, provided that the Exposition raise the money for the necessary buildings within 45 days.[56] Given the great enthusiasm with which the news was received in Springfield, fund raising was not a problem. In the course of ten days, the organizers collected pledges totaling $585,000 from 3600 Springfield residents who subscribed to buy stock to pay for the new buildings.[57] Together with the original subscription of $200,000 in 1915, this gave the Exposition a capitalization of over $750,000.

The National Dairy Show required the Exposition to construct an indoor arena, that the Exposition christened the Coliseum. It was to be 300 feet long and 180 feet wide with a seating capacity of 5,500 people. In addition, the Show required another building with 60,000 square feet of exhibit space for displaying machinery and a barn that could hold at least 1,000 cattle. The directors of the Show also required the delegation to make sure that sufficient hotel space was available in the region to accommodate the thousands of exhibitors and visitors that the show was expected to attract.[58]

By traveling with the delegation, Harold Ley was able to discuss the building needs directly with the organizers of the show and examine the facilities that had been used in Chicago. This enabled him to get a head start on the design and estimates for the buildings. As a result, Fred T. Ley & Company, probably helped by their experience with the Boston Arena and the fact that Fred had served with Joshua Brooks on the Springfield Board of Trade, was awarded the contract for the Coliseum even before the rest of the buildings were put out to bid. On Thursday, April 6, 1916, the *Springfield Republican* carried the following one-paragraph notice: "Bids for the exposition building of the Eastern States Exposition will be opened Saturday noon at room 225 of the Massasoit building. The building will cover 72,000 square feet of ground and must be ready for the National Dairy Show in October. The building committee itself has undertaken the contract for the coliseum and has engaged Fred T. Ley & Co. incorporated to do the construction work."[59]

To understand how large Fred T. Ley's company had grown, it should be noted that as it was taking on the construction of the Coliseum, it had already entered the highly competitive New York City construction market and was actively engaged in the construction of a luxury apartment building at 820 Fifth Avenue in New York City, which will be discussed in Chapter 9.

Work on the Coliseum began immediately under the direction of George S. Jewett, Fred T. Ley's on-site superintendent, but was threatened by a strike of the shovelers' union in early May. In a show of force, Fred T. Ley brought

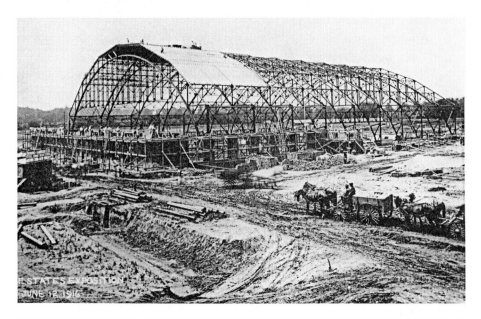

Top: Eastern States Exposition Coliseum steel arches being erected (courtesy Eastern States Agricultural and Industrial Exposition, Inc.). *Bottom:* Eastern States Exposition Coliseum, West Springfield, Massachusetts (photograph by the author).

in strikebreakers, but also agreed to arbitration of the issues, a combination of tactics that soon brought the strike to an end.[60]

The Coliseum was designed as a huge barrel vault composed of ten steel arches, each with a span of 200 feet, that supported the roof. These created nine 28-foot bays for a high-bay length of 250 feet. The steel arches required three special derricks with a combined lifting capacity of 115 tons to erect them. The first of the ten roof arches was erected on May 15. The arched arena was surrounded by a rectangular, three-story high, steel framed building faced with

Fred T. Ley Company brass builder's plaque at the Eastern States Exposition (photograph by the author).

brick. This building extended an additional 25 feet at either end of the arched high bay. These extensions provided enclosed entryways to the arena and brought the overall length to 300 feet. A columned entrance with offices above was centered on the long north side.[61]

When the arches were up, Fred T. Ley took out the advertisement that follows on the next page in the *Springfield Republican*.[62]

The construction of the buildings at the Exposition grounds turned into a competition between Fred T. Ley & Company and the Flynt Construction Company of Palmer, Massachusetts, to see who could complete their building first. Flynt was building the Machinery Hall, which today is known as the Stroh building. The superintendents for the two companies were George S. Jewett for Fred T. Ley and J.A. Morrissey for Flynt. Jewett had the head start, breaking ground on March 20, while Morrissey did not start until May 16, but the Coliseum was the more complex structure with its massive arches and greater height.[63] Due to the large scale of the project, both companies had to deal with shortages of labor and materials. The speed with which the Coliseum went up was a tribute to the high degree of organization that Fred T. Ley & Company brought to the job.

The Coliseum was said to be the largest arena building in the country at the time. Its 20,000 square foot show ring was more than 1,000 square feet

A New Record in Steel Frame Construction

The building of the big Coliseum of the Eastern States Agricultural and Industrial Exposition called for some strenuous work and we take pride in the way the Ley organization responded to the call, erecting

10 Great 200 Ft. Steel Arches in 10 Days

Which we believe to be a record in steel construction of this character.

One More Tribute to the Ley Organization and the Ley Efficiency

Fred T. Ley & Co, Inc.

Contractors
Telephone 4160

larger than the floor of the contemporary Madison Square Garden, the second arena by that name, at 23rd Street and Broadway in New York City. By the end of June, the roof was being installed and the company was preparing to start work on the interior.[64] This called for another self-congratulatory advertisement.[65]

By early September, all of the buildings were nearing completion, with

the contractors working on the last finishing touches. With the show scheduled to open on October 12, there was still time to get everything ready.[66]

When the show was about to open, Fred T. Ley took out one last advertisement.

The National Dairy Show ran from October 12 to October 21 and drew 297,000 paying visitors, in addition to the exhibitors. The crush of visitors

THE COLISEUM

Our Part in the Big Dairy Show

The toughest nut in the building/plans of the big Dairy Show was left to us to crack—the building in record time of the huge Coliseum—the biggest of the exposition buildings, and one of the largest buildings of its kind in the country.

It put the Ley organization to the test and our forces were equal to the task. The 10 great steel arches of the Coliseum were put up in 10 days, a record in steel construction—and the rest of the building was completed with the same sure speed.

FRED T. LEY & CO, Inc.
Contractors

coming across the old covered bridge from Springfield was so great that, in West Springfield, both Main Street and New Bridge Street, as Memorial Avenue was then called, were closed to automobile and horse drawn traffic.[67] The Ley-built Coliseum was the center of the Show and provided yet another milestone for Fred T. Ley & Company. Today, it continues to be an important venue at the Eastern States Exposition grounds, hosting horse shows, circuses,

and other events throughout the year. It is the centerpiece of the current version of the Eastern States Exposition, the annual Big E, held every September, which bills itself as New England's State Fair. The Big E still features agricultural and livestock exhibitions along with live music, fair food, a midway and other attractions.

At the end of 1916, at the age of 44, Fred T. Ley was a rich man and the head of one of the largest construction companies in the United States. He was beginning to enter the New York market, and was establishing important professional connections. But soon, he would have to handle his most challenging project yet, as the United States entered World War I.

7

The Salesman
and the Dreamer:
Severance and Van Alen

When William Van Alen returned from Paris in 1911, he was fired up with enthusiasm and creativity. His years of study at the École des Beaux-Arts had given him both a solid foundation in the technical aspects of modern architecture and the confidence to step out in new directions of style and design. He had been exposed to the latest developments in Art Nouveau architecture in Paris and elsewhere in Europe, and was aware of the evolving forms that would become Art Deco. Before Van Alen could put that energy to work, however, he needed clients.

Having neither the resources nor the contacts to start his own practice immediately, Van Alen took a job as an associate architect at the architectural partnership of Harold C. Werner and August P. Windolph. The offices of this firm were in the Metropolitan Life Tower at 24th Street and Madison Avenue in New York City. This new, 700-foot-tall skyscraper, designed by Napoleon LeBrun and completed in 1909, was then the tallest building in the world. It would keep that title until 1913 when the Woolworth Building, designed by the architect Cass Gilbert, topped out at 792 feet. The Metropolitan Life Tower had been designed in a classical style chosen to evoke the famed bell-tower of San Marco in Venice with balconies, balustrades, turrets, and other architectural details on the facade, and was faced with white marble from the Tuckahoe quarry in Westchester, New York.[1] Eighteen years after starting to work in this "world's tallest building," Van Alen would design another record breaking structure, the radically different, art-deco style, Chrysler Building.

Werner & Windolph was a minor New York architectural firm that specialized in houses, cooperative apartments, and smaller public buildings.[2]

Reportedly, one of Van Alen's designs for them was an apartment house with a small garden in the courtyard, for which he coined the term "Garden Apartments."[3] The claim to the first use of this term has also been made for the development now known as the Greystone Apartments in Jacksonville, Queens, designed by George H. Wells, which were completed in 1917. The garden apartment was a new concept at the time when most apartment buildings were tall, solid blocks with limited natural light and ventilation.[4] In 1912, Van Alen also obtained a copyright in his own name for a "typical floor plan of proposed apartment hotel on a lot 33 feet by 100 feet," but it is not known if this was for the garden apartment or if it was even ever built. Plans submitted with copyright applications are generally destroyed when the copyright expires.[5]

In addition to apartment buildings, Van Alen worked on larger designs for civic buildings. In 1912, he was listed as an associate architect with Harold C. Werner and August P. Windolph on an entry in the preliminary round of a design contest for a new county courthouse for New York County, that is, Manhattan.[6] Although their design has not survived, it was probably in the classical style that was the accepted norm for public buildings at the time. Van Alen's creativity was not yet being allowed to flourish. The Warner & Windolph design was not selected for the final round and the competition was won by Guy Lowell, who designed a ten-story Corinthian columned building reminiscent of a Greek Temple. That building was not actually completed until 1926.[7]

Van Alen was again listed as an associate of Werner & Windolph in 1913 in a similar competition for the Albany County courthouse in upstate New York.[8] That competition was won by Hoppin & Koen.[9] He was also listed as an associate on the design of a group of baths, both open air and interior, for the City of Saratoga, New York in 1913.[10]

In 1913, another significant event occurred in New York City. The Association of American Painters and Sculptors organized the first large exhibition of Modern Art in America. It opened in the 69th Regiment Armory on Lexington Avenue at 25th Street on February 17 and ran for one month. Now known simply as "The Armory Show," the International Exhibition of Modern Art was the first exposure that most of the attendees had to the experimental, non-realistic styles of the European avant-garde, including Cubism. More than 300 European and American artists were represented, including Mary Cassatt, Pablo Picasso, Eduard Manet, Paul Gauguin, Vincent Van Gogh and many other prominent artists and sculptors. Perhaps the most famous and

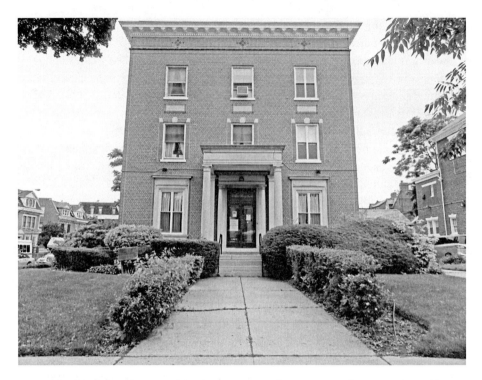

Single family house, now a Cornell University office, 1337 President Street, Brooklyn, New York (photograph by the author).

startling of the art works displayed was Marcel Duchamp's cubist-futurist painting, *Nude Descending a Staircase*. This one small picture, done in shades of brown and consisting of sharply angular figures, had been completed only the previous year. Now hanging without controversy in the Philadelphia Museum of Art, it shattered American conceptions of art, which leaned heavily on the representational, and in many ways opened the door to acceptance of the abstract, angular forms of Art Deco. The show had a major impact on the development of modern styles in architecture and furniture. William Van Alen may already have been exposed to these styles during his time at the École des Beaux Arts, because they were beginning to become visible in Paris by 1911 when he finished his studies. Even with this prior exposure, if he attended the Armory Show, as is likely, he would have seen more modern art, with more variety, in one place than had been assembled anywhere before. This must have increased his confidence in his own architectural innovations.

Except for the Garden Apartments, no buildings designed independently by Van Alen between 1911 and 1913 have been identified, nor was he credited with any other collaborations, so we must assume that he worked on the details of Werner & Windolph's designs. Van Alen did take out a number of copyrights for apartment buildings and a residence in 1912 and 1913. Although there is no record that any of the designs were actually built, they show his growing interest in innovative residential design, which would become an important element of his work after the Chrysler Building was completed.[11] They also show his concern for protecting his ideas from others who might try to copy them.

While his job at Werner & Windolph provided Van Alen with a good income, it severely limited his ability to express the creativity which had blossomed during his years at the École des Beaux Arts. To reach his full potential he would have to step out on his own. In 1914, when he was 32 years old, Van Alen left Werner & Windolph and for a brief time attempted to a solo architectural practice.

One building which Van Alen designed during this period is a three-story brick, Italianate single-family home, built in 1914. It still stands at 1337 President Street in Brooklyn and today houses a Cornell University cooperative extension office. The exterior is unremarkable, but inside, the entrance hall is terminated by an ornate white plaster fireplace and mantle in the beaux-arts style.

Soon afterwards, Van Alen decided that he needed a partner and, later in 1914, he formed his own company with his fellow architect, H. Craig Severance.[12] Severance was three years older than Van Alen, and had worked at the renowned architectural firm of Carrere and Hastings. While working there, he had established contacts with important future clients, including the Standard Oil Company and a number of real estate developers. However, John Merven Carrere had been killed in a taxicab accident in 1911 and in 1914 the firm was still in a state of transition. This may have influenced Severance's decision to go out on his own. For both Severance and Van Alen, this was their first experience as principals in a company. As in many such partnerships, the two men specialized in different aspects of the business. Severance, though a competent architect, was the salesman who obtained most of the commissions and handled the financial side of the company, while Van Alen did much of the actual design work. This arrangement was not unlike that of the famous Chicago architectural partnership of Daniel Hudson Burnham and John Wellborn Root, in which Burnham was the outside face of the firm

while Root did most of the design.[13] In 1992, Severance's daughter, Faith Hackl Stewart, recalled, "Mr. Van Alen was a Beaux-Arts man, but my father got most of the business for the firm."[14] This arrangement worked well at the start, but led to strains over issues of artistic merit and disagreements over who should get credit for their work. Slowly the two men drifted apart, but they achieved much during the ten years before the partnership ended in 1924.

Many writers have credited William Van Alen with the design of most of the firm's buildings, including one of their first projects as partners, the Standard Arcade, which was commissioned in 1914. This was a four-story building to be erected on land owned by the Standard Oil Company at 50 Broadway in Manhattan, at a cost of $225,000.[15] This was the site where the first steel framed "skyscraper" in New York, the Tower Building, had been built in 1889. It had been demolished in 1913 as uneconomical and Standard Oil wanted to replace it with a smaller structure. Severance & Van Alen probably got the commission through Severance's contacts at Standard Oil, a relationship that Severance would maintain even after the partnership broke up.

Van Alen's design for the Standard Arcade consisted of a two-story retail space with offices above, on a lot that went completely through the block from Broadway to New Street.[16] The building was three stories tall on the Broadway side and four stories on the New Street side. The facade was not much more than two giant Doric columns with a wide sheet of glass, bisected by an arched entry, between them. The interior ground floor consisted of a 20 foot wide, 26 foot high arched corridor that passed entirely through the building from Broadway to New Street, with shops on either side.

The Standard Arcade was an unusual design for the United States. An arcade is an indoor shopping center consisting of a central passage with shops opening off of it on each side. The retail establishments are typically upscale and the central passage and shop fronts are elegantly decorated. The Standard Arcade was the first arcade building in New York City and may have been inspired by European shopping arcades such as the Passage des Panoramas in Paris and the Galeries Royales Saint-Hubert in Brussels, which Van Alen would have been familiar with from his days at the École des Beaux-Arts. It may also have derived inspiration from John Eisenmann and George Smith's Cleveland Arcade of 1890, although Van Alen's passion for originality resulted in a design that was all his own.[17]

The first floor included a 7,000 square foot Horn and Hardart Automat on the Broadway front. The Automat, a restaurant where patrons chose food

that was displayed behind small glass doors and inserted nickels in a slot to open the door and retrieve the item, was a fairly new concept. The first one in America had been established by Joseph Horn and Frank Hardart in Philadelphia in 1902, but they did not bring the concept to New York City until 1912. Since only 15 Automats were opened in New York City between 1912 and 1920, the one in the Standard Arcade was one of the first in the city, and Van Alen was able to give its design some of the Art Deco touches he was developing an interest in. This Automat was of an early design and all of the food it offered was supplied through the coin operated pigeon holes, which were replenished from a kitchen behind the bank of machines. The cafeteria line that was a feature of the restaurants in later years was not introduced until 1922.[18]

The corridor of the Standard Arcade was floored with marble decorated with mosaics, and its walls had marble columns between the bronze trimmed shop fronts. A concealed courtyard in the center of the upper floors, roofed with "prism glass" provided light and ventilation to the interior shops through skylights in the arch.

At 655 feet, the block that it was on, between Exchange Place and Beaver Street, was the longest block on Broadway in the downtown area. The Standard Arcade provided a handy cut through to New Street, guaranteeing lots of foot traffic for the occupants of the retail spaces. The *New York Times* noted that "the structure will be a decided novelty in the lower part of the city, being totally different from anything now there. It is also interesting to note that the owners, recognizing the fact that more than enough tall buildings have been erected in the immediate vicinity, have planned a low structure for the site."[19]

One idea that Van Alen introduced in the Standard Arcade was the elimination of reveals, or setbacks, in the window installations. The accepted practice was to set windows four inches back from the face of the wall to create an appearance of thickness and solidity. Van Alen set the windows in the Standard Arcade flush with the plane of the wall so that they appeared to be painted on. Although this may seem to be a minor design change, it was revolutionary at the time. The first steel framed buildings had been designed to look like more traditional masonry buildings. This signature feature of Van Alen's was more consistent with the nature of the curtain wall construction that was being used, revealing the true structure of the building, and it eventually became the new standard.[20] When the Empire State Building was completed 17 years later, in 1931, its builder, Paul Starrett, would point

to the use of flush mounted windows as one of its outstanding design features.[21]

While the Standard Arcade was clearly neoclassical in its design, the use of extensive glazing on the facade and the elimination of reveals to put the windows flush with the walls were both techniques which would later be characteristic of Art Deco architecture, a style which Van Alen would embrace after the end of the Great War.

This innovative approach was deliberate. William Van Alen studiously avoided copying the ideas of others. Many years later he filed a patent infringement lawsuit that against Alcoa when they used his patented design for aluminum window frames without his permission. During the course of the trial, when Alcoa claimed that he had ignored their use of the design, thereby granting implied permission, he was asked if he had seen Alcoa's advertisements of the design in question in the architectural press. Van Alen replied that he deliberately abstained from reading architectural magazines because he was "not particularly interested in what my fellow men are doing. I wish to do things original and not be misled by a lot of things that are being done by somebody else."

Asked by the judge, "and you don't pay attention to anybody's work but your own?" Van Alen answered, "That is my general policy."[22]

In fact, in 1914, lower Manhattan was overbuilt and office space rents were under pressure, especially after the outbreak of the First World War at the end of July. The Tower Building had been demolished in 1913 because it could not attract tenants. The Standard Oil Company was looking for a relatively inexpensive building design that could occupy this valuable site, estimated to be worth $1,600,000, and provide some rental income until the market for office space opened up again. When it did, Standard Oil could replace the arcade with another tower. They liked Van Alen's innovative design, which provided a concentration of high end retail space in a part of the city where there was little of it, since most of the high rise buildings were occupied by banks and stock brokers who utilized their street level floors for their own businesses.[23]

The Standard Arcade was a strong start for the partners. The design was noted in the *New York Times* as well as in the architectural press and it received high praise for its originality.[24] It is interesting that the Standard Arcade was replaced during the building boom of 1927 by a 37-story office tower designed by Severance after his partnership with Van Alen had broken up.

The Standard Arcade made a statement and put the new partnership on the map, but the competition for large commissions like that was fierce and the bills still had to be paid, so 1914 also saw the partners taking on smaller commissions. These included alterations to a town house at 109 East 61st Street and interior renovations to a loft building, also owned by the Standard Oil Company, at 26 Broadway, next to the Standard Arcade.[25]

Severance & Van Alen's next major project was a 16-story commercial building containing retail space and offices. It is located at 1107 Broadway on the corner of 24th Street across from Madison Square in Manhattan. This was their first high-rise, curtain wall design. Originally called "The Albemarle" because it was built on the site of the old Albemarle hotel, the building eventually became known as the Toy Center North Building when it was acquired by the owners of the original Toy Center at 1099 Broadway. It was built at a cost of $1,300,000.[26]

Designed in 1915, the Albemarle was notable for its plain facade and the lack of a cornice, both of which were innovations in that era of highly decorated buildings. These aspects of the design are also elements of Functionalism, the architectural style championed by the Bauhaus in Germany, and considered by some to be a form of Art Deco, but since the design was executed during the second year of the Great War, direct German influence on it is unlikely. Instead, what we are seeing in the Albemarle is Van Alen's independent development of Art Deco elements.

One of Van Alen's innovations in the design of the Albemarle was the use of glass to face almost the entirety of the first four floors of the building, foreshadowing the glass curtain-wall construction of the modern era. This was the probably the first time that a fully glass facade had been used for more than three stories, anywhere.[27] It was a logical extension of his extensive use of glazing in the design of the Standard Arcade. Although the building still stands, this aspect of the design has since been severely altered and is no longer apparent. The century-old building is now being converted into residential condominiums and has been renamed 10 Madison Square West.

In 1915, in spite of his growing architectural practice, William Van Alen was still living at home in a Brooklyn row house at 411 Putnam Avenue with his mother, stepfather, sister and aunt.[28] However, this would soon change. On January 16, 1916, he married Elizabeth Bagley at the Tompkins Avenue Congregational Church. Elizabeth was 20 years old, 13 years younger than Van Alen, and a native of Brooklyn. The couple moved into a five-story luxury apartment house at 738 St. Mark's Avenue in Brooklyn.[29] Befitting their close

Albemarle/Toy Center North Building, 1107 Broadway, New York City (photograph by the author).

working and personal relationship at the time, H. Craig Severance was William Van Alen's best man at the wedding.[30]

The period from 1914 through 1919, when the First World War was being fought in Europe, was a depressed time for new building construction in the greater New York area, especially after the United States entered the war in April 1917. The partnership of Severance & Van Alen felt the pain of this situation. These years were unproductive of commissions for large or important buildings and the partnership worked on many small projects which gave little opportunity for the grand creative gestures that Van Alen aspired to make. In 1916, these projects included an addition to the Title Guarantee & Trust Building on Fulton Avenue in Brooklyn; new fireproof windows for a factory at 17 West 45th Street in Manhattan; alterations to the building across the street from it at 18 West 45th Street; a brick wall at the residence they had previously designed renovations for at 109 East 61st Street; and a two-and-one-half-story brick residence on Albemarle Road in Brooklyn. They did two separate sets of plans for the southeast corner of 129th Street and Broadway on the West Side of Manhattan, one for a three-story building and another for a four-story one. It is not clear as to whether either of these was ever built, as a six-story apartment block was erected on that site in 1924.[31]

Severance & Van Alen also designed several residences on Long Island, New York. The treatment of these houses in the architectural press may show the beginnings of the tensions in the partnership. In September 1918, the Architectural Record featured a house built for a Mr. Frank Bailey in Locust Valley and credited it to H. Craig Severance alone.[32] The next month, they featured a large country house designed for a Mr. C.A. O'Donahue in Huntington, and credited it to Severance & Van Alen, Architects. This house, which still stands, features a massive columned portico on the three story central building, flanked by two large wings, all faced with stone.[33]

After Great War ended, the pace of new building construction picked up and in the early 1920s William Van Alen was able to resume establishing his credentials as a modernist, with commissions for several large midtown buildings.

The first of these was the Bainbridge Building, a 12-story brick and limestone retail and loft building, at 37–39 West 57th Street. It was built as a commercial venture for Bainbridge Colby, a former Secretary of State under President Woodrow Wilson and, at the time of the commission, a law partner of Wilson.[34] Severance & Van Alen created the design in 1920, but the building was not completed until 1924, at a cost of $700,000.[35] Originally known as

the Bainbridge Building and now as the Vogar Building because it is owned by Vogar Realties and is still in use. It cost around $700,000 to build, earning the partners a hefty fee of about $42,000. The strikingly modern building has shear limestone walls with the windows set flush with the line of the facade, in Van Alen's signature fashion. Because 57th Street is wider than normal, several floors can easily be viewed from the far sidewalk, so Van Alen faced the lower floors almost entirely with glass creating oversized show windows even above street level. The front of the building is topped with a penthouse that features a steep mansard roof sheathed in copper with two dormers and a circular opening set into the pediment of the end gable. The penthouse, which is not very deep, serves to conceal the building machinery on the rest of the roof. The high, narrow proportions of the entrance arch were made possible by the steel frame construction. Only a few classical references are retained to relieve the shear facade, including some moldings and a single urn in a niche over the main entrance. On the upper floors, casement windows originally flanked bands of plate glass, but all of these have now been replaced with modern glazing. A pair of arched cornices support the dormers. This design can be described as being in the Francis I style of French Architecture, yet it is modern in its austerity and its minimal decoration allows it to express the underlying structure of the building.[36]

Leon Solon, an architect and critic noted for his innovative use of color in architecture, saw the Bainbridge Building as a revolutionary design that completed the transition from the traditional to the modern. He wrote: "In William Van Alen's work we welcome the identification of design with structure in the sky-scraper after its long architectural dissociation. [It is not a beautiful building but it is] an admirable solution of the great American problem: despite its deliberate lightness in treatment there is no sense of structural inadequacy; on the contrary, we are conscious of the presence of a structural factor of extreme rigidity and homogeneity."[37] Thus, the Bainbridge Building was recognized at the time as yet another step forward in the transition from steel framed buildings that were designed to look like masonry buildings to those that gave full expression to their modern structure. It should be noted that brick or stone facing was still the norm for even steel framed buildings due to the limitations of the glass then available. The only type of glass which could be made in pieces large enough to cover large areas and still be strong enough to resist mild impacts was plate glass, which was very expensive to produce and still limited in area. It was not until the float glass process became commercial in 1957 and means were found to make the resulting glass impact

Bainbridge Building, 37–39 West 57th Street, New York City (photograph by the author).

Bainbridge Building Penthouse (photograph by the author).

resistant, either by laminating it with plastic or tempering it, that the modern glass walled skyscraper became possible.

On a more pragmatic note, that same year, Severance & Van Alen designed a straight forward six-story brick office building at 35 Water Street. The design was for Baker, Carver & Morell and the cost of the building was $80,000.[38] This building no longer exists.

William Van Alen next designed the 12-story J.M. Gidding & Company Building, at 724 Fifth Avenue, between 56th and 57th Streets, just one block west of the Bainbridge Building. J.M Gidding was a high end department store with a special emphasis on women's clothing. This building was constructed to be its new flagship store, replacing an older one that was located to the south at 566 Fifth Avenue.[39] The Gidding Building, the design of which shows similarities with the Bainbridge Building, has a shear facade of Indiana limestone with flush-set windows, relieved only by a few geometric moldings, another nod to Functionalism. Like the Bainbridge Building, it has a penthouse with a copper sheathed mansard roof with twin dormers and a copper

102

cupola. The building was completed late in 1921 and the new store opened in January 1922.[40] The cost of the building was $400,000.[41] The original street-level design has been altered to create a modern storefront for a Prada showroom, but the appearance of the rest of the building is essentially unchanged.

The response to the Bainbridge and Gidding Buildings was mixed. The distinguished architect Richard Haviland Smythe is credited with developing the modern storefront, as typified by his designs for the Thom McAn shoe company. When he was first shown the Gidding Building, he was asked by his fellow architect and architectural critic Francis Swale, "Well, how do you like it?" Smythe reportedly replied, "How don't I like it is what you mean. Van Alen's stuff is so darned clever that I don't know whether to *admire* it or *hate* it."[42]

After the severity of the Albemarle Building design, the Bainbridge and Gidding buildings are somewhat of a throw-back to Beaux-Arts sensibilities, combining as they do mostly plain modern bases and towers with distinctly French cornices and roofs. In a sense they are transitional between Van Alen's classically trained roots and the creative fervor which would infuse his later Art Deco designs.

The term Art Deco refers to the modern decorative arts that were produced between the two world wars and that are characteristic of the 1920s and '30s. The term is derived from l'Exposition Internationale des Arts Décoratifs et Industrial Modernes, which was held in Paris, France in 1925, and popularized the style. At that time, the style was referred to as Moderne in France and Modernistic in the United States.[43] It was only three decades later that the term Art Deco came into common use.

The first use of the term Art Deco in print was apparently as the subtitle of the catalog of the commemorative exhibition at the Musée des Arts Décoratifs in Paris in 1966. The term was more generally adopted after the publication of the first English language book to examine the style in detail, *Art Deco*, by Bevis Hillier, in 1968. Hillier considered a number of names that were used at the time, including "Jazz Modern," "Modernistic," "Paris 25" and "La Mode 1925" before settling on "Art Deco," in part because it eliminated the limitation of a date and in part because it suggested a connection with the earlier Art Nouveau, a connection which she argued for.

While Art Deco is generally described as the style in vogue between the two world wars, essentially the decades of the 1920s and '30s, it had its origins in the 1910s when cubism became accepted and abstract forms began to replace the flowing botanicals of Art Nouveau. This formative period was

Gidding Building, 724 Fifth Avenue, New York City (photograph by the author).

precisely the time when William Van Alen was studying at the École des Beaux Arts in Paris, and he would not have been unaware of it. The development of Art Deco was interrupted by World War I, and it would not become popular until Europe had recovered from the war in the 1920s.[44]

In architecture, Art Deco made its presence known primarily in the exterior and interior decoration of buildings. During the immediate post-war years, when there was an absence of new, specifically architectural designs, motifs were taken directly from the objects displayed at the Salone des Artistes Decorateurs and the Salon d'Automne, which were held annually in Paris.[45]

As has been noted, among the characteristics of Art Deco architecture was the extensive use of architectural glass, especially curved glass, and this was one of William Van Alen's specialties.[46] Had he had the advantage of being able to use shatterproof float glass, as mentioned above, his use of glass would probably have been even more extensive.

Hillier examined four primary influences on the development of Art Deco: Modern Art, including Cubism, Expressionism, Futurism and Vorticism; the Ballet Russe, especially Sergei Diaghilev's production of Rimsky-Korsakov's Scheherezade in Paris in 1910; American Indian Art; and Egyptian Art.[47] The Egyptian influence came in part from the craze for all things Egyptian brought on by the discovery of the tomb of King Tutankhamun by the archeologist Howard Carter in November 1922. The common Egyptian themes that recur in Art Deco works include stylized lotus flower, papyrus plants, and pyramids that were often reduced to triangles.[48] The American Indian influences were primarily Inca, Mayan and other Meso-American themes including geometric patterns, stepped architecture and Mayan motifs.[49]

The influence of modern art on Art Deco was more pervasive but less specific. While cubism seems to have had the strongest influence, the overall simplification and flattening of forms, the use of strong geometric patterns and the use of unshaded masses of color reflect the full range of genres, including Fauvism, expressionism, futurism and constructivism.[50] To these influences can be added East Asian, African and Archaic themes. The Archaic refers to pre-classical Etruscan and Cretan art, specifically sculpture, which influenced the use of simplified figures, mythical themes, and the female nude in Art Deco sculpture.[51]

There is an ongoing discussion about whether or not there is a distinctly Art Deco architecture. Some critics contend that the underlying architecture

of the time was basically functional and that the term Art Deco should be applied only to the decoration applied to the buildings. Others discern specific forms that are characteristic of the style in the buildings themselves. While it is clear that the stepped shape of New York City's skyscrapers owes more to the zoning ordinance of 1916 than it does to meso-American or Egyptian pyramids, Van Alen's use of curved glass corners with cantilevered support is more than decorative.[52]

In 1921, the partners took on a minor commission that would have far reaching consequences for William Van Alen. The speculative developer, William A. Reynolds, had assembled a parcel of land on Lexington Avenue between 42nd and 43rd Streets. It was occupied by several low-rise buildings that he had renovated, and he commissioned Severance & Van Alen to design a penthouse to add a fifth floor to the consolidated four-story buildings. They created a heavily ornamented design that included a decorative facade which ran around the entire group of buildings and served to unite it.[53] William Reynolds remembered Van Alen six years later when he was looking for an architect for a skyscraper that he proposed to build on the site. This commission will be discussed in more detail in Chapter 10.

The next major commission won by Severance & Van Alen was from the New York Bar Association for a new building at 36 West 44th Street. This building, which runs through to West 43rd Street between Fifth and Sixth Avenues, is narrower on the 44th Street side, where the main entrance is, than on the 43rd Street side, which is the back entrance. It has many Art Deco touches, including a barrel vaulted grand concourse, reminiscent of the Standard Arcade, that originally provided a shop-lined passage through the ground floor. It was subsequently altered, removing access to the shops and terminating the arcade at the elevator bank. It is decorated with murals depicting prominent former members of the New York Bar, including Alexander Hamilton, Judge Learned Hand, Governor Horatio Seymour, President Martin Van Buren, and Aaron Burr. The exterior features a limestone facade on the ground floor, surmounted by a fourteen-story brown brick tower with large areas of plate glass set flush with the walls and a minimum of Classical moldings. The 44th Street entrance has a distinct Art Deco look due to the stylized stone draperies at the outer edges of the shop windows and the cable carved in stone which surrounds the deeply recessed doorway. The building is capped with a pediment set flush with the facade. On the 43rd Street side, the ground floor has four arched entrances, now converted into shops, but the real interest is in the setbacks at the top of the building, where two pylons

frame a pair of miniature buttresses that slope back to a baroque pediment punctured by a balcony.[54] The Bar Building was built on land owned by the New York Bar Association adjacent to its historic, four-story tall, headquarters and it towers over the older building. That building had been designed by Cyrus L.W. Eidlitz and was constructed in 1895 and 1896. The upper floors of the new Bar Building provided space for an extension of the Bar Association's library, consultation rooms, and lawyers' offices.[55] Construction of the new Bar Building was completed in 1923 at a cost of $700,000.[56]

As the partnership flourished, William Van Allen decided to apply a lesson he had learned from one of his early mentors, Clarence True. In July 1922, he began using his profits to buy property in mid-town Manhattan for investment purposes. He first purchased a four-story brownstone row house with ground floor shops at 624 Lexington Avenue, between 53rd and 54th Streets in Manhattan, for $29,000.[57] In November of the same year, he bought 677 Lexington Avenue, on northeast corner of 50th Street, and the adjoining parcel at 130 East 50th Street.[58] This area is now occupied by modern skyscrapers.

Later that year, Severance & Van Alen received a commission to prepare plans for a hotel on the Boardwalk, east of Jackson Boulevard in Long Beach, New York on Long Island. The commission came from the owner of the older Hotel Nassau there. It is unclear if this project was ever built.

At the end of the year, the partners received a commission to design a renovation and expansion to the south of the Charles Building at 331 Madison Avenue. This 14-story building, which was erected in 1911, was originally designed by Charles I. Berg. They updated its elevators and plumbing, inserted a grill of shop windows in the base of the building, and added extensive glazing on the second and third floors. They also added a superbly detailed Art Deco lobby.[59] The changes that Severance & Van Alen designed were for the Prudence Bond Company, which was moving into the building, and generally followed the original Berg design. The work was completed in 1924 and was awarded first prize by the Fifth Avenue Association for the best alteration of a building in 1923.[60] The building is still in use and in 2015 the retail space was being remodeled by the current owner, SL Green Realty Group. This was the last major commission completed by Severance & Van Alen before the partnership came to an end.

In 1924, the ten-year-old partnership of Severance & Van Alen broke up in a fight over credit for the firm's success and the direction that the partnership should take. Van Alen wanted top billing for his innovative designs, but

Bar Building, 36 West 44th Street (photograph by the author).

108

Bar Building, Art-Deco entrance details (photograph by the author).

Severance was fully aware that much of their success was due his ability to win them the commissions that allowed Van Alen to showcase that innovation. Moreover, Severance felt that Van Alen's cutting edge designs were losing them potential clients who wanted a more traditional approach. There was a lawsuit over possession of the client list and the assets of the firm that lasted for a year.[61] Afterward, the two never worked together again and, between 1928 and 1930, they competed against each other to create the tallest building in the world, a competition that Van Alen won, briefly, when his Chrysler Building topped out higher than Severance's Manhattan Bank Building in 1930. Both buildings were soon eclipsed by the Empire State Building.

8

The Builder
in the Big Apple

Fred T. Ley had been in the construction business for 21 years before he decided to enter the New York City market in 1914, the same year that William Van Alen formed his partnership with H. Craig Severance. When Fred did so, he approached it carefully. Europe was on the brink of war and the United States was refusing to take sides. The pace of construction was slowing down, but Fred still felt that there was opportunity in the largest city in the country.

In 1914, New York City had a growing population of around five million people. The city had reached its full geographic extent in 1898 with the annexation of Bronx County, and although the island of Manhattan still had more than two million residents, its population was slowly declining as rapid transit made it possible for people to live in the less crowded outer boroughs and still commute to work in downtown. In Manhattan, tenements and row houses were being replaced by office buildings and factories, providing great opportunities for construction companies and their employees.

New York, like all major cities, had an established construction industry with its own set of real estate agents, financiers, architects, construction companies, subcontractors, suppliers, unions, city officials and racketeers. Although he had encountered some of these, including the Starrett brothers and the Operative Plasterers Association, Fred T. Ley knew that this was alien territory. Outsiders were not welcomed. A fortress like this required a careful plan of attack, and Fred T. Ley had one.

He began with contracts in the areas surrounding the city itself. In January 1914, while still carrying out many major construction projects in New England, he won a $100,000 contract from the New York Central Railroad to construct a passenger station in White Plains. That town was about eight

miles north of New York City in Westchester County, New York. It was becoming a bedroom community for more affluent office workers, and although still incorporated as a village in 1914, would become a city two years later. The new railroad station was a two-story brick building, approximately 108 feet long and 40 feet wide, with a one-story brick annex, 30 feet by 20 feet, which housed the freight room. It was designed by the noted architects Whitney Warren and Charles Wetmore, who later would design Grand Central Station.[1] Fred would also use Warren & Wetmore as his architects in 1920 when planning his own building on Park Avenue. The White Plains station was demolished in 1980.[2]

Also in 1914, Fred T. Ley & Company was awarded the contract for the Proctor Theater and Office Building in Newark, New Jersey. This was an eight-story tower that housed two theaters: a large, 2,300-seat theatre at ground level and, a smaller theatre with about 900 seats occupying the top four floors beneath the roof. The fairly narrow building contained only the lobby of the larger theatre, which had its auditorium behind it in a separate building. The floors between the two theaters housed offices. The "double-decker" theaters were unusual for the time. The facade was covered with white limestone blocks and crowned with an ornate arch. The architect was John W. Merrow, the nephew of Proctor theater circuit owner Frederick F. Proctor.[3] The building still stands, but the theaters and upper floors have been abandoned since 1968.[4]

Fred T. Ley & Company then built factories for the Whitehead and Hoag company in Newark, New Jersey, and the National Casket Company in Long Island City, which is a section of Queens, New York.[5] The National Casket Company Building, designed by Ballinger & Perrot, occupies an irregularly shaped plot on the south side of Jackson Avenue, north of the Queens Borough Bridge Plaza. Today this is the intersection of 39th Street and Northern Boulevard, and the factory is still standing, although no longer used by National Casket. The reinforced concrete building is six stories high and has 140,000 square feet of floor space.[6] Whitehead and Hoag was a major manufacturer of advertising and political campaign buttons. Their new factory was built at 272 Sussex Avenue on the corner of First Street in Newark. It still stands today, although it is now abandoned and derelict.[7] While constructing these buildings, Fred T. Ley established his credit with building materials suppliers and subcontractors in the greater New York area, while at the same time evaluating their quality and reliability.

Finally, in August 1915, the Monmouth Garage Co., awarded Fred T. Ley

& Company the contract for its first project in Manhattan, a five-story garage at 226–228 East 54th Street. The contract was worth around $100,000. This building was designed by Ballinger & Perrot, the same architects who did the National Casket Company building. By then, Fred T. Ley had established an office at 52 Vanderbilt Avenue in the heart of Manhattan, across the street from Grand Central Station.[8] One month later, in September, he advertised for bids for subcontractors and materials for the garage project in the *Real Estate Record and Builders Guide*.[9] This was unusual for him and indicates that he was still establishing his contacts in Manhattan. On later projects, including the Chrysler Building, he would generally use trusted subcontractors and suppliers with whom he had an ongoing relationship.

Although this first project was relatively small, it allowed Fred T. Ley to begin establishing formal relationships with the local unions and the city bureaucracy that held sway over construction projects. He completed the garage that autumn. The building still stands, although the facade has been completely redone and it is now used for offices. In 2014, a nightclub called Lexicon occupied the ground floor.

Once he had himself established with this small project, Fred T. Ley launched his company into the big time. He became the general contractor for a luxury Fifth Avenue apartment building. In December 1915, Starrett and Van Vleck, a prominent architectural firm in New York City whose principals were Goldwin Starrett and Ernest Alan Van Vleck, had put together a syndicate to purchase a 100 by 100 foot plot on the northeast corner of Fifth Avenue and 63rd Street from the estate of J.B. Haggin for $1,400,000, or $140 per square foot. This was formerly the site of the Progress Club, an exclusive club for wealthy Jews, that had been established in response to the anti–Semitic policies of the mainstream clubs of the time. The old clubhouse still stood on the site, as Mr. Haggin had never built the mansion he had envisioned when he bought the building from the Club in 1900.

The syndicate proposed to construct a 12-story, steel framed, brick faced apartment building on the site and obtained a building loan of $1,000,000 at 4½ percent, which was a very low rate, to finance the construction.[10]

Fred T. Ley was not only the general contractor, he was one of the investors in the syndicate, along with the real estate agents Douglas Elliman and Company, and Charles Noyes, and a few of the subcontractors. This investment made him a partner with the Starrett brothers, including Goldwin Starrett, the principal in the architectural firm, but also William Starrett, the builder who was a principal in the Thompson & Starrett construction

Monmouth Garage, 226–228 East 54th Street (photograph by the author).

Luxury Apartment Building, 820 Fifth Avenue, New York City (photograph by the author).

company. This association would stand Fred in good stead three years later when the United States entered World War I, as will be discussed in Chapter 9.[11]

The building was completed by August 19, 1916. To celebrate, as well as to attract tenants, the syndicate took out four pages of advertisements in the *Real Estate Record and Builders Guide* to accompany an illustrated article about the building. The building was designated 820 Fifth Avenue and contained ten single floor apartments and two duplexes, which were marketed to the wealthy. In the article, the project architect, Goldwin Starrett, wrote,

> In planning the apartment building at No. 820 Fifth avenue, the controlling considerations were somewhat different from those met with in the usual apartment house structures. Ordinarily the value of the ground is much lower and the clientele from whom the tenants are to be drawn is much larger; the planning of these buildings has been largely reduced to a standard. In the case of No. 820 Fifth Avenue, we started from the assumption that we were to build on one of the choicest and most expensive corners in New York City, and that to make this a successful enterprise we would have to address our efforts to a very small clientele able to pay high rents and demanding in return a very unusual equipment and expensive construction and finish throughout; also we anticipated the demand for much individuality in the arrangement of apartment conveniences. We based our expectations of success on the steady demand existing for high grade apartments, and we were especially certain that a very fine apartment building in this location would meet exactly the desires of a number of wealthy people having large country homes and inclined to favor apartments, as against individual residences, for city homes. Considering the rentals that we have asked in this building, as compared with the cost of owning and maintaining a city house, especially on or near Fifth Avenue, it becomes apparent that the renting of one of these high grade apartments is, in reality, more economical than is the owning of a city house. For instance, take a $300,000 or $400,000 house, which, on Fifth Avenue, would not be considered a mansion, and which would not contain more room or accommodations than one of these apartments. The interest alone on a $300,000 investment, at 5 percent, would be $15,000; add to this $6,000 for taxes; and to these would have to be added the cost of heating and maintenance of the building. From these figures it is obvious that the rental of one of these apartments at $20,000 to $30,000 a year is cheaper and entails less responsibility for maintenance. We have provided a building that has proved adaptable to the varying demands of tenants for special layouts, and we have had no difficulty in satisfying tenants that the rentals are fair. Under the conditions, it has not been possible to practice the usual economy in building construction, and the building might have been produced in another locality at much lower cost. We are convinced, however, that the buildings which are built of the very best materials and without cutting corners in matters of fine equipment and finish will prove their worth and superiority as real estate investments.[12]

These were no ordinary apartments. Each of them occupied an entire floor, or about 10,000 square feet while the duplexes each had a floor and a half, or about 15,000 square feet. For comparison, the average house size in the United States in 2010 was about 2,400 square feet.[13] These apartments had 16 to 20 rooms and eight bathrooms apiece, including servants quarters. The flexibility of the apartment layouts was due to the use of steel frame construction, which meant that the partition walls were not load bearing and could be rearranged at will, limited only by the placement of the structural columns. The apartments rented for between $20,000 and $30,000 a year, giving the investors around a 10 percent return on investment after expenses. The building still stands today and in 2014 was the number six rated co-op building in Manhattan, which is impressive for a building that is almost a century old.

The construction of this large, high rise building at the intersection of two busy Manhattan streets required superb organization by the general contractor, Fred T. Ley. The streets could not be obstructed and there was no room to store the construction materials on site, which was entirely occupied by the building. Therefore, careful scheduling was required to make sure that the right steel members were delivered on a just-in-time basis, so they could be lifted from the truck directly to the steel erectors working above. The techniques mastered by Fred T. Ley on this project would later be applied, on a much larger scale, in the construction of the Chrysler Building.

This was a spectacular entry for Fred T. Ley & Company into the New York City construction market and immediately established the company as a major player. Nevertheless, Fred T. Ley continued to heed his motto, "No job too big or too small," contracting to build a ten-story warehouse and automobile service building for the Willys-Overland Company at 521–531 West 57th Street in Manhattan for around $300,000 at the same time that he was starting 820 Fifth Avenue.[14] He had previously put up a building for the same company in Springfield, Massachusetts. Fred also took on a $2000 renovation of a garage at 150th Street and Gerard Avenue in the Bronx as he was finishing the apartment project.[15]

Another interesting project that Fred T. Ley & Co. took on in 1916 was the construction of *Villa Vizcaya*, the Florida estate of James Deering, the son and heir of William Deering, the founder of the Deering Manufacturing Company, which produced farm equipment including mechanical harvesters. In 1902, after William had retired, his sons merged the company with its arch-rival, the McCormick Harvesting Machine Company, to form Interna-

Light rail used to transport material during construction of *Villa Vizcaya* (courtesy Vizcaya Museum and Gardens Archives, Miami, Florida).

tional Harvester, the largest producer of farm equipment in the United States at that time. Charles Deering, James' older brother, became chairman of the board of the new company, and James became first vice president. After a couple of rough years, the company prospered and James Deering, who held a significant position in the company's stock, became a wealthy man.[16]

In 1908, at the age of 49, James Deering essentially retired from International Harvester, although he remained on the books as vice president until 1922. He suffered from pernicious anemia and his doctors recommended that he avoid the harsh Chicago winters by moving to a warmer climate. After considering possible locations in southern Europe and north Africa, he decided to build his winter home in Florida. He acquired 180 acres at Brickell Point in the Coconut Grove, just south of what was then the small town of Miami. The property had frontage on the northern shore of Biscayne Bay and Deering started planning an extravagant estate combining tropical gardens with a Spanish style villa. Deering was worth around $40 million and

spared no expense on its construction. He created the name Vizcaya as a variant of the name of the Spanish explorer Vizcaino, but it also references the Spanish name for the bay and province of Biscay in Spain after which Biscayne Bay is thought to be named.[17]

In spite of its Spanish name, the estate was eventually designed primarily in the Italian Renaissance–inspired Mediterranean Revival style with Italian Renaissance revival gardens and landscaping. It contains numerous sculptures of ancient Greek, Greco-Roman, and Italian Renaissance origins and styles. Rather than use an established architectural firm, Deering chose three young and relatively inexperienced men to design the estate. The mastermind and overall designer of the project was Paul Chalfin, an École des Beaux-Arts trained painter who had previously done work for Deering in Chicago. The architect for the buildings was Francis Burrall Hoffman, Jr., who was also a graduate of the École des Beaux-Arts and the landscape designer was Diego Suarez, a Colombian.[18]

The project was started in 1914 with George Sykes as the general contractor. Deering wanted the house to be ready for him to move in early in 1916. Unfortunately, Sykes quickly fell behind Deering's aggressive schedule. A part of the problem was Deering's obsession with detail and the involvement of three separate designers which led to frequent changes of plan and conflicting decisions. Ernest Smith, an ex-employee of the Fred T. Ley & Company, was working for Sykes at the time and suggested to Chalfin that he get Fred's company to assist in the work. As a result, Fred T. Ley & Company was called in as subcontractors in February 1915.[19] Soon afterwards a committee of the designers and contractors was set up that met regularly to address matters of progress, control and coordination under the chairmanship of Paul Chalfin.[20] Deering was impressed by the efficiency and responsiveness of Fred T. Ley & Company, so in 1916 he transferred the general contract to them. In spite of a slightly rocky transition from one contractor to the other, this was a good choice, since, although the architecture was in the Renaissance revival style, the buildings were primarily constructed from reinforced concrete, a specialty of the Fred T. Ley Company.[21] They held the contract until its completion in 1922. Documents in the Vizcaya Museum archives reveal that by this time, Fred T. Ley was using standard, pre-printed contracts with blanks to allow the specification of the work, agreed on fee, and other details. The work was divided into numerous separate numbered jobs, with a certificate authorizing payment being issued by Paul Chalfin's assistant designer, August Koch, when each had been completed and the costs audited. The Ley

organization complained about the delay of two to three weeks in the issuance of certificates which was causing them to carry the costs of construction. Enough trust existed between them and Deering that a new system for payment using provisional certificates was set up with the final charges to be reconciled and adjusted later.[22] One Vizcaya contract signed in 1919 runs 19 pages and includes detailed lists of rental charges for equipment running from $0.20 per day for a typewriter up to $30 a day for an "Excavator, Keystone No. 3."[23]

These were cost-plus contracts. In the case of 1919 contract, the fee was 8 percent of the actual cost and represented the entire profit, before overhead costs, to be earned on the project. The plans were constantly changing as inspiration struck Deering and his three architects, Chalfin, Hoffman and Suarez. Only the finest materials were used and the estate was furnished with the most modern amenities. The total cost of the estate ended up being several million dollars. This project was enormously profitable for Fred T. Ley & Company, providing it with over $300,000 in net income. Much of the responsibility for the project was handled by Harold Ley, Fred's brother and partner, while Fred concentrated on his New York City ventures, and later, Camp Devens, but Fred did make occasional inspection trips that allowed him to spend time in Florida during the winter, catching up on his golf game.[24] Today the estate belongs to Miami–Dade County and is operated as the Vizcaya Museum and Gardens.

On July 25, 1916, the world of high rise architecture and building in New York City changed forever. On that date, the city's new zoning ordinance became law. It was written in response to the construction of ever taller buildings which cast the streets into shadow and channeled the winds through the canyons they created. The immediate cause of the adoption of the new code was the construction of the Equitable Life Insurance Building, completed in 1915, which rose 40 stories straight up from the building line with not a single setback. Massive buildings like this were made possible by electric lighting and electrically driven mechanical ventilation. These innovations meant that workers did not have to be located close to windows, but could be positioned in the center of large bays or even in interior rooms. However, with their 100 percent lot coverage and cliff-like facades, these buildings threatened to make the streets that bounded them unlivable.

The new law limited a building's height at the street line to a variable multiple of the street width, ranging from one for a narrow street to 2.5 for a wide one. Any building taller than 300 feet, or about 30 stories, would have

to be stepped back above that height in set ratios. Only a portion of the building equal to one-quarter of the lot's size could be built without any height limit. The required setbacks forced architects to think about buildings in new ways, so as to harmonize the levels of their towers. They also required rethinking the economics of buildings, as the setbacks reduced the rentable space per floor and forced buildings to go higher to achieve the same square footage on a given lot. These challenges resulted in a burst of creativity in architects like William Van Alen and builders like Fred T. Ley.[25]

Tragedy struck the Ley family early in 1917 and brought Fred back to Springfield for one more sad occasion. His surviving sister, Hendel Glantzburg, known to all as Annie, died at the age of 40 and was buried in Oak Grove Cemetery in Springfield.[26]

Fred T. Ley & Company had begun to make it in the Big Apple, but a bigger challenge awaited them in eastern Massachusetts. The United States had gone to war.

9

The Builder Goes to War: Camp Devens

When the United States entered the Great War by a vote of Congress at 2:45 a.m. on Friday, April 6, 1917, the country was unprepared for hostilities.

The Great War had started on July 28, 1914, when the ultimatum that was issued by the Austro-Hungarian Empire to Serbia after the assassination of the Grand Duke Ferdinand in Sarajevo expired. Since then, the United States had managed to remain in a state of "armed neutrality" for almost three more years. Although it appeared inevitable that the country would eventually become embroiled in the conflict, few preparations were made to do so. In part this was a political ploy on the part of President Woodrow Wilson, who based his 1916 presidential re-election campaign on the slogan "He kept us out of war." Wilson did not want to appear to be getting ready for hostilities while at the same time advocating for neutrality. However, unrestricted submarine warfare by Germany and an attempt by that country to enlist Mexico as an ally, revealed in the Zimmerman telegram, challenged his neutral stance. On April 2, 1917, just three months after his second inauguration, Wilson went before Congress and asked for a declaration of war against Germany. After a marathon debate, a joint session of the House and Senate voted in favor of the declaration in the early morning hours of April 6.[1]

The Army high command immediately began to plan for mobilizing its National Guard regiments as well as for drafting 500,000 men to form new National Army regiments, but the generals quickly realized that they had nowhere to assemble and train the new recruits and draftees. Unlike during the Civil War, when temporary camps were set up everywhere and training was truly basic, modern warfare called for more sophisticated facilities. Initially, the federal government wanted 16 camps that could accommo-

date up to 100,000 men each, with airfields and artillery ranges at all of the camps.

Soon after the formal declaration of war on April 6, the Army sent contingents of officers around the country to identify possible sites for training camps. In Massachusetts, Col. Beaumont B. Buck, the inspector general for the Department of the Northeast, travelled around the state to look for a suitable site. The basic requirements were a large tract of empty land and good connections to the railroad network. Cities and towns competed for what they saw as a facility that would give them an economic boost. In Springfield, the Board of Trade set up a special committee on April 7, the day after the declaration of war, to evaluate possible sites for a camp near the city. Available land in Chicopee and East Longmeadow was quickly identified.[2] The Fisk Tire Company, of which Fred T. Ley was a director, offered to donate its 45 acre Fisk Park, formerly Imperial Park, in Chicopee, to the government for free. The army appreciated the offer, but it was looking for square miles, not acres.[3] Two locations quickly emerged as front runners: the land around the city of Springfield in the western part of the state and the small town of Ayer in the eastern part. Both had good railroad connections and sufficient open land for the purpose. Ayer had the advantage of being isolated from urban population centers. There was some concern on the part of the Army that locating a camp near a large city with its numerous taverns would provide too many temptations for the troops. Springfield, however, had a larger number of voters and more political clout than the small town of Ayer. The lobbying was fierce.[4]

On April 28, it was announced, prematurely, that Ayer had been selected as the site of one "concentration camp," so named because troops would be assembled there. This was to be located on land near that which had been used during the Civil War, when the town hosted Camp Stevens. The site was about a mile square and extended into the neighboring towns of Harvard and Shirley. It was only one-quarter mile away from the junction where the Boston and Main Railroad crossed the Central New England. In the Springfield area, hope was maintained that a second camp would still be constructed in East Longmeadow, and that additional camps might be built in other places around the state.[5]

One problem was that there were no facilities in Ayer or any of the other sites, and all of the land was privately owned. Although the government quickly stepped in and began negotiating for leases on the land, the camp still remained to be built. Again, unlike in the Civil War, merely raising a

tent city was not going to be a feasible solution. As late as May 12, Brigadier General Clarence R. Edwards, the commander of the Department of the Northeast, was still considering additional sites in Fitchburg and Townsend.[6] Plans continued to be in a state of flux. On May 16, the *Springfield Republican* reported that Springfield was still in the running for the location of the camp, and that the size of the facility had been scaled down from 100,000 men in four divisions to 30,000 men in one division, with the other Massachusetts troops being sent to camps in the South, where the weather was less likely to interfere with their training.[7]

Finally, on May 17, more than one month after the United States had declared war, General Edwards announced that a National Army camp would definitely be located in Ayer. The site, which had grown to 5,000 acres, or about eight square miles, was to be made ready to accommodate 35,000 men, including infantry, heavy field artillery, signal corpsmen, an aviation squadron, and a balloon unit.[8]

Around the country, there were 32 camps in all, 16 for the National Army, as the draftee regiments were called, and 16 for the National Guard. The other National Army camps were Camp Lee, in Petersburg, Virginia; Camp Jackson, in Columbia, South Carolina; Camp Gordon, in Atlanta, Georgia; Camp Pike, in Little Rock, Arkansas; Camp Upton, in Yaphank, Long Island, New York; Camp Dix, in Wrightstown, New Jersey; Camp Meade, in Annapolis Junction, Maryland; Camp Sherman, in Chillicothe, Ohio; Camp Grant, in Rockford, Illinois; Camp Zachary Taylor, in Louisville, Kentucky; Camp Custer, in Battle Creek, Michigan; Camp Dodge, in Des Moines, Iowa; Camp Funston, in Fort Riley, Kansas; Camp Travis, at Fort Sam Houston, Texas; and Camp Lewis, at American Lake, Washington.

The National Guard camps were Camp Greene, in Charlotte, North Carolina; Camp Wadsworth, in Spartanburg, South Carolina; Camp Hancock in Augusta, Georgia; Camp McClellan, in Anniston, Alabama; Camp Sevier, in Greenville, South Carolina; Camp Wheeler, in Macon, Georgia; Camp Sheridan, in Montgomery, Alabama; Camp Shelby, in Hattiesburg, Mississippi; Camp MacArthur, in Waco, Texas; Camp Logan, in Houston, Texas; Camp Cody in Deming, New Mexico; Camp Doniphan, at Fort Sill, Oklahoma; Camp Bowie, in Fort Worth, Texas; Camp Beauregard, in Alexandria, Louisiana; Camp Kearny, in San Diego, California; and Camp Fremont in Palo Alto, California.[9]

Many of these camps would become permanent Army installations in later years, most notably Forts Meade, Jackson, Dix and Devens, but at the

start they were all seen as being temporary cantonments to be occupied only for the duration of the war. Even so, the Army did not have the manpower or the expertise to build these camps itself. Each would be a major undertaking and would require the skills and organization of a large construction company. A significant percentage of the lumber and construction material output of the country, not to mention skilled construction workers, would also need to be requisitioned to build the camps. This would put a major damper on civilian construction projects for the next two years.

On the same day that the selection of Ayer was announced, the laborers union in Springfield was threatening to strike for a $3 a day minimum wage and a 44 hour week, plus time and a half for overtime and double time for Sunday and holiday work. The contractors, including Fred T. Ley, countered by offering to meet all the demands, except that they insisted on maintaining a 48 hour week. This averted the strike. A strike would have put considerable financial pressure on Fred T. Ley, but he was already recognizing the challenges ahead and sizing up the possibilities offered by the construction of the camp in Ayer.[10]

The next day, May 18, 1917, orders were received for the Massachusetts National Guard units to start recruiting to increase their ranks from peace strength to war strength. The units involved were the Second, Sixth and Ninth Infantry Regiments, which were already in federal service and the Fifth and Eighth Regiments of Infantry and various auxiliary units which had not yet been called up. However, the troops were not expected to report for training until August 1, at the earliest.[11] The Massachusetts regiments were part of the Fifth Militia Division. The initial plan was for them to be sent to the new camp at Ayer after being mobilized on July 25.[12] This proved unrealistic, however, and the camp was eventually designated as a National Army camp for draftee regiments.

The slowness of the American mobilization was remarkable, especially when compared to the mobilizations in Europe in 1914. Whereas the American troops were to just begin to report for training 3½ months after the declaration of war, the Germans, Russians and French had their divisions in the field and ready to fight within days of the outbreak of hostilities. This slowness on the part of the Americans was due to a number of factors, including the political situation noted above, and the small size of the United States Army in time of peace. It was also abetted by the lack of a need to defend the borders of the country from hostile neighbors.

Actual development of the camp at Ayer began with a survey carried

out by Army engineers in late May. By that time, leases had been negotiated with the more than 40 owners of land on the site.[13]

Oversight of the construction of the camps was delegated to the advisory committee of the Council of National Defense, which had been established in August 1916, by an act of Congress, H.R. 17498. The Council itself consisted of the secretaries of War, Navy, Interior, Agriculture, Commerce and Labor. These eminent figures only set policy, however. They did not take an active role in the work ahead. Instead, they relied on the advisory committee and its subcommittees which were composed of prominent civilian businessmen and experts in various fields. These men served for a nominal $1 per year, and thus were known as the "dollar a year men." The advisory committee then created a construction subcommittee to arrange for the creation of the camps.

Although the Army was normally required by law to advertise for bids for all large contracts, on April 12, Woodrow Wilson's Secretary of War, Newton Baker, declared the existence of a state of emergency. This declaration suspended the requirement to advertise for bids, in order to expedite the contracting process. Therefore, the construction subcommittee of the Council of National Defense, under the leadership of William A. Starrett, decided to award the contracts for the camps to companies that they knew had the expertise and financial stability to complete them quickly and according to government specifications. These contracts were awarded on a no-bid, cost-plus basis. This meant that 32 separate construction companies had to be selected, one for each camp. Depending on each contractor's capabilities, the contracts held out the opportunity for significant profits as well as national prestige. This put Starrett in the uncomfortable position of having to choose companies based on his personal knowledge of their performance without appearing to play favorites.

Before the war, William Starrett had been a partner in the Thompson-Starrett Construction Company of New York City. To facilitate oversight of the construction, as well as to comply with War Department regulations, he resigned from the company and was commissioned as a major in the U.S. Army. He would later be promoted to colonel. Starrett was placed under the nominal command of Col. I.W. Littell of the Construction Division of the Quartermaster Corps. This was because troop housing fell under the Quartermaster Corps rather than the Corps of Engineers, at the time.[14] Although Starrett reported to Littell, he operated independently because the colonel was not familiar with civilian construction contracting practices.

This was the same William Starrett with whom Fred T. Ley had partnered on the construction of the luxury apartment building at 820 Fifth Avenue in New York City. His brother, Paul Starrett, was president of the George A. Fuller Construction Company, and another brother, Goldwin Starrett, was a principal in the architectural firm of Starrett and Van Vleck.

To help them select the contractors, the members of the construction subcommittee sent out a confidential questionnaire to leading members of the American Institute of Architects, chief engineers of major railroads, and others who were in a position to make judgments about contractors, asking them to recommend reliable companies. From the list generated by this questionnaire, they selected firms that they thought could handle the jobs, and sent each of them another questionnaire with specific questions relating to their ability to execute the contracts, including statistics about their personnel and equipment. They were asked about the types of work they had done previously and for what companies. The subcommittee wanted to know whether they normally worked on a fixed bid or a cost plus basis and whether their finances were on a solid footing.[15] Then, as each of the 32 sites was selected, they sent a list of three possible contractors for each cantonment to the Construction Division of the War Department, with the preferred contractor's name at the top of the list. The Division usually forwarded the subcommittee's first choice to Secretary of War, who generally approved the Construction Division's recommendation. Only after receiving the Secretary's approval would the Construction Division enter into the contract.[16] Although this bureaucratic approach slowed the awarding of the contracts, it was important because it created the impression that the Secretary of War was actually responsible for the selection and somewhat insulated Starrett from the charge of favoritism.

On the advice of the advisory committee, the Construction Division awarded the contracts for the camps on a cost-plus basis, meaning that each construction company would be paid for all direct costs plus a percentage to cover indirect costs and profit. This percentage was set on a sliding scale starting at 6 percent, for the largest projects with estimated costs over $3,000,000 and increasing to 10 percent for smaller projects with costs under $100,000. There was a maximum fee of $250,000.[17] However, it is not clear if the cap applied only to the original contracts or if the inevitable change orders and additions were also covered by the cap.

Given that the fee included the contractor's overhead expenses, this scale allowed for a profit of only about 3.5 percent. Moreover, the contractors would be reimbursed for the cost of construction, not paid in advance, meaning

that they would have to put up a substantial amount of their own money to get the projects started. When the standard contract was being written, representatives of several contractors were called in to review it and offer suggestions. Among them was James A. Mears, who was the manager of Fred T. Ley's New York City office. Mr. Mears stayed on in Washington for four or five months on the company payroll, with Fred's approval, serving as a volunteer assistant and secretary to the subcommittee.[18]

The involvement of contractors in writing the standard contract, and the selection of the contractors primarily by William A. Starrett, later led to charges that the contracts were awarded through an "old boy" network of cronies of the Starrett brothers with political pressure applied by congressmen. Given that Starrett knew the heads of most large construction companies personally, and that, having been a contractor himself, he knew what contract terms it would take to entice these large firms to drop their other projects and put their resources into building the camps, it was inevitable that he would be accused of insider dealing. However, there was really no other method of getting the camps built in the time required.

At long last, on June 11, more than two months after the declaration of war, Fred T. Ley & Company received a telegram informing them that they had been awarded the contract for the construction of the camp at Ayer.[19] The contract was estimated to be worth around $5,000,000, but the actual cost of the camp would turn out to be more than $12,000,000. As noted above, the contract was awarded on a cost-plus basis, with a 6 percent fee capped at $250,000. Had the fee not been capped, Fred T. Ley would have stood to receive about $720,000.

It was estimated that over 5,000 men would be employed on the project, which was expected to include over 2,000 separate buildings. The contract was to be completed by September 1, giving Fred T. Ley only three and a half months to do the work.[20] This contract was a great coup for Fred T. Ley. His company had been selected from a long list of firms, and been awarded the contract on the strength of a reputation for fast, quality construction work as exemplified by his construction of the Coliseum for the Eastern States Exposition on time and on budget in 1916, and his work on the luxury apartments at 820 Fifth Avenue in New York City. Moreover, the contract was a recognition that Fred T. Ley & Company was in the first rank of general contractors in the United States.

On June 17, Fred T. Ley took out a triumphant advertisement in the *Springfield Republican*.

Construction began immediately. When it did, the site was nothing by open fields with one dirt road running through it. The only place to get a meal was at the restaurant in the railroad station.[21] The immediate need was to build up the organization, which would ultimately number almost 10,000 men. The first step was for Fred T. Ley to call a meeting of all the major construction union representatives from Springfield, Boston, and Worcester, Massachusetts. Ayer, the site of the camp, was under the jurisdiction of the Worcester unions, but they were not large enough to supply all the labor needed. After a day-long session, chaired by Fred's brother Harold, the unions agreed to a 48-hour week, an increase from the 44-hour week which had recently been instituted, in return for using the Boston wage rate for all labor. This was a higher wage scale than that used in Springfield or Worcester. The company also agreed that the union workers could put in a ten-hour day instead of the normal eight-hour day, and be paid time-and-a-half for the extra two hours.[22]

Men started to arrive at the site on June 18, just one week after the contract was awarded, and by the next day more than 1,000 were on the job. The ability to hire and organize large numbers of workers on short notice was one of the strengths of Fred T. Ley & Company. Mr. Frank Rogers was appointed as the Fred T. Ley & Company superintendent on the site, and the project was supervised for the government by Captain Edward Canfield, Jr., of the U.S. Army Quartermaster Corps.[23]

The first order of business was to clear the land and build enough barracks to house the workers who were going to construct the camp. Because of the Town of Ayers' small population and remote location, it was impractical for the workers to commute to the site or to find lodgings locally, so most of them lived at the camp until it was completed. As quickly as buildings could be erected, more men were brought onto the site. A commissary, kitchens, and dining halls were established to feed them. It was estimated that some 16 million board feet of lumber were going to be used. However, many were skeptical that the September 1 deadline could be met. Army officials offered their opinion that should the camp be ready by that date, "the Ley company will have set a new record in engineering."[24]

In fact, the company soon found that it was necessary for the men to work 16 hours a day to meet the schedule, and with all that overtime, for the first time in their lives the laborers were making big money. This caused problems, because the regular employees of Fred T. Ley & Company, their foremen and time keepers, were on fixed salaries rather than hourly rates.

They were making about $30 a week, while the laborers were averaging $50. In order to keep their skilled employees from transferring to day labor, the company found it necessary to raise wages all around. In the opinion of Harold Ley, this domino effect was the beginning of the period of inflation that hit the country during its participation in the Great War.[25]

A rail spur was constructed to link the site of the camp to the two major railroads at the junction in Ayer, and a rail yard was laid out at the edge of the camp. This enabled construction materials and equipment to be delivered directly to the site without being unloaded onto trucks. As the materials arrived, they were checked in and distributed to the building sites as needed.[26]

Because the camp was considered to be temporary, very simple construction techniques were used. The basic building was a two-story barracks, 143 feet long by 43 feet wide with an attached kitchen. This was designed to house a single company of 133 men under one roof. The buildings were of wood frame construction with a single thickness of boards for the outside walls. This was covered with tar paper which was held in place by battens. In some cases, this was then covered with siding. Camp Devens had 247 of these barracks buildings. In addition, 60 single story buildings were constructed for officers' quarters. Another 421 buildings housed administration offices, shops, store rooms, and stables.[27]

Camp Devens Buildings, Ayer, Massachusetts (Fred T. Ley & Company).

Fred T. Ley & Company did experience some financial difficulties at the beginning of the project. They had entered the contract on a capped 6 percent fee, which was lower than their standard 8 percent, with the understanding that they would not have to invest any of their own funds in it. The government would reimburse them for all costs as they were incurred. Unfortunately, due to bungling by the government auditor, the reimbursement for payroll was delayed for six weeks, causing Fred T. Ley to lay out some $760,000 of his own money to keep the laborers on the job. The problem was that many of the men were illiterate to the point where they could not sign their names, or signed them differently each time. Fred was used to this, and his company used a system of numbered brass tags to identify the workers for pay purposes. The auditor claimed that this did not meet government standards as called for in the contract. After negotiations, and threats by Fred to close the job down, a new auditor was appointed and new procedures were agreed on and the reimbursements were brought up to date. It was a mark of Fred's patriotism and his dedication to completing any job he took on that he took the financial risks involved.[28]

In late July, it was announced that the new camp in Ayer was going to be named for General Charles Devens, a lawyer from Worcester, who had served gallantly with the Massachusetts troops in the American Civil War. After that war he was appointed to the Supreme Judicial Court of the Commonwealth of Massachusetts and later served as United States Attorney General under President Rutherford B. Hayes.[29]

By late August, the camp, now up to 9,000 acres, was reported to be 75 to 80 percent complete. In addition to the buildings described above, the camp included a full hospital, an independent water supply, telephone system, waste treatment plant, swimming pools, fire department, and its own electrical generating plant. The town of Ayer benefited from the construction of a new $50,000 hotel and an influx of religious and fraternal organizations, including the Young Men's Christian Association, the Knights of Columbus, the Odd Fellows, and others that wanted to cater to the spiritual needs of the soldiers.

Major General H.F. Hodges, the commander of the new division, arrived at the camp with his staff on August 26. By this time, the National Army had been integrated into the Regular Army and the unit was designated the 76th Division of the United States Army. The 76th was unofficially known as the "Liberty Bell Division" because its number echoed the last two digits of 1776. This was reflected in the unofficial division patch which was a blue liberty

bell with a white crack on an olive drab background. The 76th would be the first draftee division to be activated in the United States, largely because its camp was ready first.[30]

On September 1, right on schedule, Camp Devens was declared ready for use, although some stables, gun sheds and workshops still needed to be completed. In addition, the temporary buildings housing the 3,000 construction workers still had to be torn down to make room for the parade ground. It was a technical victory for Fred T. Ley, but far from the end of the Camp Devens story.

That night, the leading men of Springfield hosted a banquet at the Springfield Country Club to celebrate the completion of the project and honor the three Ley brothers, Fred T., Harold and Leo. Special notice was given to the superintendents of the work, Frank Rogers, Albert Gillis and John Crowley. Of interest was a statement that the actual date of final completion of the project was a "rather indefinite matter, since the government has constantly kept adding to the requirements."[31] This situation would later cause great difficulty for Fred T. Ley.

Thousands of young men would pass through Camp Devens, either on their way overseas or on their return. Among them was one Howard Johnson, who after the war would found the Howard Johnson restaurant chain. He served in 26th infantry division, known as the "Yankee Division," and was demobilized there on May 3, 1919.[32]

The first intimations of trouble came in late October. The Associated Press reported that due to the failure of the heating system at Camp Devens, the men might have to be transported to California for the winter. Fred T. Ley responded by issuing a statement that said that the heating plant was not included in the original specifications, and that the Army had not decided on the design of the plant until late August. He went on to say that the heating plant was now in the process of being built and should be completed by late November.[33] This statement was followed by a tour of the state by Mr. V.T. Goggin, a representative of the Ley company, who gave illustrated lectures describing the building of Camp Devens. The tour was undertaken "in order to correct … erroneous reports that have been circulated lately in regard to the construction of this camp."[34] The company also published an illustrated, commemorative book that gave details of the project and contained photographs of the work in progress as well as the finished camp.[35]

In December, the company was compelled to defend itself against charges that it had overpaid steamfitters working on Camp Devens. A news-

Camp Devens Souvenir Book (Fred T. Ley & Company).

paper reported that they had been paid $1.60 per hour, instead of the regular rate of $0.78. It took a special committee of the Boston Society of Architects to clear the company of the charges. This was significant, because overpaying the men would not only have increased the cost to the government, but also have increased the profits of the Ley company under its cost-plus contract.[36]

In addition to Camp Devens, Fred T. Ley & Company also entered into contracts for other defense projects. These included the construction of a shipyard and buildings at Bristol, Pennsylvania; a chemical plant at Perryville, Maryland; reconstruction of the arsenal at Watervliet, New York; a chemical plant at Brunswick, Georgia; and, a shipyard and six concrete ships at Mobile, Alabama.[37] The last defense contract that Fred T. Ley won was for a tetryl plant in the town of Senter, Michigan. This contract was awarded on September 14, 1918, and cancelled three months later on December 8, after the armistice was signed, but before the plant was completed.[38] Tetryl is a sensitive explosive (2,4,6-Trinitrophenylmethylnitramine) which was used in detonators during the First World War. Senter was a small town on the upper

peninsula of Michigan where the Atlas Powder Company had an explosives plant, originally built to supply the copper mines in the area.

After the war ended, charges of war profiteering replaced the urgency to do everything possible to support America's troops. Bills that had previously been paid promptly by the government were suddenly held up. Fred T. Ley had to file numerous claims against the government for expenses incurred in carrying out his contracts which had been disallowed due to a lack of receipts or to contract irregularities. It seemed that in the hurry to get things built during the war, paperwork was often lost and contracts were sometimes written with clauses that were not allowed under government regulations. The claims ranged from $45 for ten cases of oxtail soup for which no receipts could be found to $1,727.70 for liability insurance.[39] One of these claims, the claim for reimbursement of a liability insurance premium, even went to the Supreme Court before being finally denied in 1927.[40]

Although an investigation into the War Department and the Council of Defense launched by President Woodrow Wilson in 1918 found no major corruption, violations or theft in the mobilization program, the direction of the political winds was changing.[41] Wilson, a Democrat whose health was failing, lost control of both the United States House and Senate to the Republicans in the elections of 1918. The Republican controlled Congress, faced with a chaotic demobilization of the army and a demand for spending reductions, went looking for villains. In March 1920, the Select Committee of the U.S. House of Representatives on Expenditures in the War Department held hearings on the building of the training camps. It was concerned about the way the contracts for the camps were awarded, especially because the man in charge of the contracts was Col. William A. Starrett, formerly of the Thompson & Starrett Company in New York City, who was accused of giving them to his cronies in the business, including Fred T. Ley. They also criticized the cost-plus nature of the contracts, which were open-ended as to the final cost. The Republican dominated committee referred its findings to the Justice Department. However, three of the four Democrats on the committee drafted a minority report defending the way the contracts had been let and executed.[42]

When Warren Harding, a Republican, was elected President of the United States in November 1920, the situation got worse. Auditors were sent to the Springfield office of Fred T. Ley & Company and began pouring over the books related to the Devens job. In 1923, Harry M. Daughtery, Harding's Attorney General, filed a $5,000,000 lawsuit against Fred T. Ley & Company

alleging that it had illegally collected excess profits from its construction of Camp Devens. Similar suits were filed against all of the other general contractors as well. This was a political move, but the suit dragged on for four years, until it was finally dismissed in June 1927, halfway through the administration of Calvin Coolidge. Coolidge was also a Republican, but he understood the absurdity of the charges.[43]

In spite of these complications, the Camp Devens project was marginally profitable for Fred T. Ley & Company, but, perhaps more importantly, it increased Fred's experience with large scale construction projects and allowed him to develop a cadre of outstanding supervisors. In many ways, Camp Devens laid the foundations for the next great expansion of Fred T. Ley's company. However, Fred T. Ley & Company mostly avoided government contracts in the future, preferring to work with the private sector where politics rarely affected contracts and the role of profit in business was recognized and appreciated.

Although the site of Camp Devens is still in use as Reserve Forces Training Base Fort Devens, none of the original buildings constructed by Fred T. Ley & Company remain. Fort Devens was almost completely rebuilt both before and after World War II. Today, a large portion of the site has been converted to an industrial park which also houses the Fort Devens Museum.

10

The Dreamer on His Own

The mid-town high rise office buildings that William Van Alen had designed in partnership with H. Craig Severance (the Bainbridge, Gidding, Albemarle, and Bar Buildings) were statements of his development beyond his Beaux-Arts roots. Unfortunately, they were appreciated mostly by other architects and, except for his low-rise Standard Arcade of 1914, the public did not take much notice of them. They were also constrained by Van Alen's need to satisfy both Severance and the clients he brought in, which limited Van Alen's opportunities for creative design.

Freed from the constraints of the partnership and able to seek clients who were open to innovation, Van Alen could at last pursue his dream of producing truly new designs. In 1924, Van Alen's first design on his own after the breakup of the partnership was so innovative that it was even commented on in the popular press. This was not another high rise skyscraper but rather the new six-story Childs restaurant building at 604 Fifth Avenue, at 49th Street.

The Childs Unique Dairy Company was one of the first national dining chains serving mid-priced food in a consistent setting. It was founded in 1889 by the brothers Samuel S. Childs and William Childs in lower Manhattan. The concept was to provide economical meals to the working class, quickly, and with a strong emphasis on cleanliness and hygiene. They reinforced these elements by using white tiled interiors and waitresses wearing white uniforms. The Childs brothers also introduced the "tray-line" self-service cafeteria style of serving food. A signature visual element of Childs restaurants was a griddle in the front window with an attractive young woman facing the street and flipping pancakes.[1]

The chain grew at a steady rate and by the time that Childs commissioned Van Alen to design the restaurant at 604 Fifth Avenue, the company

had around 100 locations in some 29 cities, almost all of which used a similar design. The restaurants featured white tile or marble walls and mosaic tile floors with simple, geometric designs, which created a sense of austerity and healthfulness. While there were some tables for four, most of the tables in the larger locations were arranged for 12 diners, forcing patrons to eat with strangers. This, along with the low prices and cafeteria-style food service, gave the restaurants a decidedly lower middle class reputation.

In 1924, Fifth Avenue in mid-town was still a fashionable residential area filled with the brownstone mansions of the Vanderbilts and other rich capitalists. William Childs managed to lease the site of the former residence of financier and railroad baron Russel Sage, who had died in 1906. It was located between the Collegiate Church of St. Nicholas on 48th Street and the residence of Robert Walton Goelet, the heir to a real estate fortune, on 49th. The Sage mansion had already been converted to a flower shop, which was tolerated, but a Childs restaurant was seen by the area residents as an undesirable, middle class establishment. To counter this criticism, William Childs decided to break from the spare, formulaic designs of his earlier restaurants and try for an upscale look in the new building which he would put up to replace the mansion. He interviewed around 20 architects before choosing William Van Alen for the commission.[2] Childs had worked with Van Alen once before, in 1920, when Severance & Van Alen included a Childs restaurant on the ground floor of a commercial building they designed further south at 377 Fifth Avenue, but that had been done in the original corporate style. That building cost $80,000.[3]

The midblock site had the garden of St. Nicholas church along its south end, and on that side Van Alen gave the new six-story building a curved corner wrapping the front wall into the side wall so that the interior looked out over the church lot, effectively doubling the frontage of the restaurant. This corner included curved, plate glass windows and was the first building in New York City to use cantilevered construction, with no corner column. The facade was almost 60 percent plate glass surrounded by narrow bands and columns of white limestone. Nestled between the dark gothic stone of St. Nicholas and the equally dark brownstone Goelet mansion, it stood out as a bright ray of modernity in an otherwise somber block.[4]

The critic John W. Harrington said the building seemed "at first blush to be entirely of rock crystal" and called the technique the "Quartz school of architecture." The architect G. H. Edgell commented, "When viewed from slightly uptown each story seems to be supported at the edge only by the

Childs Restaurant, 604 Fifth Avenue (Museum of the City of New York).

frail, curved pane below. The effect is rather terrifying and fascinating at the same time."[5]

The building was topped with a sculptured geometric Art Deco cornice that vaguely suggests a line of waitress's caps. The restaurant occupied the first two floors and the upper four were rented out.

Childs 604 Fifth Avenue, corner window today (photograph by the author).

In addition to the unique corner design, Van Alen included windows set at the floor level of the slightly elevated first floor, where the main dining room was located. This put the bottom third of the windows at the eye level of passing pedestrians. The resulting view of the lower extremities of patrons sitting at the tables inside, especially if they were women, was considered shocking at the time, and the restaurant quickly installed curtains.[6]

The interior of the restaurant also deviated from the standard Childs

formula. Instead of the signature austere white walls and tile floors, Van Alen designed it in a "California mission style," using light brown Caen limestone and bronze trim.[7] The building cost $150,000.[8]

The building has been subsequently altered. When the church and its garden were replaced by an office building in 1950, the curved plate glass was removed and glass blocks were substituted. The storefront was changed several times to accommodate a series of chain restaurants and today it houses a T.G.I. Friday's.

Van Alen maintained a continuing relationship with the Childs Restaurant Company between 1924 and 1928. In addition to the architecturally unique building at 604 Fifth Avenue, he designed a Childs restaurant to be built into the Gidding Building, which he had designed while still a partner with H. Craig Severance. He also designed a Childs restaurant in the Ansonia Hotel at Broadway and 73rd Street. The Ansonia was where Babe Ruth lived when the Yankees were playing at home.[9] He designed another Childs restaurant on the ground floor of an apartment building at Broadway and 102nd Street. He even designed a Childs restaurant that was built at 2 Massachusetts Avenue NW in Washington, D.C., across from the City Post Office Building. It is a one-story, triangular building designed to fit the point where F Street meets Massachusetts Avenue at a sharp angle. It is characterized by its grey stone block walls set with large arched windows. Today that building is used as a SunTrust Bank branch.

Looking beyond New York City, Van Alen won the commission for the Garfield-Grant Hotel at 275 Broadway in Long Branch, New Jersey. This six-story, steel framed building faced with light brown brick was commissioned by the Newark businessman William J. Greenfield, the president of the Community Hotel Corporation of Long Branch.[10] It was completed in 1926. It was named jointly for President Ulysses S. Grant, who had dubbed Long Branch "America's Summer Capital" and President James A. Garfield, who was brought to Long Branch to recover after being shot by a disgruntled office seeker in Washington, D.C., on July 2, 1881, and who died there on September 19 of the same year. The name is somewhat ironic, as Grant and Garfield were political enemies who competed for the Republican presidential nomination in 1880. The Renaissance Revival exterior design does not reflect any of the Art Deco or other modern themes that Van Alen had been experimenting with. This indicates that this was very much a client-driven commission which gave him very little artistic freedom, and reflects on his need to generate cash by accepting less than ideal commissions.

Garfield-Grant Hotel, Long Branch, New Jersey (photograph by the author).

At the time it opened, with 100 rooms, the Garfield-Grant was the largest year round hotel in the summer resort town of Long Branch. In addition to being the largest, it was also the costliest and most elaborate. The lobby did have some Art Deco touches and featured brass stair rails and wrought iron balusters. The construction was handled by the Amsterdam Building Company of New York with a total cost of $450,000. Today, the Garfield-Grant Hotel exists as the Garfield-Grant Building. When the interior was converted into office space, the opulent design of the original rooms and much of the lobby was lost, but the original Renaissance Revival exterior still remains, as well as some of the finishes in the lobby. Having been built of brick rather than wood, it is one of the few early 20th century Long Branch hotels to survive, the rest having succumbed to fire.[11]

In 1927, Van Alen went back to the concept he had used for the Childs restaurant building at Fifth Avenue and 49th Street. He used a curved glass corner in the controversial but innovative design of the Lucky Strike cigarette storefront, at the northwest corner of 45th Street and Broadway near Times

Lucky Strike storefront with curved oval glass windows, 45th Street and Broadway, New York City. Postcard.

Square. The storefront was only one part of his design for the building, which was done for the American Tobacco Company and stretched from 45th to 46th along the west side of Broadway.[12] The storefront, which occupied the corner of Broadway and 45th Street, was done in stainless steel, with three large elliptical windows. There was one on each of the street facades and one which curved around the corner in a 90-degree bend. The architect and critic Francis Swale disliked the "distortion" of this window, but appreciated its novelty.[13] The architectural critic Christopher Gray called this storefront "a spectacular feat of glazing that remains unduplicated."[14] Unfortunately, this building no longer exists. Today, the site is occupied by the Marriott Marquis hotel.

Another William Van Alen design was the Delman shoe store at 558 Madison Avenue, near 56th Street, also done in 1927. Delman's was a designer, manufacturer, and retailer of fashionable, high end, handmade women's shoes. For this flagship storefront, Van Alen combined two existing seven-story buildings and converted them into shops. The Delman store occupied the first two floors of the structure. On the street level, he created four small

show windows, below eye level, in each of which only one pair of shoes was displayed at a time. These windows were flanked by symmetrical doorways. Above, in the center of the second floor facade, he installed a large elliptical window, where cobblers in blue smocks sat hand-crafting shoes, which attracted an audience which could watch them from the sidewalk. The architectural critic Kenneth Murchison wrote that Van Alen had made a "moving picture out of a couple of [shoemaker's] lasts."[15] The first and second floor elements were tied together by a dark, decorative band that contrasted with the light facade. It ran across the first floor, rose into elaborate finials above the doors, and flanked the elliptical window. At the top he put a curious classic-modern touch, a triangular gable designed as an abstract rendition of the traditional form of a broken pediment. By a happy coincidence, the AT&T building, now the Sony Tower, which was built on the site of the Delman Building in the early 1980s, also sports a broken pediment at the top of its 37 stories. The architect of the newer building, Philip Johnson, claimed not to have been aware of the similarity with Van Alen's Delman Building design.[16]

One of Van Alen's last major building designs, before beginning his work on what would eventually become the Chrysler Building, was the Sports Plaza Building at 421 Seventh Avenue, in Manhattan. It was begun in 1926 and finished in 1927 at a cost of $250,000.[17] Rising 14 stories with a penthouse above, this L-shaped, high-rise office building was his most austere design to date. It again included sheer white limestone walls with flush windows. There was an almost complete absence of ornamentation and no cornice, echoing his 1915 design for the Albemarle building on Madison Square. Its major decorative element is the use of contrasting red marble lintels and spandrels (the horizontal panels between floors) surrounding the windows on the first four stories, a bold use of color in geometric shapes that has Art Deco overtones.[18] The building originally included a Childs restaurant on the ground floor. It is still in use today, but most of its lower floors are obscured by billboards and signage.

As an example of the variability of William Van Alen's work during this period, he was asked to participate in a competition for the design of the new Beaux-Arts Institute of Design, of which he was a member. The completion was held in the tradition of the École des Beaux Arts. On November 17, 1927, the participating architects were given three hours to produce a sketch of the front elevation of their design. The winner was Fred C. Hirons. Van Alen came in third, but his design was not at all innovative and modern, but rather an odd mixture of Renaissance inspired forms and new French

Sports Plaza Building red marble entrance surround and spandrel, 421 West 33rd Street, New York City (photograph by the author).

ideas. Perhaps he was distracted by another project that he was working on at the time.[19]

In 1927, William Van Alen accepted a commission that he probably did not realize would turn out to be his greatest masterpiece. The project began as a real estate speculation with no pretensions to greatness, much less the intention to dominate the New York skyline. The parcel on Lexington Avenue between 42nd Street and 43rd Street was owned by the Cooper Union, a venerable institution of higher education. The Cooper Union for the Advancement of Science and Art was founded by inventor, industrialist and philanthropist Peter Cooper in 1859 and is located at East 7th Street and Third Avenue in Manhattan's East Village neighborhood. Like Trinity Church, it owned and leased out a large amount of valuable Manhattan real estate.

In the 1880s, several small apartment buildings with commercial tenants on the street level were erected on the site. By 1911, when the site was leased by William H. Reynolds, a well-known developer and politician who had served in the New York State Senate, they had become somewhat shabby and rundown. Reynolds had built Dreamland Park, a famous amusement center on Coney Island in Brooklyn, in 1903, as well as numerous residential devel-

opments and row houses throughout New York City. Soon after acquiring the lease to the land on 42nd Street, Reynolds combined the apartment buildings into a single block and converted them to offices for himself and for rent. In 1921, he commissioned the firm of Severance & Van Alan to design a penthouse for the building and a new, unified facade with checkerboard detailing.

Reynolds was hoping to capitalize on the proximity of the site to the new Grand Central Terminal. Between 1903 and 1913, the old New York Central terminal building was torn down in phases and replaced by the current structure, which was designed by the two architectural firms of Reed & Stem and Warren & Wetmore, who agreed to work as associated architects in 1904. Reed & Stem were responsible for the overall design of the building, while Warren and Wetmore added architectural details in the Beaux-Arts style. The three railroads using the station were the New York Central; the New York, New Haven and Hartford; and the Long Island Railroad. Their electrified tracks approaching the terminal, as well as the yards where the cars were sorted and stored, were buried under Park Avenue. The result of this was the creation of several blocks worth of prime real estate, including the parcel controlled by Reynolds. The new Grand Central Terminal opened on February 2, 1913.[20]

As noted in above, in 1921 Reynolds had commissioned the partnership of Severance & Van Alen to design a penthouse for the low buildings on the site. As a result, when he decided to propose an office tower on the parcel, he was already acquainted with Van Alen and familiar with his work. In 1927, Reynolds hired Van Alen to produce a design for a 40-story office building, which would have been only about 400 feet high, on the Lexington Avenue site.

Over the next few months, William Reynolds asked for changes in the design to make the building taller and taller. By August 1928, the design had grown to 67 stories and a height of 808 feet, 16 feet higher than the Woolworth Building, making it a design for the tallest building in the world, if it were ever built. These plans were not fully developed, but were simply elevations showing the general outline of the building, its setbacks, and a suggestion of its decoration. Van Alen's final sketch, published in *The American Architect* on August 20, shows a design with three levels of setbacks surrounding a decorated tower, including gargoyles on the corners at the base of the tower. All of these features would be included when the design was redone for Walter Chrysler later in 1928.

However, it does not appear that Reynolds had the financing necessary to actually construct William Van Alen's design. He seems to have treated the plans as a speculation. He was paying Van Alen a monthly retainer based on the amount of work he did, and took possession of the plans that Van Alen drew, rather than contracting with him for a fee based on a percentage of the final cost of the building. While this gave Van Alen a steady source of income, it would cause problems when Reynolds later sold the site and the plans to Walter Chrysler.

William A. Starrett, the noted architect and builder who had headed the subcommittee on construction of cantonments in World War I, commented on

that modern city-created phenomenon—the speculative builder. All cities have them, but only in New York and perhaps in Chicago do they deal regularly in skyscrapers. Speculative building is not the highest type of construction, neither is it all its name may insinuate.

A speculator frequently turns a profit without turning a spadeful of earth. For example, he assembles a building site, putting up enough option money to hold the lots for a year, or he controls them on a contract of sale with a deposit of earnest money. Now he hires an architect to draw him an imposing picture of a skyscraper; if it is several stories higher than the Woolworth Tower, so much the better. This he sends to the newspapers with a statement that the work will start next Thursday. The newspapers like pictures of high buildings, real or imagined, because we readers have a weakness for them.

The next morning fifty brokers are waiting in the promoter's office to ask him if he wants to sell. They have no purchasers in view, but are confident of finding such. The speculator will sell, he states, if the offer is interesting. The brokers hurry out to work for him for nothing, the newspapers have advertised his property with publicity he could not buy. The site is a good one and the psychology attracts a buyer, frequently another speculator. The promoter takes his quick profit on the real estate and steps out.[21]

Apparently following a business plan similar to this, although he had held the lease for 16 years, William H. Reynolds started shopping Van Alen's plans around, and eventually found a buyer in Walter Chrysler.

11

The Builder
and the Archbishop

Fred T. Ley did not limit his vision for his company to the United States. After the completion of Camp Devens and while the war in Europe was coming to an end, he grasped an opportunity to expand into the rapidly developing South American market. As his brother Harold recalled,

Sometime around 1918 I received a phone call from a man in a New York Bank who said "Someone in Peru has cabled us three thousand dollars to be deposited in your account."

I was simply astonished at his announcement, since neither Fred nor I, nor anyone else in our organization knew a soul in Peru, let alone anyone who would send us three thousand dollars. But I recovered from my astonishment sufficiently to ask for further details and was told that it had been sent from the new Archbishop of Peru. We sent our New York manager, James A. Mears, down to the bank immediately, where we got the following information.

It seemed that the Catholic Church owned considerable property of great value in Lima, which had accumulated over centuries. Lima is subject to earthquakes, and frequently during a quake a stream of rubble and debris would come down on the heads of the parishioners. So the Archbishop conceived the idea of erecting new buildings made of reinforced concrete.[1]

The new Archbishop was Emilio Lisson Chaves, a member of the religious order the Congregation of the Mission, also known as the Vincentian Fathers. He served from February 25, 1918, until his death on March 3, 1931. The archdiocese controlled substantial real estate holdings, including not just ecclesiastical buildings but commercial space as well. The Archbishop had contacted another American firm which passed on the opportunity and referred him to Fred T. Ley & Company as one of the leading companies that specialized in reinforced concrete construction. After building many bridges out of the material while constructing street railways, the company had

147

erected several large manufacturing and office buildings using this type of construction and had developed expertise in the techniques employed. On the basis of that referral, the Archbishop had cabled $3,000 to cover the expense of having the company send a representative to Peru to discuss potential projects. Harold Ley was taken aback. He commented that this "marked the only time in forty years in the construction business that a prospect had sent us money in advance of completing a deal."[2]

Fred T. Ley was flattered by the Archbishop's confidence, but also a little leery of the political and economic situation in South America. In its favor, Peru had a stable, democratic government controlled by the social elite, and was welcoming foreign investment. But economically, it was still recovering from the "War of the Pacific" which it had fought with its neighbor, Chile, 40 years earlier.

That war had its origins in the breakup of the Viceroyalty of Peru in the wars of independence fought between 1808 and 1824. The Viceroyalty covered all of South America except Brazil, and when the various regions gained their independence, the boundaries of the new states were not always well defined. Bolivia claimed the province of Antofagasta which reached to the Pacific Ocean between Chile and Peru, while Chile claimed both that province and three more, Tarapacá, Tacna and Arica, in southern Peru. After a short lived confederation, Peru and Bolivia separated, but allied themselves with each other by a secret treaty. In 1879, Chile invaded Bolivia's coastal province, attacking the port city of Antofagasta. Bolivia declared war on Chile and Peru followed suit in support of Bolivia. The war continued for four years, and the Chilean army captured the Peruvian capital of Lima. The war ended with the Treaty of Ancón in 1883, under which Chile received Bolivia's Pacific coast province of Antofagasta and Peru's southern province of Tarapacá. It was agreed that the final decision on the fate of the provinces of Tacna and Arica was to be delayed for ten years.[3]

Although the hostilities were long over, the two adversaries still had not resolved the status of the two disputed provinces by 1918, and tensions between the two countries contributed to the economic uncertainty in the region. Fred and Harold therefore drew up a contract that severely limited the company's exposure to risk. It required the Archdiocese of Peru to pay all expenses of Ley company employees who were sent to Peru from the time they left New York until they returned there. It also specified that all material and equipment be paid for in American dollars when it was delivered to the New York docks for shipment. All that the company would have to furnish was its expertise.

Fred T. Ley sent the manager of his New York office, James A. Mears, to Lima, where he spent six weeks negotiating with the Archbishop and checking out potential projects, suppliers, and the local labor situation. This was the same man who had advised Col. William Starrett and the subcommittee on construction of the World War I cantonments. When Mears returned to New York he had a signed contract with no changes from that originally proposed by the Ley company. He reported that the archdiocese was planning to spend one million dollars a year on new reinforced concrete structures, and that Fred T. Ley & Company would receive 10 percent of the cost of any project as its fee. That was 25 percent higher than the company's standard fee of 8 percent and amounted to at least $100,000 of revenue for the company annually with little or no out of pocket expense.

The first superintendent to be sent to Lima was a man named Spaulding. He was a graduate of the Massachusetts Institute of Technology, trained in the design and construction of reinforced concrete buildings. Moreover, as Harold Ley observed, "he neither drank nor smoked and, as far as we knew, had no lady friends but his wife, whom he took along."[4] In Lima, Spaulding opened an office and set up the subsidiary Fred T. Ley & Cía. Ltda.

Spaulding used local labor and mostly local supervision, but he imposed Fred T. Ley & Company organization and systems on them. This meant a high level of organization and planning, rapid execution of projects, hard bargaining with suppliers, and a focus on profits. Speed was of the essence, because of the cost-plus nature of their contract with the Archdiocese. They faster they could build, the more money they could make.

The first project that Fred T. Ley & Cía. Ltda. took on was a six-story office building at a major intersection in downtown Lima. Two years previously, a building of the same general design had been started across the street from the building that the Ley company was erecting. When Mr. Spaulding started on his building, the other building had only reached the fourth floor, and they were still working on the fifth floor when the Ley company completed their project. This success attracted a lot of favorable publicity.[5]

Another publicity coup occurred a few years later. President Augusto B. Leguía y Salcedo had been planning a massive celebration to commemorate the 100th anniversary of Peruvian independence, which had been proclaimed by José de San Martín in Lima on July 28, 1821. About six weeks before the scheduled date of the event, a fire broke out in the Peruvian White House, where the President lived. Spaulding told the President that if he would grant the necessary permissions, Fred T. Ley & Cía. Ltda. would complete the

repairs to the building in time for the celebration. The President gave the order to go ahead, and Spaulding met the deadline.[6]

Eventually, Archbishop Chaves asked Fred T. Ley & Cía. Ltda. to manage all of the Church's real estate holdings in Lima, collecting the rents and maintaining the properties. This was because there was little or no corruption in the Ley company, as opposed to the existing situation where graft soaked up most of the income from the properties before it could reach the Church treasury.

In 1928, the *Springfield Republican* reported on the success of Fred T. Ley & Company in South America.

> Since 1919 the subsidiary concern called Fred T. Ley & Cia. Ltda. has maintained offices in Lima, Peru, where it has carried on extensive construction and improvements for the Roman Catholic archbishopric, while having administration of the church properties in the territory. Several apartment and office buildings have been erected recently for this client, and others have been initiated. At the same time the company is doing millions of dollars' worth of building for other interests in Lima and throughout Peru.
>
> The Hotel Bolivar, a modern structure of 200 rooms, fireproof and rated as one of the finest in South America is one of the buildings erected in Lima by this concern.[7]

The Hotel Bolívar, also known as the Gran Hotel Bolívar, is now a historic hotel located on the Plaza San Martín in Lima, Peru. Designed by noted Peruvian architect Rafael Marquina, it was built in 1924 and was the first large, modern hotel ever built in Lima. As a part of a government program to modernize the Peruvian capital, the hotel was constructed on what was then state property. The Hotel Bolívar was opened on December 6, 1924, which was the centenary of the Battle of Ayacucho, where General Antonio José de Sucre had defeated Spanish troops who were trying to reconquer the newly independent nation of Peru.[8]

As the company continued to expand, it took on more and more commercial clients in Peru. One outstanding work was a group of 14 buildings for the Hospital Nacional Arzobispo Loayza. Named for Jeronimo de Loayza, the first Archbishop of Peru, who founded it in 1549, it is one of the largest hospitals in Lima and is now a public hospital. The company took on many projects for banks, including the Banco International de Peru, the Royal Bank of Canada and the Banco Italiano. A five-story bank and office building was built for the Compañía de Seguros Italia, and the six-story Wiese building was erected for Emilio F. Wagner & Company, a dealer in engineering instruments. Fred T. Ley & Cía. Ltda. built the five-story Olcese building, and a

two-story showroom and office building for Milne & Company, a distilling and import-export company. A soda water plant was built for Bartin Brothers, and a cotton factory for Alexander Eccles & Company, which was a firm of English cotton brokers. A dormitory was built for the Escuela Naval del Perú, the Peruvian Naval Academy, in La Punta, Callao, overlooking the Pacific Ocean. This building was destroyed by an earthquake in 1974. They also built the Villa Maria school for the American Sisters of Philadelphia in Miraflores, an upscale suburb of Lima.

Fred T. Ley & Cía. Ltda. also engaged in various suburban projects for different interests. Notable in this connection was a large beach, breakwater and wharf development at La Perla, a resort area in Callao near the naval academy. They constructed much of the infrastructure, including paving and sewer and water lines, for the development of the Jesús María Urbanization, which is now one of the most centrally located districts of Lima and usually ranks in the top four districts in terms of quality of life in the city.

Early in 1928, Fred T. Ley himself travelled to Lima, Peru, and onwards to Chile and Colombia where he scouted for opportunities, returning to the United States at the end of March. Later that year, he authorized other subsidiaries to be organized in Santiago, Chile, and Bogota, Colombia. In Santiago their first project was a new nine-story reinforced concrete building for the government owned newspaper *La Nación* which cost about $500,000 and was completed in 1930. Another government building that cost around $300,000 was also erected. In Bogotá they erected a building for a branch of the National City Bank of New York, a predecessor of today's Citibank, as well as five or six other structures, including two more banks.[9]

All of this furious expansion had taken place under contracts that put little of the parent Fred T. Ley & Company's capital at risk. However, it all came to a halt with the stock market crash of 1929 and the world-wide depression that followed it. Capital for new buildings dried up and North American companies pulled their money out of the region. Fred T. Ley & Company held on for a few more years, but finally closed the offices of Fred T. Ley & Cía. Ltda. in the early 1930s. Harold Ley put it well when he wrote, "We made a good deal of money while we were in South America, but we should have made a small fortune out of it. It was undoubtedly the most unusual experience of our construction career."[10]

While developing his South American Division, Fred officially moved the headquarters of Fred T. Ley & Company from Springfield, Massachusetts, to 19 West 44th Street in Manhattan in 1919. At the same time, he established

his own permanent residence in the city.[11] His brother Harold also moved to New York, while Leo remained in Springfield to run the Massachusetts office.

As mentioned above, the period from 1914 through 1919, when the First World War was being fought in Europe, was a depressed time for new building construction in the greater New York area. In an attempt to improve the situation, a committee was formed in October 1917 to see what could be done to stimulate building construction in the city and the surrounding area. The committee was established by the Building Material Exchange, an organization founded in 1882 to bring together materials suppliers and buyers and to stabilize prices. The committee was sponsored by the Manhattan Borough President, Marcus M. Marks. Five sub-committees were appointed. The first one was to look into whether a demand existed for new building construction, and how large that demand was; the second, into the supply and price of building materials; the third into to the supply and price of labor. The fourth sub-committee was to examine what was termed "the money situation," that is the availability of financing; and the last was to consider potential new legislation to support the construction industry. Fred T. Ley & Company, which was rapidly establishing a presence in the New York market, was represented on the committee by Ernest L. Smith from their New York office. He served on the sub-committee evaluating the demand for new construction.[12] Serving with Smith on that sub-committee was Philip Hiss, the Chairman of Housing Section of the Council of National Defense, who Fred T. Ley knew from his interactions with the Council while building Camp Devens earlier that year, as was discussed in Chapter 9.[13]

In December 1917, Fred T. Ley & Company won the contract to construct a modern garage and service station for the Peerless Motor Car Company of Cleveland, Ohio, a maker of luxury automobiles, to use as its New York City showroom.[14] The site is now occupied by a New York Sanitation Department building.

The prestigious, exclusively male, Racquet and Tennis Club had moved into their new clubhouse at 370 Park Avenue in 1918, but still owned the old one. It was situated on a plot of land that ran from 25 West 43rd Street through the block to 28 West 44th Street. August Belmont and Charles Sabin, the trustees for the Club, were anxious to dispose of the property, which the club no longer needed. At the same time, S.W. Strauss & Company, a Chicago investment house which had recently opened an office in New York, was looking to make a good real estate loan in Manhattan. A real estate broker, James T. Lee, who had worked with the Ley brothers before, approached Strauss

and suggested that Fred T. Ley & Company should be encouraged to buy the site. The price was $725,000.

Fred T. Ley & Company obtained a generous first mortgage from Strauss and a second mortgage from the Racquet and Tennis Club. They took possession of the property on May 1, 1919, and proceeded to erect a 21-story office building that was ready for occupancy exactly one year later. Between the two mortgages and notes that they issued to the subcontractors, the Ley brothers were able to construct this building without any investing any of their own money. When the building, now known as the National Association Building, opened, it was already 90 percent rented out with a rent roll of $900,000. In 1920, the first year of operation, Fred T. Ley & Company were able to pay all operating expenses, interest and amortization out of the income and still make a profit of $260,000.[15]

In January 1920, Fred T. Ley joined a syndicate headed by Walter Russell, a developer of co-operative apartment houses, that leased the entire block bounded by Park and Vanderbilt Avenues between 48th and 49th Streets from the New York Central Railroad. This was a part of the development of Park Avenue that followed the electrification and roofing over of the New York Central tracks in Manhattan from 42nd to 96th Streets between 1903 and 1913. The railroad leased the air rights over its Grand Central yards primarily for the construction of luxury apartments. These new buildings allowed Park Avenue to challenge Fifth Avenue for the title of the most prestigious address in Manhattan.

Fred T. Ley & Company proposed to erect a 16-story luxury apartment house designed by Warren & Wetmore on the site. Occupying the entire block, the building had natural light and ventilation on all four sides, as well as having a large courtyard. It included a restaurant on the ground floor that could provide meals to the entire building. The apartments were designed to deal with "the difficult problems of the times, such as the servant problem and the service problem."[16]

The *Real Estate Record and Builders Guide* elaborated on this issue and its solution in the Fred T. Ley Building.

> The modern apartment must have every facility for full housekeeping, and yet it must be absolutely independent of the servant problem. What has come to be known as the double service system has been evolved to perfection in this building. Double service means that a family may fall back upon the service of the building outside of his apartment, or supplement his own household service by the facilities which the building itself offers. The restaurant and hotel service provides this so far as food is concerned, and the hourly maid service system

provides it so far as household service is concerned. It means a staff of maids, valets and butlers are on hand to be called at any time, for any purpose, from making beds to serving at a formal tea, for which services they are paid by the hour. This makes it possible to cut one's staff of servants or dispense with a fixed retinue all together if one desires. Instead of having eight and ten servants' rooms, three or four answer the purpose in the double service system. Special attention has been given to domestic labor saving devices to simplify cleaning. Kitchen walls are tiled to the ceilings, and steel cabinets with steel porcelain shelves are used in place of wood. Every attention is given to the details of household economy in so far as labor devices are concerned. The refrigeration is electric; the iceman will not knock at the door. Store rooms sufficiently large to contain fifteen or twenty trunks are provided for every apartment, within the apartment.[17]

The building was conceived as a co-operative and was financed by cash paid by the prospective co-op members, who accounted for two-thirds of the apartments. The other third would be rented for a total of about $270,000 a year. The rental income was expected to exceed the running expenses, so the owners would only be paying the interest on the loans they took out to buy into the project, reducing their effective rent to about one-third of the market rate. The ground lease would cost approximately $2,000,000 for the first 21 years and the building itself would cost $4,000,000, putting the total investment at $6,000,000. Since most of the ten owner-occupied apartments took up an entire floor, the cost to buy into this project was around $600,000, making it an extremely exclusive building.[18]

The building that was eventually erected had only 12 stories, probably due to the difficulty of finding enough subscribers at the asking price, as the country went through a mini-depression in 1920 and 1921. Fred T. Ley and his family had a private apartment that occupied the entire top floor. By this time, Fred and Mignon had two sons, Frederick A. and Theodore M., and one daughter, Mignon, all of whom lived with them in the apartment.[19] When the building was complete, Mrs. Ley hired a struggling art critic by the name of Jean Paul Slusser to decorate the apartment. Slusser was moonlighting as a set and costume designer for the theater at the time, but would go on to become a well-known Midwestern artist, professor at the University of Michigan and director of the University of Michigan Art Museum. Mrs. Ley had seen some decorative silk panels of Slusser's at an exhibit at the Architectural League of New York, and visited him at his rather shabby apartment at 344 East 57th Street. Slusser later recalled that she came in a chauffeur driven limousine, but didn't seem to mind climbing the stairs in the building where

he lived. He clearly impressed her at this meeting, since she commissioned him to decorate the entire apartment.

Slusser did a number of original paintings and lunettes over the drawing room doors and he decorated the library doors in painted designs based on Persian and Indian miniatures. He also introduced her to Mr. Frankel, a Viennese decorator, who sold her a magnificent tapestry for the apartment. Sadly, in the New York way of sacrificing history for progress, the building was later demolished and all of Slusser's work on it appears to have been destroyed, although a few photographs have survived.[20]

At the same time that Fred T. Ley was constructing his own apartment building, his company began building another one for Walter Russell. This was to be owned by Russell and financed by a mortgage and a bond issue, rather than being a co-op. It is probable, but not certain, that Fred T. Ley had an equity interest in the building. The plans for the building were elaborate. The *Real Estate Record and Builders Guide* reported:

> Replicas of the famous hanging gardens of the palaces of ancient Babylon will be among the distinctive features of a fifteen-story apartment house to be built at 145 West 55th Street. These elaborate gardens are planned for the very top of the structure, while at the various set-backs the same decorative scheme will be carried out. Thus occupants of the building will have real front yards of plant life and greenery. This will be the first time that any building in New York has been planned with the view of utilizing the set-backs in such an artistic manner. Another unusual feature of this improvement will be a tile swimming pool which will be restricted to the use of the tenants and their guests. On the main floor and facing a terrace arranged as a sunken garden will be the restaurant. There also will be facilities for serving meals in the apartments. Construction work on the apartment building, which will be known as Holbrook Hall, will begin at once.... Plans call for 280 rooms with servant accommodations. The architectural design of the entire facade will be of the Italian Renaissance type. The first three floors will be faced with white stone while the apartments are arranged in suites of three rooms, consisting of living room, chamber, servant's pantry and bath.[21]

The inclusion of garden terraces on the roofs of the setbacks were an early example of what are now being promoted as "green roofs." The relatively small, three room apartments with no kitchen were unusual in an upscale apartment building, being more like hotel suites than true apartments. It appears that there were no accommodations for families with children. The building still stands at 145 West 55th Street and is still used as residential apartments.

At the same time, Fred T. Ley formed the Liggett-Winchester-Ley Company to construct an office building at the northeast corner of Madison

Avenue and 42nd Street. He served as president of the company and the building contained the New York offices of the Liggett and Meyers Tobacco Company.[22] The Liggett Building was a plain 22-story tower built of red brick and masonry, designed by Carrere & Hastings. It was one of the first high-rise buildings to be erected after the First World War, and it reassured architects and builders about the effects of the new zoning law. The building's 15-story base supported a two-story setback zone and a freestanding, five-story pavilion. Hastings united these elements by accentuating the corners, creating a sense of corner pylons, sheathed in brick with windows appearing to have been punched out of them. The pylons rose through the setback line and buttressed the central mass. The exterior of the building is essentially unchanged and still in use today.

John Taylor Boyd, Jr., commented about the Liggett Building: "If the architect proceeds to fill this shell [the building envelope established by the zoning law] with a building, he will find that the result has no form or proportion or symmetry of outline. It is his duty to model within the limits of the legal shell a beautiful building…. He may even find it necessary to … sacrifice a bit of space here and there in order to achieve his design. Such was the method employed in the Liggett Building. The fine symmetry of its upper stories is not prescribed by the law, which would enforce only two setbacks, those on the street."[23]

Another major project was the Fisk Building at 250 West 57th Street. As discussed in Chapter 6, Fred T. Ley had been a director of the Fisk Rubber Company and had built its factory in Chicopee, Massachusetts. It was therefore natural for the company to look to him when it wanted to put up a corporate headquarters building in New York City. The building that resulted fills the entire frontage of 57th Street between Broadway and Eight Avenue, just south of Columbus Circle. It is a 25-story office building with a frontage of 240 feet and a depth of 54 feet on Broadway and 100 feet on Eighth Avenue, designed by Carrere & Hastings in association with R. H. Shreve. The building was controlled by the Fisk Rubber Company and contained their executive offices and salesrooms. Excess space was rented to tenants in the automobile and allied industries. The owner was the 1767 Broadway Company, Inc., the principal stockholders of which were Fred T. Ley & Co., the Willys-Overland Rubber Company, the Willys Corporation, and the Fisk Rubber Company.

The building was constructed with set-backs to obtain a maximum of natural light and ventilation. The first and second floors were devoted to stores and salesrooms and the balance of the building was offices. The location

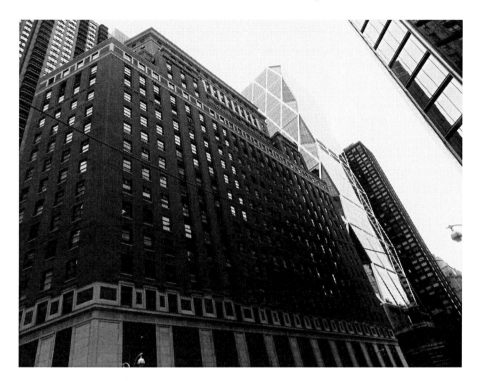

Fisk Building, 250 West 57th Street, New York City (photograph by the author).

was an especially attractive one. It was in the heart of the automobile district of Manhattan, where a number of companies in the automotive industry had their offices, and the rental demand was heavy. It was convenient to Columbus Circle and two subway lines were nearby.[24]

The architect and critic, Robert Stern, describes the building as follows:

> From Columbus Circle the Fisk Building offered a convincing image of a man-made acropolis, a sixteen-story red brick cliff that served as a broad pedestal for a colonnaded temple raised high against the sky. The base of the building was a two-story cage of bronze and glass that offered maximum exposure to the automobile showrooms within. The wall above was set back slightly to avoid any sense of structural instability. Two vertical bands of windows rose through the base into "dormers" above the setback line, latching onto the pedestal of the roof-top temple, while the fourteenth- and fifteenth-floor windows were grouped together to suggest a two-story order of piers.[25]

The building still stands and retains its exterior design, although it has been renovated and updated with modern offices.

Smaller projects that Fred T. Ley & Company took on in 1920 included a four-story reinforced concrete warehouse for the Passaic Cotton Mills in Passaic, New Jersey, designed by Charles T. Main of Boston, and costing $700,000, and a ten-story brick and stone store and loft building at 234–242 West 39th Street costing about $300,000.[26]

This mass of work kept Fred T. Ley & Company occupied through all of 1920 and much of 1921, enabling the company to survive the business slowdown of that period. In 1922, as the economy revived, the company began work on a number of smaller projects. In Manhattan, they built the Berkley Arcade at 19 West 44th Street. This arcade stretched through the entire block to West 45th Street and was also a Starrett & Van Vleck design. In New Jersey, the company constructed buildings for the 2nd National Bank of Phillipsburg, the First National Bank of Ridgewood; and the First Presbyterian Church of New Brunswick.[27]

At the end of 1922, Fred T. Ley took on another major project. He was approached by Charles Sabin, the president of the Guaranty Trust Company, whom he had known for many years, and who had sold him the Racquet and Tennis Club property on 43rd Street in 1919. Sabin asked if Fred could do something with the lot on the northeast corner of Broadway and Liberty Street in Manhattan, which was across the street from the Guaranty Trust Building. The lot was owned by the Wendel Estate, but Sabin's company had taken out a long lease, intending to use it for expansion. Then the company changed its mind, and wanted to free itself from the lease.

Fred was told that it would be impossible to arrange financing for a building, because the Wendel lease had conditions that made refinancing impossible, but he was not deterred and he approached the lawyers in charge of the estate personally and persuaded them to make several changes that made the project possible. With their approval, he bought the lease from the Guaranty Trust Company at a rate of $50,000 a year.

Fred secured a generous first mortgage from S.W. Strauss and Company, the same investment house that had financed the National Association Building in 1919. He then made a deal with the Westinghouse Company for them to rent everything above the 13th floor, and to advance $350,000 on a second mortgage. The building would be known as the Westinghouse Building and would serve as their corporate headquarters. He followed that by renting the ground floor to the upscale men's clothier, Rogers Peet & Company, and they advanced him $90,000 on their lease.

The Westinghouse Building was designed by Starrett & Van Vleck, with

whom he had a close association. It has 23 stories with the first four faced with white limestone and the rest with beige brick. Construction started in 1923 and was completed in 1924. According to Robert Stern, the Westinghouse Building "marked an important step toward realizing the aesthetic potential of the zoning law. The cornices were suppressed, flattened against the wall at each of the setbacks."[28] When the building was complete, Fred T. Ley and his brothers had made a clear profit of $150,000 and owned 100 percent of the stock in the building. The building earned them a generous income until 1930, when the depression hit and occupancy and rent fell drastically. It continues in use today.[29]

In 1923, Fred T. Ley & Company built the Croydon Hotel at 12 East 86th Street in Manhattan, between Fifth and Madison Avenues. This 15-story hotel has since been converted to a cooperative apartment building with 343 units which now begin at rentals of $4,200 a month for a one bedroom apartment.

Fred T. Ley would continue to use the same business model, investing his own money in many of the buildings he constructed and reaping substantial rewards from both construction profits and future rents and increases in real estate value. By creating separate corporate entities for each building, he limited his liability if a project ran into financial difficulties, while reaping the profits if the building was a success, which most were. Doing so, he built the reputation that made Walter Chrysler seek him out 12 years later to be the general contractor for his eponymous building, the tallest in the world.

During the 1920s, Fred T. Ley and his wife continued to vacation in Europe on an almost annual basis. They travelled to France in August of 1924, 1926, 1927 and 1928, each time spending about a month in the south of that country. They also spent some time in the Bahamas in the spring of 1926.[30] From 1921 on, they lived in their top floor apartment in the Fred T. Ley building on Park Avenue and 48th Street, only a few blocks from the company offices at 19 West 44th Street.

In addition to its large volume of work in New York City, Fred T. Ley & Company continued to find work in New England. At the end of December 1927, at the height of a real estate boom, the prominent Boston realtor W.J. McDonald announced plans to build the "world's largest building," a 22-story, 300-foot-tall retail and office building covering three acres on Berkeley Street between St. James Avenue and Stuart Street. The owners of the building were organized into a company called the New England Department Store, Inc. The architects were Blackall, Clapp & Whittemore and George Nelson Meserve. Fred T. Ley was the general contractor, a director of the company,

and an investor in the building. The owners predicted that the building could be completed within one year.[31] The building would provide 1,600,000 square feet of rentable space.[32] On January 18, the company took out a two-page advertisement in the *Springfield Republican*, detailing the plans for the building and announcing the opening of a business office in Springfield. The developers were offering ownership units consisting of two preferred shares, paying a $9 annual dividend, two common shares of stock in the New England Department Store, Inc. and two common shares in the New England Building, Inc. for $260, payable in installments. The Department Store company would operate the business and the Building corporation would own it and the land on which it stood.[33]

There must have been some problems with raising the financing, because the building was never even started. In July 1930, the site was still being used as a parking lot when McDonald announced that work on the New England Building would start in August. The height of the planned building was now given as 40 stories, and Fred T. Ley had been replaced as the contractor by the H.K. Ferguson Company of Cleveland.[34] Liberty Mutual Life Insurance Company finally built a smaller building on the site in 1936.[35] It is probable that Fred took a substantial loss on his investment, although it is also possible that McDonald bought him out.

By 1928, Fred T. Ley & Company had participated in a wide range of projects, including several major high rise, steel framed buildings, erected in the crowded conditions of Manhattan. It had also constructed many reinforced concrete buildings and worked with a wide range of architects. The tallest building it had constructed so far was the 25-story Fisk Building. Its organization included a large number of experienced construction managers and it had strong working relationships with trusted subcontractors. Fred T. Ley was poised to take on his most important project yet, the Chrysler Building.

12

The Dream Is Built:
The Chrysler Building

Nineteen twenty-eight was a momentous year for Walter P. Chrysler. His eponymous Chrysler Corporation was doing well and in April, he opened negotiations to acquire the Dodge Brothers Automobile Company from the banker, Clarence Dillon. The founders of that company, John and Horace Dodge, had both died in 1920. In 1924, their widows sold the company to Dillon, but he had no experience in the automotive business and without the vision and management skills of the Dodge brothers, the company became less and less profitable. Dillon offered the company to Chrysler, who needed more manufacturing capacity, and on July 31, 1928, they closed the deal, merging Dodge into the Chrysler Corporation. The deal was done by issuing new Chrysler stock and assuming the Dodge corporation's debt. Walter Chrysler was proud of the fact that he had acquired Dodge without paying a penny of cash. With that one step, he made the Chrysler Corporation the third largest automobile company in the world, after General Motors and Ford.[1] On July 7, in the midst of the Dodge negotiations, he introduced the first Plymouth automobile as the start of a model line that was lower priced than his luxury Chrysler brand. Then, in August, he introduced the DeSoto as a mid-priced brand positioned between Plymouth and Chrysler. The DeSoto came in seven separate models with features, including a windshield wiper and hydraulic brakes, that were state of the art at the time.

On August 16, Walter Chrysler decided to build a new plant devoted to Plymouth production and broke ground for it on October 10. Five days later, on October 15, 1928, he acquired the lease and the plans for what would become the Chrysler Building from William H. Reynolds, for $2,000,000.

Under construction from 1928 to 1930, the Chrysler Building was intended to be a business venture for his sons, Walter Jr., and Jack Chrysler,

who weren't interested in the automobile business. Walter Chrysler felt strongly that rich men's sons should not be idle, but should do meaningful work. When the building was finished, he would encourage his sons to get to know the people who made it run, from the janitors to the building engineers, and to gain an understanding of how it functioned.[2]

The first rumors of Walter Chrysler's interest in the site appeared in the *New York Times* on October 4. The *Times* reported:

CHRYSLER DEAL PENDING

Auto Man's Office Fails to Confirm Rumor of Realty Purchase

In the absence from the city of both Walter P. Chrysler and former State Senator William H. Reynolds, no definite information was forthcoming from their respective offices regarding the rumor that Mr. Chrysler was negotiating to purchase the leasehold held by Senator Reynolds on the easterly Lexington Avenue Block front between Forty-second and Forty-third Streets. The report is that Mr. Chrysler, if he obtained the property, would use the building to be erected there for the main offices of his automobile interests. While no deal has been closed, as stated by the Chrysler offices, it is understood that Mr. Chrysler has been studying the proposition. Whether he would erect the sixty-seven-story building planned by Senator Reynolds or revise the plans is also problematical.

It was announced a few weeks ago that Strauss & Co., had agreed to finance the sixty-seven-story building with a loan of $7,500,000. Since that time the tenants in the buildings on the site have vacated the premises, but no move has yet been made to demolish the structures. Mr. Reynolds obtained a long lease on the property several years ago from the trustees of Cooper Union.[3]

The Cooper Union for the Advancement of Science and Art was established in New York City by the inventor and industrialist Peter Cooper in 1859. It was his intention that it be an institution of higher education that admitted anyone who was qualified irrespective of their race, sex, or finances. Through its original endowment by Cooper and additional acquisitions over the years, it came to own large tracts of land in Manhattan, which it leased to provide income to finance the school. It continues today as one of the leading schools of engineering, architecture and art in New York city.

At first, Cooper Union, which owned the land that the Chrysler Building would be erected on, was reluctant to allow the transfer of the lease from Reynolds to Chrysler, not understanding Walter Chrysler's financial position. Chrysler had enough money to construct the building, but most of it was tied up in Chrysler Corporation stock and municipal bonds. Finally, Chrysler agreed to give Cooper Union a $7,500,000 first mortgage sinking-fund gold bond backed by his holdings. The amount of the bond would be reduced as specific milestones in construction were reached. The purpose of

this bond was to protect Cooper Union if Chrysler did not complete the project.[4]

On October 13, 1928, the W.P. Chrysler Building Corporation was registered in Albany, New York. It is clear that by this date, Walter Chrysler had already decided to give the general contract to Fred T. Ley & Company, which had moved its New York offices to 578 Madison Avenue, a little over a half mile uptown from the building site. Chrysler must have been in discussions with Fred T. Ley for some time, because when he formed the new corporation, he hired Frank B. Proctor away from Fred T. Ley & Company and made him the vice-president in charge of construction for the W.P. Chrysler Building Corporation. Proctor was an experienced Ley company superintendent who had worked on Camp Devens, among other projects. He was therefore familiar with the Ley organization and methods, and was now in the unusual position of overseeing his former boss. Walter Chrysler's putting one of Fred T. Ley's top people in charge of overseeing the general contractor rather than using one of his own managers was an indication of his trust in Fred T. Ley, but it was typical of Chrysler to insist that the man in ultimate charge of construction report directly to him.

Chrysler's purchase of the lease closed on October 15, and construction started immediately. Like Fred T. Ley, Walter Chrysler was not one to waste time. When he took over the Dodge Corporation earlier in the year, he had the signs on the plant changed to "Dodge Division of Chrysler Corporation" and his own managers in the Dodge company headquarters before the ink on the contract was dry. In the case of the Chrysler Building, Fred T. Ley had already lined up the Albert A. Volk Company as demolition contractors, and they had 150 men on the job on October 16, the day after the closing, beginning to take the old buildings down.[5]

Fred T. Ley had a long working relationship with Albert Volk, having used him as a demolition contractor since at least 1920.[6] Albert Abba Volk was the brother of Jacob Volk, who had started the family wrecking business around 1900. With only $300 in capital, Jacob bought tools and a wagon on which he painted his lifelong slogan: "The most destructive force on Wall Street." Albert and Jacob were sons of Sussman Volk, the man who is said to have opened the first Jewish delicatessen in New York City and who introduced pastrami to America. Jacob is credited with two major innovations in the wrecking industry: the "upside-down method" of taking down buildings and the wrecking ball, a replica of which serves as his brother Albert's tombstone.[7]

The conventional method of tearing down a building was to start at the top, throwing debris down chutes to the street, where it was gathered and loaded into trucks. Jacob Volk's "upside-down" method instead began by tearing down the interior of the building first, starting with the ground floor, and leaving only enough structure to support the outer walls. The debris accumulated inside the building as the men worked upwards, and could be loaded into trucks inside the building with power shovels. When the interior was removed, the outer walls were collapsed into the interior and again trucked away. This reduced the time needed to take down a building almost 10-fold, while minimizing the disruption to the adjacent streets. When Jacob died in 1929, he was famous enough to be profiled by E.B. White in the Talk of the Town column in the *New Yorker* magazine. Albert Volk had set up a rival wrecking company using the same methods as his brother and after Jacob's death Albert continued in the wrecking business for many years.[8]

It was not until almost three weeks after demolition had begun that Chrysler finally met with William Van Alen, on Monday, November 5, and gave him the commission for the building design.[9] Walter Chrysler threw out the designs Van Alen had created for Reynolds and told him to come up

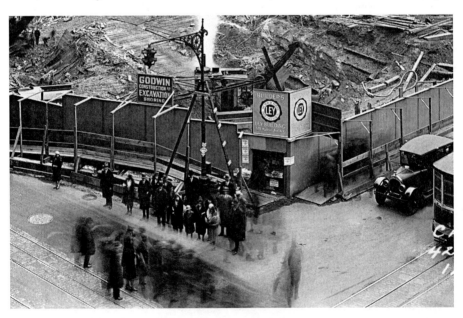

Chrysler Building excavation with signs for Fred T. Ley & Company and Godwin Excavation (courtesy Princeton Architectural Press).

with a new design that was more innovative, something that would be unique. This put Van Alen in a difficult position, because the new design could not deviate too much from the old one in plan, without holding up construction. The plan, or horizontal design, of the building determined both the placement and the size of the columns. This, in turn, determined where it was necessary to excavate for the footings, and how large those footings would have to be. Chrysler informed Van Alen that excavation was scheduled to start within a week. Van Alen began working on his new sketches the next day.

William Van Alen did not work alone, of course. He had a staff of drafts-men and worked closely with the structural engineer, Ralph Squire, and the mechanical engineer, Louis Ralston. It is also known that he contracted with Hugh Ferriss, the architect and illustrator, for two renderings of the Chrysler Building. Ferriss included a drawing of the Chrysler Building under con-struction in his book, *The Metropolis of Tomorrow*.[10] That illustration had been done for an advertisement of the American Institute of Steel Construc-tion in *The American Architect*, in 1929.[11]

By November 9, the site was cleared, and Fred T. Ley & Company had placed its distinctive green signs with their "Seal of Service" on the walls of the abutting building overlooking the site.[12] On November 11, excavation began. The excavation and shoring subcontractor was the Godwin Construc-tion Company of New York.[13] By November 17, the packed earth access ramp to 42nd Street was complete and five steam shovels were filling an endless stream of trucks.[14] At that time, the steam shovel was the premier excavation machine on construction sites as the modern excavator and back hoe had not yet been developed. The adaptation of the hydraulic cylinder to con-struction machinery which made these newer excavation machines possible did not occur until after the Second World War.

The Godwin Construction Company would eventually be operating six steam shovels, four derricks, 20 hydraulic drills and 40 trucks for hauling away the material that was removed. This consisted of 5,000 cubic yards of old foundations and floors; 10,000 cubic yards of earth; and 25,000 cubic yards of rock, just to create the basement level. An additional 16,000 cubic yards of rock were removed to create the sub-basement boiler room and the shafts for the footings that would support the tower columns. The base of these footings reached 69 feet below the level of the street. The rock, which was part of the extremely hard and strong formation known as the Manhattan Schist, had to be blasted to break it up before it could be taken out. No records of where the excavated material was disposed of survive, but in the ongoing

effort to increase the land area of the island, it was probably used as fill along the shores of Manhattan. The entire excavation process took a little over two months.[15]

To provide direct access to public transportation, an underground tunnel was excavated from the basement level of the building to the 42nd Street station of the IRT subway system's Lexington Avenue line. This tunnel would also give underground access to Grand Central Terminal and the Commodore Hotel, making the Chrysler Building a convenient location for companies that had many out-of-town visitors. The connection was initially opposed by the IRT, but they finally permitted it when Walter Chrysler agreed to build the passageway at his own expense.

Because Walter Chrysler had asked Van Alen to draw up new plans for the building, the excavation had to proceed without a final design. The problem with this was that once the excavations for the column footings were finished, it would be extremely expensive to change the location of the columns. Van Alen therefore decided that he would use the same column spacing as in the original design that he had done for Reynolds, and the foundations, when poured, would be strengthened so that they could bear any additional weight that the new design might add.

When the excavation began, an earth ramp was used to move trucks and equipment into and out of the excavation, but as the men dug deeper, this was replaced by a wooden ramp that could more easily be extended. As mentioned above, access was from the 42nd Street side. As the excavation got deeper, wooden shoring had to be used to prevent the walls from caving in and undermining adjacent streets and buildings. This consisted of massive wooden beams which were angled upwards and braced against boards placed on the basement walls of the building next door and the soil under the adjacent streets. This temporary shoring required some 50,000 board feet of lumber to complete.[16]

Excavation continued through the holidays, and by late January 1929, the steel-reinforced concrete foundation walls were taking shape. An eight-to-ten foot high wooden fence had been erected around the site, and in the New York City tradition, it was pierced by openings through which "sidewalk superintendents" could watch the progress of the work. A temporary construction office was set up in the curb lane of 42nd Street, and a large sign was put up announcing "The Chrysler Building—being erected on this site— ready for occupancy Spring of 1930," and giving the address of the rental office at 415 Lexington Avenue, just across 43rd Street from the construction

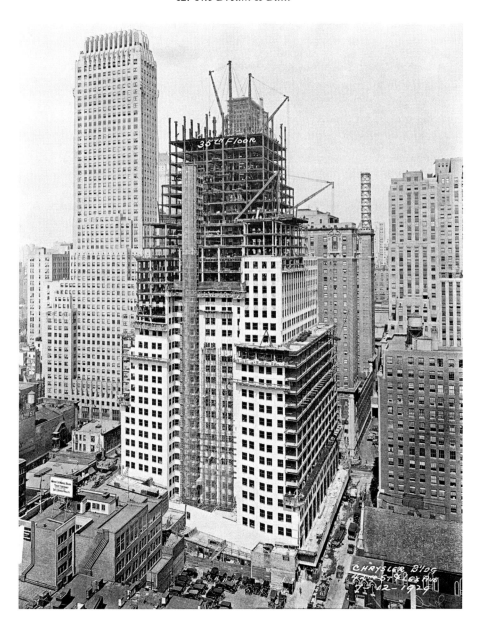

Chrysler Building under construction, showing the use of derricks to raise steel members from a truck parked on the street (courtesy Princeton Architectural Press).

site. Walter Chrysler had gone public with his date of completion, and the pressure was on Fred T. Ley and William Van Alen to meet the deadline.[17]

On March 7, Walter Chrysler released a set of building plans to the press. These plans showed a skyscraper with 68 stories and a stated height of 809 feet. This was only marginally taller than the last set of plans that Van Alen had drafted for the Reynolds Building.[18] The publication of the plans was a gauntlet thrown down to William Van Alen's ex-partner, H. Craig Severance, who had been engaged to design the Manhattan Company Building as the tallest building in the world, and who would take the announced height of the Chrysler Building as a benchmark to be exceeded.

The Manhattan Company Building was the idea of George Ohrstrom. A financier and real estate developer who had made his fortune by acquiring water companies, Ohrstrom assembled five abutting parcels of land on Wall Street and persuaded the Bank of the Manhattan Company to lease him a sixth on the condition that he build a high rise building that they could use as office space. The Bank had recently merged with the International Acceptance Bank and needed more room for its expanded operations. Originally conceived as a 40-story office tower, Ohrstrom decided to go higher and make it the tallest building in the world. Unfortunately, Walter Chrysler also had the same goal and by the time Ohrstrom was ready to start building in March of 1929, Chrysler already had his foundations in the ground. The competition between these two has been extensively chronicled in Neal Bascom's book, *Higher*.[19] William Van Alen's role in this race to the sky was to keep revising the plans to add height and to find a way to stretch the final few feet after Ohrstrom's building had topped out. Fred T. Ley's role was to keep building quickly and safely and to find ways to put Van Alen's plans into action.

The concrete bases for the columns of the Chrysler Building were poured around billets made out of crisscrossed steel beams. The first billet, marking the first element of the steel construction, was settled into place on March 10.[20] Two days later, on March 12, H. Craig Severance was given the go-ahead to begin detailed plans for the Manhattan Building.[21]

By March 13, the concrete footings for the columns that were going to support the central tower were ready to be poured, and the steel fittings that would attach the columns to them are were in place.[22] Once the concrete was thoroughly cured, on March 27, actual steel construction began with the setting of the first columns. During the early stages of steel erection, two 30-ton derricks and three 20-ton ones were used. The subcontractor for steel

erection was Post & McCord, a highly experienced company that worked on many high rise buildings in Manhattan.[23]

By April 9, Fred T. Ley had the first tower columns set in place.[24] They weighed 25 tons apiece and were capable of carrying a load of seven million pounds each. These columns carried four trusses, each two-stories tall, that would support the ceiling of the main lobby. The trusses were so heavy that they could not be transported by truck and had to be assembled on site. The trusses were needed because Walter Chrysler had insisted that Van Alen design a lobby sufficiently grand to reflect the superlatives of the rest of the building. This meant that there could be no columns interfering with the view, and so the trusses had to distribute the weight of the columns above them to those around the edge of the lobby. The result was a large, tall triangular space that spoke to a deliberate and conspicuous sacrifice of prime rentable square footage in order to make a statement.

With the columns for the tower in place, the shape of the building began to emerge. Its base was a trapezoid approximately 200 feet on a side along Lexington Avenue.[25] Four setbacks would reduce this to a rectangular tower 107.5 feet by 88 feet at the 31st floor. This dimension would be maintained until the 59th floor, where another setback would reduce it further to the 66th floor, but at this stage those steps were not yet apparent.[26]

The steel was fabricated in a yard in Brooklyn. The rolled steel shapes arrived from the mills in Pennsylvania and were assembled into beams, columns and other structural members. Holes were drilled for the rivets that would attach them to the structure. Each element was numbered and then trucked to the site in the exact order needed for erection. On site, they could be taken off the trucks by the derricks and hoisted directly to where the steel workers put them in place, eliminating the need for extensive storage on site.[27]

On April 15, Walter Chrysler called William Van Alen to his office. Chrysler was well aware of Severance's plans for the Manhattan Building, and did not want to let that project overtop his. He told Van Alen to alter his plans as necessary, but to be sure that, in the end, Walter Chrysler's would be the world's tallest building.[28]

By May 17, steel had been erected to the 8th floor, revealing the basic H shape of the building above the 4th floor. Two "light courts," the same width as the tower, one on the west side facing Lexington Avenue, and the other on the east side, were cut out from the street line back to the base of the tower, so that on those two sides the tower face was, except for two small setbacks,

shear above the fourth floor. Their orientation provided the maximum amount of sunlight to penetrate the courts.

A practice was started of posting the number of stories reached on a placard at the bottom of the Ley Company sign attached to the steel work.[29] One week later, steel had been erected to the 12th floor, and the work of laying brick to create the walls had started.[30] The first three floors above the street level, from the top of the shop fronts to the base of the fifth floor windows, were faced with white Georgia marble. This material was also used in trim on the floors above that level, which were faced with light and dark gray brick in decorative patterns designed by Van Alen.[31] The subcontractor for this work was the Jacob Gescheidt Company.[32] The bricklayers and masons worked from adjustable safety scaffolding provided by the Patent Scaffold Company.[33]

The windows were of metal framed, double-hung design.[34] The window sills were made of extruded aluminum with a z-shaped cross section, according to a design of Van Alen's for which he obtained a patent.[35] He provided drawings for them, and Fred T. Ley & Company sent them to the Aluminum Company of America, which created a die and produced them. This later led to a lawsuit in which Van Alen alleged that the Aluminum Company had stolen his design and was selling the window sills for use in other buildings in violation of his patent. The suit did not reach trial until 1941 when it was dismissed because it had not been filed in a timely manner.[36]

By early June, Van Alen had come up with a plan to win the race for height with Severance and claim the title of the world's tallest building. On June 5, he presented Walter Chrysler with set of secret plans for a spire that could be concealed inside the building until the Manhattan Building topped out, and then erected to best whatever height Severance had achieved. Chrysler was pleased with the idea.[37]

As the work progressed there was a strong emphasis on both safety and speed. Both were helped by organizational methods that were based on the procedures that Fred T. Ley had developed for his company over many years but which were probably unprecedented in scope on a project of this scale. An official committee on safety was established and continued to work throughout the project to identify hazards and eliminate them. As a result, only one life was lost in the construction of the Chrysler Building. A man was working in one of the elevator pits in the basement of the building while an engineer in the upper stories was using a plumb bob to check for vertical alignment. The string of the plumb bob rubbed against a board and

broke, and the bob fell and hit the man in the pit on the head, killing him instantly.

To improve communications, a telephone system was installed and extended upwards as construction progressed. Horns were also installed throughout the building and a system of signals was devised, with each subcontractor given his own distinct call sign. When his signal sounded on the horn, the sub-contractor knew to go to the nearest telephone for instructions. Official bellmen were hired to control the elevators and hoists with audible signals. The permanent stairways were installed floor by floor as the building rose, minimizing the use of ladders, and permanent elevators, supplied by the Otis Elevator Company, were installed as soon as possible.[38] These elevators were of an automatic design, with push buttons for floor selection, which was new technology at the time. Mechanical and electrical equipment was located in the sub-basement and on the 30th and 60th floors, which were reserved exclusively for this purpose.

Although the elevator cabs used during construction were strictly utilitarian, they used the same shafts and lifting machinery as the ones that would grace the finished building. Van Alen used rich materials in the design of the permanent cabs and their enclosures to create a luxurious and dramatic effect in the Art Deco style. He lined the four elevator halls on the ground floor with the same red marble that he had used in the entrance halls and main concourse. There were a total of 28 passenger elevators. Their doors were done in an abstract, Art Deco, lotus pattern executed in metal and inlaid wood veneers, using a recently developed process called Metylwood. The lotus was one of the Egyptian inspired elements typical of Art Deco. The interior of the elevator cabs were veneered with thin sheets of Spanish elm, which were applied directly to the steel sections that bolted together to form the cab. The wood was laid so that the grain ran horizontally. It was divided into sections by strips of a copper, zinc, and nickel alloy known as German silver, and polished to a satin finish. The back corners of the cab were rounded to make a continuous wrap.

Van Alen integrated an innovative ventilation system into the design by installing a ceiling fan in each cab. In keeping with the design of the walls, concentric circles of inlaid metal strips surrounded the fan. As part of the ventilation system, floor and ceiling grilles were integrated into the design of the wraparound walls. Four different designs, all of them abstract patterns, were used in the cabs. They used a variety of inlaid wood veneers, including Japanese ash, English gray hardwood, Oriental walnut, dye ebonized wood,

satinwood, Cuban plum pudding mahogany, myrtle burl, and curly maple. Ceiling fans in the elevator cabs were of metal also executed in striking abstract designs.

The elevators were not only beautiful, they were practical, having been designed to move the huge numbers of office workers that the building would house quickly and efficiently. At Walter Chrysler's insistence, they were capable of speeds of 1,000 feet per minute, even though the New York City building codes in effect at the time only allowed them to operate at 700 feet per minute. The building also had three of the longest continuous elevator shafts in the world.

There were a number of significant internal systems that had to be installed to provide heat, ventilation, power, communications and other services to the tenants of the building. All of this infrastructure was installed by subcontractors who kept pace with the rising structure, moving up floor by floor as the enclosure of the exterior proceeded. As the general contractor, Fred T. Ley and his supervisors had to coordinate all these different trades and make sure that the work was properly completed before the finished floors and interior walls were put in place.

The building was heated with steam supplied through mains from the New York Steam Company. This enterprise had been formed in 1880 to provide steam from central generating stations to buildings in Manhattan through underground mains. This system is still in use and is now a part the of Con Edison corporation. Its mains are what produce the wisps of steam that rise from gratings in the streets of Manhattan during the winter. The Chrysler Building was supplied by the huge, newly completed Kips Bay Station which occupied an entire block along the East River between 35th and 36th Streets.[39] This eliminated the need for a boiler plant in the building itself, although space was allocated for one if the need should arise in the future. The steam entered the building at 130 pounds per square inch (psi) pressure and was reduced to five psi for distribution at the 3rd, 30th and 60th floors. The basement and sub-basement were equipped with a wet sprinkler system for fire suppression, and provisions were made to extend this to the 4th floor at a later date, if required. Natural gas was also piped to all floors.[40]

The building had a sophisticated air treatment and handling system that included both water spray and conventional filtration, pre-heating, and chilling with constant intake of fresh air and exhaust of stale air. This was the first installation of this type of system in a New York City office building.[41]

The building included a special incinerator called the "Destructor" to

dispose of waste from the building and significantly reduce the amount of waste that would need to be trucked away. This machine was 19 feet long, eight feet wide and nine feet high. It could incinerate as much as 1120 pounds of waste per hour.[42]

Electric wires and telephone cables were routed through underfloor ducts made of Orangeburg fiber pipe. This enabled great flexibility in the design of offices, as well as allowing for upgrades to this element of infrastructure as technology advanced.[43] Orangeburg Pipe (also known as "fiber conduit") is bituminized fiber pipe made from layers of wood pulp and pitch pressed together. It was used from the 1860s through the 1970s, when it was replaced by polyvinyl chloride (PVC) pipe for water delivery and acrylonitrile butadiene styrene (ABS) pipe for drain, waste, and vent piping. The name comes from Orangeburg, New York, the town in which most Orangeburg Pipe was manufactured. It was produced primarily by the Fiber Conduit Company, which changed its name to the Orangeburg Manufacturing Company in 1948. The electrical service to the building was designed to serve a routine demand of 2.5 megawatts. The feeds to the building included five 13,800 volt lines and three 3,000 volt lines.[44]

To avoid the lost time that would result if the workmen had to descend and leave the site for meals in the middle of the work day, lunchrooms were set up at several levels within the building, an arrangement reminiscent of the commissaries that Fred T. Ley had established during the building of Camp Devens. A medical facility was located on the ground floor and staffed by a doctor and a nurse to deal with any injuries that might occur.[45]

Perhaps most importantly, meetings were held weekly between Fred T. Ley and his construction supervisors; the structural, mechanical, and electrical engineers; and the sub-contractors, to discuss the work of the coming week and to eliminate any confusion or lack of coordination. He also met frequently with William Van Alen to make sure that Van Alen's designs were being properly executed.[46]

The final appearance of the Chrysler Building depended on a material that was invented in Germany only 16 years earlier. On October 17, 1912, engineers Benno Strauss and Eduard Maurer, who worked in the laboratories of Friedrich Krupp Grusonwerk AG in Essen, Germany, had patented the first practical austenitic stainless steel alloy. They called it Nirosta, because it never rusted. It was a chrome-nickel steel alloy, similar to today's 304 stainless steel, which has 18 percent chromium and 8 percent nickel in the alloy. It had similar strength to structural steel, but was outrageously expensive.

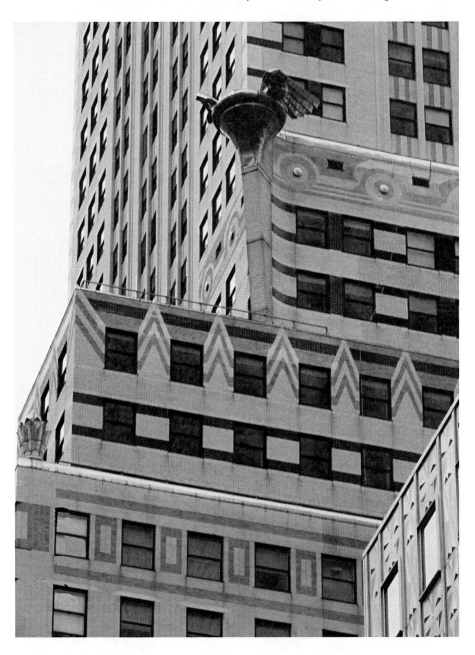

Chrysler Building architectural details, including the Nirosta "radiator cap" ornaments and decorative brickwork (photograph by the author).

Although the Krupp company held the patent, it did not have a manufacturing presence in North America, so it licensed steel companies in the United States to produce the alloy. Sheets of Nirosta steel were used to cover the dome and the spire of the Chrysler Building from the 61st floor upwards. Nearly 48 tons of the metal were used. Walter Chrysler personally selected the material, not only for its high polish, but most importantly for its low maintenance. Being highly corrosion resistant, it did not have to be painted, but only needed to be washed occasionally, and for the most part rain took care of that task. In addition to the spire, Nirosta steel was used to create the exterior architectural ornaments, including the acorns, gargoyles, and plaques based on the caps used on the radiators of Chrysler cars, which Van Alen used to adorned the building. Choosing it as a unifying element, he also used the metal in the store fronts and windows; the lobby lighting and trim; and, the basement treatment.[47] The amount of Nirosta steel needed was so great that it had to be produced by three separate companies. Crucible Steel Co. of America and Republic Steel Corporation produced sheets of the metal while the Ludlum Steel Company produced rolled bars and accessories.

The finishing of the interior of the building proceeded as the tower rose. Even as he modified the design of the structure to achieve more height, William Van Alen turned his attention to these details. The most spectacular expression of his creativity inside the building was the public space on the ground floor. Walter Chrysler told him to spare no expense, and Van Alen used a variety of rich and exotic materials and techniques to create one of the greatest Art Deco spaces in the world.

There are three street level entrances to the building. The main entrance is on Lexington Avenue and there are one each on 42nd Street and 43rd Street. The three entrance lobbies lead into a triangular main concourse with two massive octagonal piers, and the four elevator halls open off of the concourse to the east.[48]

The walls of the entrance lobbies, the concourse, and the elevator halls were faced with "Rouge Flame" Moroccan marble, which has variegated markings in tones of buff to soften the red color of the ground. The floor was covered with yellow Sienna travertine, imported from Italy and set in diagonal patterns designed to subtly guide visitors around the building. The shop windows which opened onto the entrance lobbies and main concourse, as well as the directory boards, were framed in Nirosta steel. These were topped with crenellations in Art Deco designs, also made of Nirosta steel. Carrying on the theme, the entrance and service doors were made of the same material.

Chrysler Building lobby (photograph by the author).

An information booth made of the same red marble with a Nirosta steel back was placed between the service doors opposite the Lexington Avenue entrance.[49]

The lighting on the ground floor is particularly striking. Van Alen concealed incandescent lamps behind curved reflectors made from Nirosta Steel and positioned so as to shine on various materials that altered their tone to achieve an effect of glowing stone. Over the three street entrances and the entries to the elevator halls, the light shone on polished Mexican onyx panels that were arranged in a stepped pattern, giving the light an amber glow. Similar fixtures were placed on the octagonal piers. The names of the streets outside were spelled out in Nirosta letters in front of the lights over each entrance. Van Alen's use of indirect lighting expands on an interest first expressed in a patent for an indirect street lighting system which he filed in 1923.[50]

Van Alen commissioned the artist Edward Trumbull to paint a large mural on the ceiling spanning the main concourse and the Lexington Avenue entrance lobby. This was a very Art Deco touch that helped achieve a unity of design throughout the space.

Edward Trumbull (1884–1968) was one of the foremost American mural-

ists of his generation. He had studied with Robert Reid at the Art Students' League in New York and with Frank Brangwyn in London. In 1932, after he had completed his mural in the Chrysler Building, Trumbull supervised the creation of more than 40 murals and 50 sculptural pieces for the new Rockefeller Center.

The 97 by 110 foot ceiling mural that Trumbull painted in the Chrysler Building is titled *Energy, Result, Workmanship, and Transportation*.[51] A muscular figure of Atlas dominates a triangular panel above the information booth. From this figure, three bands extend following the triangular form of the main concourse. One consists of a series of abstract patterns symbolizing primitive, natural forces. Another depicts construction workers and techniques, in tribute to the men who built the Chrysler Building. The last showcases the development of modern transportation, emphasizing airplanes rather than automobiles. On the ceiling of the Lexington Avenue entrance lobby is a panel which shows the building as seen from the outside. The warm tones of the mural are harmonious with the rich colors of the stone used in the walls and floor of the space.

At the north and south ends of the main concourse, curved staircases lead to a mezzanine at the second floor level and to the basement, with its connection to Grand Central Station. Highly polished black marble is used on the on the curved walls of these staircases with dramatic effect, and is carried over to the walls of the basement corridors. The railings, of course, are made of Nirosta steel and they terminate in massive red marble newel posts. Art Deco inspired zigzag motifs decorate the inner railing. The steps are made of gray and black terrazzo. Molded glass light fixtures hang above the staircases from ceilings that are finished with aluminum leaf.[52]

While the ground floor was the grandest space in the Chrysler Building, Van Alen designed the office floors with equal attention to detail. The partition walls inside the building were made of steel, to reduce the risk of fire. They were given a natural walnut grained surface produced by a patented process using photography to reproduce the look of actual walnut panels. The panels were modular and could be rearranged quickly and conveniently to accommodate the needs of individual tenants. They were manufactured by the E.F. Hauserman Company of New York City. The interior doors were also fireproof, using a hollow steel construction to reduce weight. The doors were made by the Metal Door and Trim Company of La Porte, Indiana, and the J.C. McFarland Company of New York City.[53]

Van Alen chose marble from quarries in the state of Georgia for the

restroom partitions. The men's rooms used "Creole Marble," a boldly patterned grey and white stone, while the ladies rooms used the patterned pink "Etowah Marble."

In early July, when the 24th floor was reached, use of the three lighter derricks was discontinued and a 20 ton stiff leg derrick was added to transfer steel from street level to a holding stage cantilevered off of the 26th floor setback. Other derricks, that were positioned in the center of the structure and rose with the steel frame, were used to set the beams and columns. Columns from the fabrication yard were delivered in two-story lengths with the fittings needed to connect them to the structure attached. After these were set atop the existing columns, the floor beams, which were mostly rolled steel sections, were attached to them, starting from the outside and working inwards.[54]

Between May 25 and July 26, steel was erected from the 12th floor to the 45th, a rate that was slightly faster than one floor every two days, a remarkable rate at the time. Then, between July 26 and August 30, steel was erected to the 61st floor, at a similar rate. Fred T. Ley knew that faster rates of steel erection translated into lower labor costs and fewer delays in the construction phases that followed.[55]

In early August, when the 50th floor was erected, another derrick was installed there with another transfer platform cantilevered off of the setback at that level. This was used to raise steel from the 26th floor staging platform.[56]

As the steel went up, so did the walls. The bricklayers kept pace with the steel erectors, and the last brick was laid on October 15, just one week before the spire was raised and the building topped out.[57]

Because stainless steel was a new material, proper welding techniques for it did not yet exist. Due to its high non-ferrous metal content, stainless steel cannot be welded using conventional methods, such as oxy-acetylene torches. The welding must be done under an inert gas shield. Therefore the dome and the ornaments on the Chrysler Building were riveted together rather than welded and the seams were sealed with solder where necessary for waterproofing.

The scaffolding used around the spire was different from that used lower in the building. It was known as "Gold Medal Tubelox Scaffolding," and consisted of pipe sections held together by patented, bolt-together, collars that were tightened with ratchet wrenches. It was supplied and erected by the Chesebro-Whitman Company. This scaffolding began at the 61st floor and extended from there to an elevation of approximately six feet above the extreme tip of the finial.[58]

The final spire surmounting the building is 185 feet high and eight feet square at the base. It weighs 27 tons. The spire was fabricated and delivered to the building in five units. It was assembled in a vertical position inside the building and lifted intact from below to its final position. This was done in the space above the 49th floor in which the water tank that would provide fire protection to the upper floors would eventually be installed.[59]

Support was provided for the finial at the 65th floor. An outrigger platform was created around the top of the tower. This provided a working platform and support for a guy derrick, that is, a lifting device consisting of a mast fitted with a boom and supported by guy wires. This platform had to be unusually wide to allow for the necessary leverage. The derrick mast was placed close to the edge of the opening in the roof and the boom was pulled tight up to the mast. Cables from the boom were attached to the finial spire at its center of gravity and it was lifted into position. The tip of the spire was fitted with a crystal point.[60]

On Thursday, October 23, 1929, the spire was raised through the top of the dome and fixed in place.[61] The Chrysler Building had topped out at 77 floors and 1,046 feet and 4¾ inches tall, but the height was not immediately revealed. Walter Chrysler was waiting for the Manhattan Building to top out before making the announcement.[62]

The 60-foot-tall cap that completed the steelwork for the Manhattan Building was finally set on November 12. Severance believed that at 925 feet, he had won the race and had the tallest building in the world. It was not until four days later, on November 16, that the Dow Services' *Daily Building Report* published the true height of the Chrysler Building and awarded it the title of world's tallest building.[63]

When the American flag symbolizing topping out was raised, it was significant for two very important facts. A record in steel construction in both speed and height had been made and not a single workman had been seriously injured in an accident related to the steel erection. Fred T. Ley was extremely proud for "having contributed this poem to the steel and building industry."[64] The next day, Black Friday, October 24, 1929, the stock market crashed.

The first tenant moved into the Chrysler Building on February 28, 1930, two months before Walter Chrysler's target date. The private Cloud Club, located in the dome, which still exists but is no longer in use, opened in July. The building also included a public observatory on the 77th floor where Walter P. Chrysler's box of handmade tools, the emblem of his enterprise and

personal success, was displayed. The observatory has been closed for many years.

In spite of the financial crisis, office rentals were so successful that on September 11, 1930, footings were poured for an annex that would provide even more office space. Fred T. Ley continued as the general contractor for this building with William Van Alen as the architect. The annex was completed on January 9, 1931.[65]

Even as Fred T. Ley was celebrating his success with the Chrysler building, his mother, Martha Hallenstein Ley, was reaching the end of her life. She lived to see his triumph, but died on December 29, 1930, and was buried in Oak Grove Cemetery in Springfield.

The Chrysler Building as completed has 77 stories. It stands on a plot of 37,555 square feet and has a volume of 14.3 million cubic feet and a total floor area of around one million square feet. It has 32 elevators that can travel at speeds up to 1000 feet per minute.[66]

Construction involved 21,000 tons of structural steel, 391,881 rivets, 3,826,00 bricks, 446,000 pieces of tile, 794,000 pieces of partition block, 3750 plate glass windows, 200 sets of stairs, two-fifths of a mile of aluminum railings, 35 miles of pipe, 15 miles of brass strip for joining terrazzo floors, and 750 miles of electrical wire, all of which had to be delivered to the site as needed and assembled or installed by Fred T. Ley's subcontractors. Two thousand, four hundred men worked on the construction.

When completed, the Chrysler Building was praised by Kenneth Murchison as representing "our modern life, its changing conditions and forces with more accuracy and clearness than almost anything else in the way of an office building that has lately burst upon the startled vision of the classicists and the columnists."[67]

In a promotional book produced by the Massachusetts Mutual Insurance Company in 1978, half a century after groundbreaking for the building, it was said:

The Chrysler Building is dedicated to World Commerce and industry. It was created with a desire to meet the demand of business executives of today who, with their intense activities, must have the most favorable office surroundings and conditions.

The need for abundant light and air resulted in a building of fine proportions and great height. The importance of accessibility and transit facilities dictated the location. The desire for the utmost in conveniences determined the inclusion of unusual facilities of every necessity contributing to the contentment and satisfaction of the business man in his office home.

As an environment in which work may be accomplished efficiently and in comfort, it is believed the finished structure establishes a new ideal—one which will stand as a measure of comparison for office buildings of the future.

The Chrysler Building is therefore dedicated as a sound contribution to business progress.[68]

13

After the Chrysler Building

After the two and a half years of intense collaboration which produced the Chrysler Building, William Van Alen and Fred T. Ley never worked together again. There was no animosity, but each man went his separate way, continuing to pursue his own new ideas and enterprises.

The design of the Chrysler Building brought William Van Alen both fame and criticism. When construction was almost complete in late 1929, the magazine *The Architect* praised the design and awarded him the honorary title of "Doctor of Altitude." The next year Kenneth Murchison described him as "the Ziegfield of his profession."[1] However, George S. Chappell, the architectural critic of *The New Yorker*, who wrote under the pseudonym T-Square, had some harsh words to offer. "It is distinctly a stunt design, evolved to make the man in the street look up. To our mind, however, it has no significance as serious design; and even if it is merely advertising architecture, we regret that Mr. Van Alen did not arrange a more subtle and gracious combination for his Pelion-on-Ossa parabolic curves."[2]

Chappell's allusion is to the Greek myth of the giants who piled Mt. Pelion on top of Mt. Ossa in Thessaly in a fruitless attempt to storm heaven. Chappell is referring to the stacked arches that make up the base of the spire at the top of the building.

Lewis Mumford, the renowned writer, essayist, and architectural critic, who favored the more austere International Style, criticized the Chrysler Building for its "inane romanticism, meaningless voluptuousness, and void symbolism,"[3] but it was these qualities which captured the popular imagination and helped make it one of the most famous buildings in New York.

On the plus side, *Architectural Forum* editorialized: "It stands by itself, something apart and alone. It is simply the realization, the fulfillment in metal and masonry, of a one-man dream, a dream of such ambition and such

magnitude as to defy the comprehension and the criticism of ordinary men or by ordinary standards."[4]

Unfortunately, Van Alen's brilliant design skills were not matched by an equally brilliant business sense. When he accepted the commission as Walter Chrysler's architect, Van Alen had not insisted on a written contract. Instead, he accepted $34,000 as his fee for the preliminary work he had done for Senator William H. Reynolds. This gave Reynolds ownership of the resulting plans, which he sold to Walter Chrysler with no further compensation to Van Alen. This form of compensation made sense when he was drawing speculative sketches for Reynolds, who may or may not have intended to actually build something, but once Chrysler commenced construction, Van Alen's expectations changed. In return for producing new plans for Chrysler, he accepted an additional $74,000 in periodic payments during construction. When the building was complete, he asked Chrysler for the remainder of the standard 6 percent architectural commission which had been established by the American Institute of Architects. In the case of the $14,000,000 Chrysler Building, the total amounted to $865,000. Always one to drive a hard bargain, Walter Chrysler refused to pay, claiming that Van Alen had agreed to a fixed fee of $8,000 per week. He made Van Alen a counter-offer of a total of $175,000 to settle the dispute. In evaluating these numbers, it is important to remember that the architect's fee had to cover not only his personal time working on the project, but also all of his expenses, including the salaries of his draftsmen and other employees.

Not satisfied with Chrysler's offer, on June 17, 1930, Van Alen placed a mechanic's lien for $725,000 against the W.P. Chrysler Building Corporation. He also named as codefendants Cooper Union, which owned the land under the building, and the Reylex Corporation, the company headed by William H. Reynolds, for which he had prepared the preliminary plans. Van Alen's lawyer stated: "Originally Senator Reynolds, who held the leasehold, had Mr. Van Alen prepare a set of drawings for a speculative office building and agreed to pay him a fixed amount. When Mr. Chrysler took over the leasehold he retained Mr. Van Alen to redesign the building, and Mr. Van Alen designed an altogether different type of structure. There was no specific agreement for the payment of the architect. When Mr. Van Alen rendered his bill he asked for the 6 percent fee established by the American Institute of Architects. Many architects charge a fee of 10 percent."[5]

The suit dragged on for over a year in the New York Supreme Court. Finally, in late August 1931, the two parties settled for an undisclosed amount.[6]

The settlement was apparently amicable, as Van Alen continued to maintain an office in the Chrysler Building. However, the suit was not well received in the real estate community. The concept of an architect placing a lien on a building and suing his client in a dispute over fees, when no written contract existed, caused many developers to have second thoughts about employing Van Alen. As a result, his success with the Chrysler Building did not lead to more major commissions. The onset of the Great Depression, which put a damper on new building, probably contributed to this lack of work, but Van Alen's temerity was cited several times in the architectural and building press as bad policy. The dispute provided the basis for an article in *The American Architect*, by Clinton H. Blake, the noted architectural and building lawyer, titled "What to put into a contract to keep out of trouble with clients." Printed above the article were a cutting from the *New York Times* reporting Van Alen's suit, and the heading "If the architect of the Chrysler Building had applied the information contained in this article there probably would have been no suit over his fee."[7]

When the Chrysler Building was completed in 1930, Fred T. Ley was 58 years old and still actively leading his namesake company, although it was no longer exclusively a Ley family operation. In 1929, while engaged in building the Chrysler Building, Fred T. Ley & Company, Inc., which had been a closely held Massachusetts corporation, was converted into a publicly traded company, incorporated in Delaware. This gave the company access to more capital, which was essential as it continued to expand its real estate business alongside its contracting work. However, the Leys retained a controlling interest, as evidenced by Fred's continuing to hold the presidency. He and his brother Leo made up two-thirds of the three member board of directors, while the third member was their long-serving vice-president, Leonard Manning. Harold had left the company in 1921 to devote his full time to the Life Extension Institute, which he had founded, and moved to New Hampshire. On May 12, 1930, the stock was quoted at $42 with $3 annual dividend, for a yield of 7 percent, indicating that the company was quite profitable, even though the stock price was down from the $60 it had fetched in 1929.[8] This situation did not last, and at the bottom of the market, in the spring of 1932, the stock sold for $1.[9]

Although Fred had moved the company headquarters to Manhattan, where he and his wife had settled permanently, the company continued to be active in the Springfield, Massachusetts area. In 1929, it completed the Massachusetts State Office Building on Dwight Street in Springfield; a large

house for Mr. Clarence J. Schoo at Maple and Mill Streets; a $40,000 addition to the American Bosch Plant; and a $160,000 power plant for the Strathmore Paper Company at Mittineague, West Springfield. At the beginning of 1930, Leo Ley, the company treasurer, estimated that it had around $4,000,000 in uncompleted projects being worked on, including the finishing work on the Chrysler Building.[10] At the end of 1930, Fred T. Ley announced that the company had already booked $3,500,000 in projects for 1931, including a building for the Springfield Hospital, now Baystate Medical Center, and an office building with retail space on the corner of Fifth Avenue and 33rd Street in New York.[11]

After the completion of the Chrysler building, William Van Alen concentrated on his real estate business. He had acquired the northeast corner of 56th Street and Lexington Avenue along with other properties in Manhattan, starting in 1922. In September 1929, while finishing work on the Chrysler Building, he announced plans for a 26-story apartment-hotel on the Lexington Avenue site. This might have revealed how he would design when he was both client and architect, and could set his own goals and standards. Unfortunately, a month later the stock market crashed and the subsequent depression prevented him from moving forward with his plans.

Van Alen continued to be active in the professional architectural community as well. He was a leading member of the Society of Beaux-Arts Architects, and at their annual ball on January 23, 1931, was one of the two dozen architects invited to attend dressed as their most famous building. Held in the main ballroom of the Hotel Astor, the party's theme was "Fête Moderne—a Fantasie in Flame and Silver" and tickets sold for $15. The *New York Times* advertised the event as something "modernistic, futuristic, cubistic, altruistic, mystic, architistic and feministic." *New York Times* writer Christopher Gray described the event as "one of the great parties of the last century," in his 2006 article about the affair. According to Gray, the party was meant to "recognize the dawning of a new age of architecture and, coincidentally, the new age of financial gloom" as the Great Depression drew closer.[12]

In the spring of 1931, Van Alen joined a group of architects in an alumni visit to the École des Beaux-Arts in Paris. They chartered the ship *American Farmer* for the trip. The *American Farmer* was a small, 50-passenger ship of the American Merchant Line that also carried cargo. It carried the architects from New York to London, from which they presumably took the boat train to Paris.[13]

On the return trip in June, the architects got into a heated discussion

about the direction and force of the Gulf Stream. Van Alen demonstrated that he was man more of action than words, by scrawling a note on that day's lunch menu, stuffing it into an empty wine bottle and throwing it overboard. The note offered a reward of $5 to anyone who found it and returned it to Van Alen at the Chrysler Building. On January 22, 1932, the note arrived in the mail at Van Alen's office with a letter stating that it had been discovered on January 10 by Mr. Colin Campbell at the south end of the island of Tiree in Argyleshire, Scotland. The note had travelled about 2,000 miles in six months or less. Van Alen dutifully sent Mr. Campbell a check for the reward. It was most likely Van Alen himself, never adverse to publicity, who notified the *New York Times* of this event.[14]

Although Van Alen designed no more large buildings, he did work on innovative single family houses. In May 1929, he obtained a copyright on plans for a "Spanish Villa," but it is not known if this was ever built.[15] Then, in 1933, the R.H. Macy department store company sponsored an exhibition of modern housing designs created by architects who were famous for their skyscrapers. The entrants submitted scale models of their houses, which were displayed in Macy's flagship store on 34th Street in Manhattan. The list of distinguished architects invited to submit designs included Leonard Schuyler, the designer of the Waldorf-Astoria hotel; Harvey Wiley Corbett, the architect of the Roerich building; Raymond Hood, the designer of the Daily News building; Lawrence White, the architect of the Savoy-Plaza; and William Van Alen. Van Alen's entry was a boxy, two-story house entirely covered with copper sheathing. One commentator suggested that this was a reference to his use of stainless steel cladding on the Chrysler Building, but it also fore-shadowed his foray into modular steel housing.[16]

Perhaps Van Alen's second best known, if temporary, work in New York was the House of the Modern Age, a prefabricated steel structure that stood as an exhibition piece at the corner of Park Avenue and 39th Street for six months in 1936. What is not commonly known is that this house was one of the first of what was projected to be a nation-wide rollout of prefabricated housing.

The concept of pre-fabricated steel buildings was not new. In 1928, L.W. Ray, the construction superintendent for the White Castle hamburger chain had developed a moveable building made of porcelain-enameled steel panels which were secured with a locking device that dispensed with rivets or bolts. This arrangement made the building easy to construct or deconstruct on site. This design enabled White Castle to construct cheap, uniform buildings that

could easily be moved if a lease expired and a more desirable or less expensive site was available within a reasonable distance. White Castle established its own subsidiary, the Porcelain Steel Building Company in Columbus, Ohio to produce the buildings.[17] White Castle had a strong presence in New York City, and it is likely that William Van Alen actually ate in one of these steel hamburger stands. His genius was to take this commercial concept and apply it to domestic architecture.

In 1933 or 1934, Van Alen partnered with Barnett E. Moses to found the National Houses Company, Inc.[18] This company was based in New York and was formed to manufacture prefabricated houses out of steel. Moses was the general manager and Van Alen designed the houses and served as a director of the company. In 1935, Van Alen announced that he had devised an all-steel house of prefabricated hollow panels each of which was nine feet high and four feet wide, with steel casement windows. It was to be bolted together, spray painted and coated with marble dust. He would file a patent for this design in 1938.[19]

To bring attention to this innovation, National Houses, which was rumored to have financial backing from the General Electric Corporation, set up demonstration houses in department stores around the country. The National Houses Company claimed that stores in 30 different cities would take part in this promotion, however only four exhibitions have been confirmed from news reports. In Cleveland, a metal house of Van Alen's design was set up in the William Taylor and Son & Co. department store, which used it to display "a large line of house furnishings and materials." In New York City, R.H. Macy's ran a similar promotion.[20] In Newark, New Jersey, a house was built on the roof of the Kresge's department store.[21] In Pittsburgh, one was built in the auditorium of the Joseph Horn Company's store.[22]

On July 23, 1936, Van Alen and the National Houses Company erected the House of the Modern Age, a seven-room model house of steel, on a vacant lot at the northeast corner of 39th Street and Park Avenue in Manhattan. The interior was decorated in the modern style, with photo murals, glass-block detailing and mildly modernistic furniture. The interior design was done by Madame Yna Majeska (Henriette Stern) with furnishings by the Modernage Furniture Company.[23] Majeska was an Art Deco designer, decorator and book illustrator. Perhaps best known for the illustrations she created for Karen Blixen's *Fantastic Tales*, Majeska also created costumes for Cecil B. DeMille, the Ziegfeld Follies, and Irving Berlin's Music Box Review. The Modernage Furniture Company had been founded in 1925 in New York by Martin H.

Feinman, a Russian immigrant, as a retailer of modern furniture with an emphasis on Art Deco designs. It sold designs by Feinman and others. The furniture itself was generally produced by contract manufacturers.[24] Some of the Modernage designs have become collector's pieces, including the George Nelson Gate Leg Dining Table and their classic "D" upholstered chair. The company expanded to Miami, Florida in 1940 and went out of business in 2007.[25]

The House of the Modern Age was designed to sell for less than $10,000, and 1,500 people had walked through it by noon of the opening day. In January 1937, the house was purchased by Pat Padgett, a radio comedian, disassembled and shipped to his home in Gloucester, Virginia. It is not known if it still survives.

A second copy of the House of the Modern Age was built in Brooklyn. Four days after the model-house opening, a building lot at the western edge of Sea Gate, a gated community at the western end of Coney Island, was purchased by Dean C. Gilmore. A house, valued at $8,500, was completed on the land at 5100 Ocean View Avenue in 1937. In the city building records, the tax assessor wrote "steel" as the description of the type of structure and gave the owner's name as Paul Gilmore.

Although a building permit has not been found, the current owners have drawings by William Van Alen in their possession which show typical details of a steel house, and the details of their building match written descriptions and period photographs of the model house. The exterior is coated with white marble dust, which gave it the nickname "The Sugar Cube." A 1940 photograph from the Municipal Archives shows the Sea Gate house as a brilliant white cube dramatically set on the beachfront.[26]

Van Alen designed another all-steel house in 1937 to help a client deal with an unusual circumstance. The Karlopat Realty Company had purchased a lot on the corner of 107th Street and Riverside Drive on the upper west side of Manhattan, intending to erect apartment buildings on the site. Unfortunately, after acquiring the property, they discovered that there was a deed restriction requiring the first building to be erected on the lot to be a single family home. The quickest and cheapest way to get around this restriction was to buy a pre-fabricated structure from the National Houses Company. Van Alen designed the house for the Karlopat company as a medium-sized, low cost workingman's residence, which met standards established by the Federal Housing Authority. The building cost $4,000.[27] It had two bedrooms, a living room, and a dinette. Each room had one of Van Alen's signature corner windows.

When the house was completed in May 1937, National Houses and Consolidated Edison, which had installed the heating and air-conditioning in the building, obtained the use of the house for a 30 day exhibition period. This was promoted by a flyer in the gas bills sent out by the utility. After that, the house was rented out to a succession of tenants for $100 per month, before being torn down and replaced by the originally planned apartments.[28]

National Houses used a franchising model. Rather than build the houses itself, the company licensed its designs to local metal fabricators, who then set up regional National Houses companies in their cities. These hired local builders and architects to carry out the actual construction. For example, in Cleveland, Ohio, the franchisee was the Sanymetal Products Company. They, in turn, formed the Cleveland National Houses Company as a separate enterprise in 1936. A Pittsburgh National Houses Company was also formed.

There may be more of Van Alen's prefabricated houses out there somewhere, but if so, they have not been identified. It was reported that ten of the houses were constructed in the Cleveland, Ohio, area.[29]

Unfortunately for William Van Alen, the expected boom in pre-fabricated housing did not take place. By 1938, the National Homes Company was in trouble, as evidenced by the fact that a Mr. E.G. Breen was awarded a judgment against the company, Barnett E. Moses and William Van Alen in the amount of $3,345, the approximate cost of one of their smaller houses, presumably for failure to deliver.[30] That same year, Van Alen lost his Lexington Avenue real estate in a foreclosure action.[31] In spite of these setbacks, William Van Alen remained active in the architectural community and was, if not rich, at least financially secure.

In spite of the success of Fred T. Ley & Company in building construction, it was not able to insulate itself from the economic crisis that the United States found itself in during the 1930s. In 1936, at the height of the Great Depression, the company filed in the federal court for the Southern District of New York for reorganization under Chapter 77B of the federal bankruptcy code. At the time, Fred T. Ley was the president, based in New York City, while his brother Leo H. Ley, the treasurer, was based in Springfield. At the time of the filing, the company was listed as having storage yards in Springfield, Boston, and New York, as well as owning all of the stock of the Ley Realty Co., which owned the Ley Building and had interests in other properties in Manhattan.

The Chapter 77B filing was not a liquidation, but a reorganization that allowed the company to restructure its debt, on which it had defaulted by

failing to pay principal and interest on its bonds when they came due. The company had assets of $976,261, which balanced with its liabilities, but most of the assets were accounts receivable, mortgages, and outstanding loans, which the company was having difficulty collecting, and the rest was in real estate equity, which was not liquid.

President Fred T. Ley issued the following statement:

> We were induced to take this action principally because of the past due maturity of the secured serial 6 percent gold notes and the indebtedness due to the 75 Central Park West corporation. The foregoing indebtedness impedes our efforts to obtain desirable and profitable construction contracts. Our present financial position also makes it difficult to obtain the essential completion bonds.
>
> We, accordingly, discussed these problems with Carl H. Borets and Fred H. Mason, who were constituted agents for the noteholders under the collateral liquidation plan and agreement put into effect in November 1933. As a result of further discussion with other creditors and some of the holders of substantial amounts of notes, Messrs Borets and Mason evolved and submitted a plan of reorganization.

The bond holders were given new notes for 45.5 percent of the face value of the old bonds, plus common stock and warrants to buy further common stock at the current price, if the stock price should rise in the future. Fred T. Ley further noted: "Under this plan, all net earnings, with the exception of that portion necessary for the rehabilitation of the working capital, will go to creditors until they are paid in full."[32]

Although the South American offices were reported to be busy with work in 1929, they also could not avoid the consequences of the developing depression. The last major project the company undertook there was a building for the British Legation in Lima, Peru, in 1931, although they maintained an office in Bogota headed by Thomas Wyllie through at least 1936.[33] In response to the general business downturn, Fred T. Ley & Company closed down its South American subsidiaries in Peru, Colombia, and Chile in the late 1930s.

In April 1937, having restructured their debt and restored their credit, Fred T. Ley & Company secured a $70,000 contract for an addition to the printing plant of the Herald News in Fall River, Massachusetts.[34] Work continued in New York City as well, with the company winning a $600,000 contract for the new Westchester Avenue bridge over the Bronx River and a renovation of a building on Chambers Street in Manhattan worth $80,000. A unique project that the company took on was the construction of a little Art Moderne–style newsreel theater inside the vast Grand Central Terminal in 1937. It was located near Track 17 and seated 242 people. The designer was

Tony Sarg, the same person who created the first balloons for the Macy's Thanksgiving Day Parade.[35] It was reported that the volume of construction that the company was involved in was the highest it had seen since 1931. But there were no more $14,000,000 skyscrapers.[36]

In 1937, the company's Springfield office still occupied the entire third floor of the building on the northeast corner of Main and State Streets, where the Mass Mutual Civic Center now stands.[37] That year, Fred T. Ley, although living in New York City, served on a committee of Springfield businessmen that studied and recommended the establishment of a central purchasing department for that city. This indicates that Fred was still actively involved with the Springfield community, although he had sold Bonnie Brae, his home there, some years earlier, after moving to New York City.[38]

By 1938, the construction business was picking up again. In Springfield, the company won a $20,000 contract to put up a building for the Van Norman Machine Tool company on Wilbraham Road. It was also building four pumping stations for the City of Springfield, as a part of its interceptor sewer system. To aid in that work it purchased one of the largest capacity truck cranes available.[39]

Mid-way through 1938, Fred T. Ley was selected by Grover Whalen, the president of the New York World's Fair Corporation, to be a member of the advisory board of the 1939 World's Fair. He served on a committee of real estate, engineering and architectural experts.[40] His company also was awarded the contract to build the exhibit building for the Beech-Nut Packing Company at the World's Fair. At that time, the Beech-Nut company was primarily known for its eponymous chewing gum, but it had also recently started selling strained baby food and it used the World's Fair to promote both product lines. That construction contract was worth $166,000.[41] The Beech-Nut Building was designed by the architect Magill Smith and was situated on Rainbow Avenue in the fairgrounds in Flushing Meadows, Queens.

At the end of 1939, Leonard Manning, who had been vice-president in charge of the Fred T. Ley real estate business and worked in the New York office, resigned from the company, apparently for reasons of health. He was key player in the company, having been a vice-president since 1924, and at the time of his resignation, one of the three directors of the company, the others being Fred T. and Leo Ley.[42]

In 1940, the company erected a new manufacturing building, Building 104, at the Springfield Armory. This building had the distinction of being the first factory in the United States to use fluorescent strip lighting. The lighting

ORDNANCE DEPT. S. A
Contract: # W-6905-qm 53
Contractor: Fred T. Ley,Inc.
Factory Type Bldg.-South end
looking east.
Nov.15,1940 - Neg. #2570-9A

Springfield Armory Building 104 under construction. Springfield Armory National Historic Site, 2579-SA.1.

was installed by Collins Electric of Springfield, under sub-contract from Fred T. Ley.[43] Today, this building is a part of the Springfield Technical Community College Technology Park.

A number of honors were bestowed on William Van Alen in his later years. Among them, he was elected as a member of the National Academy of Design in 1943. In 1945, his portrait was painted by Henry R. Rittenberg. This portrait is reported to be in the possession of the National Academy of Design, but inquiries to the Academy have received no response.

William Van Alen died on May 24, 1954, at the age of 71, leaving only his widow and his sister, Eleda Van Alen. No children or even nieces or nephews are known to survive. He left most of his estate in trust for his wife, and upon her death in 1970, she bequeathed a portion of it to the National Institute of Architectural Education, as the Society of Beaux-Arts Architects had been renamed in 1956. The Institute sponsors a yearly Van Alen prize,

and in 1995 changed its name to the Van Alen Institute, to honor its bene-factor. It continues dedicate itself to critical inquiry into contemporary forms of public space from its offices at 30 West 22nd Street in New York City.[44]

But of Van Alen's office and professional records—scrapbooks, drawings, correspondence, student work—very little is known to survive. At the time of his death he was living at 27 Prospect Park West, in Brooklyn. He was still maintaining his architect's office at 139 East 57th Street.[45]

In reporting William Van Alen's death, the *New York Times* wrote that he was "an architect of advanced views, one of the leaders of his profession in the use of new principles of design and methods of construction. He early favored an approach to design through steel rather than masonry and pointed with strong disapproval at some of the early sky scrapers encrusted from top to bottom with heavy masonry forms, rows of columns, and heavy stone cor-nices."[46]

William Van Alen is buried with his wife, parents, and sister in Cold Spring Cemetery, Cold Spring, New York.[47]

In 1940, Fred T. Ley and his brother and business partner from the begin-ning of the company, Leo L. Ley, split the company into two separate entities. Leo took over what had been the Springfield and New England division of the firm and named it the Ley Construction Co, while Fred continued to run the New York based operation as Fred T. Ley & Company.[48]

Fred became a member of the Union League Club, an exclusive men's club in New York City favored by professionals. It had strong ties to the Amer-ican Red Cross, and Fred was active in raising money for that organization.[49]

In 1921, Fred's brother Harold had retired from active participation in the company to concentrate on his work with the Life Extension Institute. This was an organization that he had founded in 1913 to explore ways to increase the average lifespan of the population by promoting hygiene and a healthy lifestyle. He persuaded former United States president William Howard Taft to serve as its first chairman and enlisted a large number of prominent physicians to serve on the board. He remained active with the Institute for the rest of his life, but also continued to participate in real estate deals with his brother Fred T. He split his time between New York City and the exclusive Bald Peak Club in New Hampshire. He died in New York City on May 11, 1956, shortly before his 82nd birthday.[50] He was predeceased by Fred's other brother and business partner, Leo Ley, who died in Springfield on August 18, 1953, at the age of 74.[51]

In his later years, Fred T. Ley and his wife continued to live in their large

apartment on the top floor of the Ley building on Park Avenue, along with a succession of dachshunds. Fred developed congestive heart failure and was treated for years by the eminent cardiologist, Dr. Myron Cleveland Patterson, who was associated with the Roosevelt Island hospital in New York City. Dr. Patterson lived in Peter Cooper village in lower Manhattan and, in an unusual concession to Fred's wealth, made house calls at the Ley's residence. Fred was always formal, and dressed in a suit, generally a brown one, when the doctor was due to call.[52]

Fred T. Ley died, as a result of his heart condition, on July 13, 1958, in New York City. He was 86 years old. He was still chairman of Fred T. Ley & Company at the time, and the company still operated in most of the eastern states.[53] Fred's sons did not want to be involved in the construction business, and after his death the New York based Fred T. Ley & Company was sold and broken up.

The Springfield based Ley Construction Company, which Fred's brother Leo Ley had taken over in 1940, continued as a general contractor into the 1970s. In 1955, Robert Tait Ley, Leo's son, became president of the company and maintained the offices in Springfield until 1969, when he moved them to Enfield, Connecticut and later to West Springfield. The company was sold to Stewart & Bennet of Rochester, New York, in February 1972, but continued to operate under the Ley name. The successor company to Stewart & Bennett was itself acquired by Wellco, Inc. in 1996. That company now operates under the name Welliver and is based in Montour Falls, New York.[54]

After Fred's death, his wife, Mignon Ley, moved out of their apartment in the Ley Building and into Imperial House, a luxury apartment building which is now a co-op, at 150 East 69th Street in Manhattan. She died there on August 6, 1965.[55]

William Van Alen and Fred T. Ley were very different individuals, but both were remarkable men who started at the bottoms of their professions and rose to the very top. Their one collaboration, the design and construction of the Chrysler Building, remains a revered New York City landmark in active use to this day. Their legacy is in the buildings they created, many of which are in or will soon be entering their second century of existence. The men who designed and built them should not be forgotten.

Appendix A:
The William Van Alen Catalog

* Extant 2016
× Demolished
No symbol indicates not built or status unknown

**Possibly worked on by William van Alen
(while working for Clarence True) [1898–1902]**

1899 * Seven-house red brick group in the Flemish style at the northwest corner of 90th Street and West End Avenue.

**Possibly worked on by William van Alen
(while working for Clinton & Russell) [1902–1908]**

1903 * Beaver Building, a highly decorated triangular building at 82–92 Beaver Street.

1905 × 71st Infantry Regiment Armory at Park Avenue and 34th Street, which was razed in 1976.

1904 * Langham Apartments, one of the towering apartment buildings lining Central Park West between West 73rd and West 74th Streets, 135 Central Park West.

1905 * U.S. Express Company Building at 2 Rector Street.

1905 × Hotel Astor, Times Square, Phase 1.

1906 * Apthorp Apartments at 390 West End Avenue, which was briefly the largest apartment building in the world.

1906 * Wall Street Exchange Building at 43–49 Exchange Place.

1906 × Consolidated Stock Exchange Building, 61–69 Broad Street, since razed.

By William van Alen (while working for Clinton & Russell)

1904 * Whitney Central National Bank Building, 228 St. Charles Ave, New Orleans.

Appendix A

By William Van Alen while at the Atelier Donn Barber

1908 Paris Prize–A Theater.

By William Van Alen at the École des Beaux-Arts 1908–1911

A Monument in the Midst of the Sea.
A Mineral Bath House.
A Hotel.
A City Hall.

By William van Alen with Werner & Windolph

1912 New York County Courthouse—not built—copyright #33627; I-1125.
1912 Floor plan for a proposed apartment hotel on a lot 33 feet by 100 feet—copyright #33393; I-1140.
1912 An apartment house on a corner lot, four stories—copyright #24777; I-1062.
1912 Typical floor plans of apartment houses—copyright #24778; I-1080.
1913 Albany County Courthouse—not built.
1913 Typical floor plan of a four-story apartment house—copyright #23585; I-1576.
1913 Apartment House on an irregular lot—copyright #15800; I-1437.
1913 Apartment House—copyright #8279; I-1228.
1913 Residence—copyright #8280; I-1229.
1913 Interior and open air baths for city of Saratoga NY—copyright #16206; I-1496.
1913 Garden Apartment Building.

By William Van Alen

1914 * 1337 President Avenue, Brooklyn, New York. Now Cornell University Extension Office.

By H. Craig Severance and William van Alen

1914 × Standard Arcade at 50 Broadway. [Replaced by 50 Broadway, a 37-story tower, designed by H. Craig Severance, 1926, completed in 1927.]
1915 * Toy Center North Building at 1107 Broadway.
1916 × West 129th St, se corner of Broadway, 1916. [Perhaps not built. Currently 556 W 126th St., six-story apartment block erected around 1924.]
1918 * House for C.A. Donahue, Huntington, L.I.
1920 × 35 Water Street. [Currently 4 New York plaza, Chase Operations Center building, 1968.]
1920 * Childs Restaurant, 377 Fifth Avenue.
1921 × Penthouse for Reynolds at Lexington Avenue and 42nd Street.
1920–1924 * Bainbridge Building, now called the Vogar Building, 37 West 57th Street.

1922 Hotel in Long Beach, Long Island, NY. This may not have been built.
1923 * Bar Building at 36 West 44th Street.
1923 * J.M. Gidding & Company Building at 724 Fifth Avenue.
1923 U.S. Patent 1656045, Street-lighting System.
1924 × Charles Building at 331 Madison Avenue (Designed in 1911 by Berg, renovated and expanded by Severance & Van Alen in 1924).

By William Van Alen

1924 * Childs restaurant at 604 Fifth Avenue.
1926 * Garfield Grant Hotel, Long Branch, New Jersey.
1927 * Sports Plaza Building at 421 Seventh Avenue (Seventh Avenue and 33rd Street).
1927 Childs Restaurant in 421 Seventh Avenue (Sports Plaza)
1927 × Lucky Strike storefront in the American Tobacco at the NW corner of 45th Street and Broadway (1927). [Currently the New York Marriott Marquis, 1535 Broadway.]
1927 × Delman shoe store at 558 Madison Avenue. [Currently the Sony Tower, 550 Madison Ave, 1984.]
1927 * Childs Restaurant in Washington, D.C., at 2 Massachusetts Avenue NW, currently used as a SunTrust Bank branch.
1924–1927 × Childs Restaurant 2101 Broadway at 73rd St in the Ansonia Hotel.
1924–1927 × Childs Restaurant 2689 Broadway at 102nd in an apartment building.
1924–1927 × Childs Restaurant in 724 Fifth Avenue, the Gidding Building.
1924–1927 × American Tobacco Building 46th & Broadway. [Currently the Marriot Marquis.]
1927 Beaux-Arts Institute of Design Competition—3rd place.
1927 Reynolds Building Design—not built.
1928–1930 * Chrysler Building at 405 Lexington Avenue (1928–1930).
1929 U.S. Patent 1794809, Window Sill.
1936 * House of the Modern Age, currently called The Sugar Cube, Sea Gate, Brooklyn.
1937 × 107th & Riverside Drive House, possible houses in Cleveland, Pittsburgh & Miami.
1938 U.S. Patent 2260353 Prefabricated House Construction.

Appendix B:
Projects by Fred T. Ley & Co.

Sanitary Sewer, Plymouth, Massachusetts—1893

Street Railways
Springfield Street Railroad—1889
Hartford, Manchester and Rockville Tramway—1894
Palmer and Monson Street Railway—1897
Springfield Suburban Street Railroad—1900
Cheshire, Connecticut Street Railway—1904
Berkshire Electric Railroad—1902
Waltham Railroad—1908
Shelburne Falls & Colrain Street Railway bridge (Bridge of Flowers)—1908
Southbridge to Palmer connector—1911
Portland, Gray & Lewiston electric railway including 24 concrete bridges—1912
Pittsfield Street Railway—1913

In and around Springfield, Massachusetts
Ludlow Reservoir Filters—1906
Little River Water System 1908–1910
Kimball Hotel, 1909–1911
Henry J. Perkins Company—1912
A.C. Hunt & Company—1912
Faith United Church—1912
Fisk Tire Plant, Chicopee—1912
Forbes and Wallace Department Store addition—1912
Gilbert & Barker Manufacturing Co.—1912
Fred T. Ley Building, NE corner of Dwight and Worthington—1913
Potter Knitting Company—1913
YMCA—1913
Stevens—Duryea Showroom, 141 Chestnut Street—1913

Springfield Hospital, Frederick Wilcox Chapin Memorial Building—1914
Main and Liberty Building—1914
Third National Bank and Trust Co.—1915
First Church of Christ, Scientist, later the Masonic Building, 559 State Street—1915
Eastern States Exposition Coliseum—1916
Capitol Theater, Main and Pynchon Streets—1919
Liberty Methodist Church, 821 Liberty Street—1921
Third National Bank and Trust Co. Expansion—1922
Victor Factory—1922
WICO Plant—1922
St. Andrew's Episcopal Church, 335 Longmeadow Street, Longmeadow, MA—1924
Springfield Hospital, Main Building and North Wing, 159 Chestnut Street—1930

Around New England

Nashua NH—Hudson MA bridge over the Merrimac River—1911
Shelburne Falls Power Company Dam, canal, power house, transmission lines to
 Vernon, VT—1912
Dam, powerhouse, and canal for the Connecticut Company, Waterbury, CT—1912
Engine roundhouse, Cedar Hill, CT for NYNY&H—1912
Camp Devens—1917

Eastern Massachusetts

Boston Arena—1909
Fore River Ship Building Company office building, Quincy, Massachusetts—1910
Wyman Building, Beacon Hill, Boston—1912–1913
The New England Building, Boston

New York City

National Casket Company in Long Island City, Ballinger & Perrot—1914
Monmouth Garage Co., 226–228 E 54th St.—1915
820 Fifth Avenue, Luxury Apartment Building, Starrett & Van Vleck—1915
Peerless Garage, 642–650 W 57th St.—1917
The Prasada, 50 Central Park West, renovations—1919
Ley Building, Park & Vanderbilt between 48th and 49th Streets, Warren & Wet-
 more—1920
Commercial building, 234–242 West 39th Street—1921
Apartments 139–145 West 55th Street– 1921
Fisk Building, 250 West 57th Street, 1921, Carèrre & Hastings—1921
International Business Machines Building, 509 Madison Ave, Donn Barber—1922
Berkley Arcade, 19 West 44th St, Starrett & Van Vleck—1922
Liggett Building, 35 east 42nd St at Madison, Carèrre & Hastings—1922

Appendix B

Westinghouse Building, 150 Broadway, 1924, Starrett & Van Vleck—1924
Chrysler Building, William Van Alen—1930

Elsewhere in the United States

New York Central passenger station, White Plains, New York Warren & Wetmore—1914
Proctor Theater and Office Building, Newark, New Jersey—1914
Whitehead & Hoag Factory, Newark, New Jersey—1914
Villa Vizcaya, Miami, Florida—1916-1924
Passaic Cotton Mills, Passaic, New Jersey—1920
Hotel, Albany, New York—1920
National Bank of Phillipsburg, Phillipsburg, New Jersey—1922
First Federal Savings and Loan, Waynesburg, Pennsylvania—1922
First Presbyterian Church, New Brunswick, New Jersey—1922
First National Bank of Ridgewood New Jersey—1922

Lima, Peru

Six-story office building—1919
Presidential Palace repairs—1921
Gran Hotel Bolívar—1924
14 buildings for the Hospital Loayza
Banco International de Peru
Royal Bank of Canada
Banco Italiano
Compañía de Seguros Italia, bank building
Wiese Building for Emilio F. Wagner & Co.
Olcese building
Milne & Company Building
Bartin Brothers soda water plant
Alexander Eccles cotton factory.
Dormitory for the government naval school
Villa Maria school for the American Sisters of Philadelphia in Miraflores, a suburb of Lima.
Breakwater and wharf development at La Peria
Jesus Maria Urbanization infrastructure

Chile

La Nación Building—1928

Colombia

National City Bank of New York

Appendix C: Chronology of the Chrysler Building

1928

October 15, Walter Chrysler buys the lease and existing building from Reynolds (B)

October 16, Fred T. Ley begins demolition of the existing building. Albert Volk is the demolition subcontractor. (B)

November 5, Van Alen meets with Walter Chrysler and gets the commission (B)

November 6, Van Alen begins sketches for the Chrysler Building (B)

November 9, the site is cleared. Ley signs erected (S)

November 11, (? A Sunday) Excavation begins with Godwin Construction as the excavation and shoring subcontractor (B)

November 17, excavation is underway (S)

1929

January 21, excavation continues. Original earth ramp is replaced by wood as excavation nears the end. Rock is being blasted. (S)

February 12, foundation forms are in place (S)

March 7, plans for the Chrysler Building released to the press. (B)

March 13, Concrete bases for the columns have been poured (S)

April 9, the first columns are in place (S)

April 15, Chrysler and Van Alen meet. Chrysler tells him to build the world's tallest building (B)

May 17, steel erected to 8th floor (S)

June 5, Chrysler gets the plans for the spire (B)

June 25, steel erected to the 12th floor, Brick work started (S)

July 5, steel erected to 31st floor (S)

July 20, steel erected to 39th floor (S)

July 26, steel erected to 45th floor (S)
August 30, steel erected to 61st floor (S)
October 23, the vertex is raised (B) Topped out at the 77th floor (S)
October 24, the stock market crashes
November 1, Spire is installed (S)

1930

February 28, first tenant moves in (S)
July, the Cloud Club opens (S)
September 11, 1930, footings for the annex are poured

1931

January 9, the annex is completed

B—Neal Bascomb, *Higher*
S—David Stravitz, *The Chrysler Building*

Appendix D:
Vendors and Subcontractors[1]

Demolition—Albert A. Volk Company
Excavation and Shoring—Godwin Construction Company
Bricklaying—Jacob Gescheidt & Co., Building Contractors
Hanging Scaffolds—Patent Scaffold Co.
Scaffolding for the spire—Chesebro-Whitman Co.
Hoisting machinery—Pelham Operating Co.
Steel Erection—Post & McCord, formed in 1904, said to be the largest steel erection company in the New York market. Had an arrangement to buy all of its steel from American Bridge at the "best price."
Guniting (Spraying fireproofing concrete onto steel beams and columns)—Gunite Construction Company
Tile manufacture—Robertson Art Tile Co. of Trenton New Jersey. Tile was actually made in Morrisville, Pennsylvania.
Tile Setting—W.H. Jackson Co.
Lathing—William J. Scully
Steel Lath—produced by Truscon Steel Co.
Elevators—Otis Elevator Co.
Elevator fronts and cabs—The Tyler Co.
Rubber Tile Floors—Stedman Rubber Flooring Co.
Roofing—Tuttle Roofing Co.
Metal Treads for stairs—American Abrasive Materials Co.
Fireproof Doors—National Fireproof Sash & Door Co., Brooklyn
Granite curb—Justin R. Clary
Windows—Campbell Metal Window Co.
Basement windows, store and shop fronts—David Lupton's Sons Co.
Revolving Doors—Van Kannel Revolving Door Co.:
 In 1888 Theophilus Van Kannel, of Philadelphia, Pennsylvania, was granted a patent for his unique revolving door design. It was easy to pass through from either direction, could not be blown open by the wind even in a storm, and

blocked street noise from entering the lobby of a building. He formed the Van Kannel Revolving Door Company, with his main office and manufacturing facilities on East 134th Street, in New York City.

From the 1942 catalog of International Revolving Doors:

CHRYSLER BUILDING, New York. Only Revolving Doors could serve in face of terrific suction drafts at the entrance of this tallest of buildings. Building proper is served by 11 Revolving Doors. Schrafft's (tenant) uses 4. Architect, William Van Alen.

All doors, frames & trim—Metal Door & Trim Co., Inc., Laporte, Ind & J.C. McFarland Co.

Tower coverings, metal ornaments, copings and flashings—Benjamin Riesner, Inc.

Dome Trim—Henry Klein Co., Inc.

Guniting of Dome—Gunite construction co.

Steel Office Partitions—E.F. Hauserman Co. Clestra Hauserman invented the moveable steel wall business in 1913. E.F. Hauserman conceived the product and began manufacturing it in Cleveland, Ohio.

Window sills—Aluminum Company of America (Lawsuit)

Fire Pumps—Lecourtenay Co. p 49

Plumbing—John Weil Plumbing Co, p. 49

Window Shades—Arlington Window Shade CO.

Window cleaning—Equitable Window Cleaning

Soundproofing—Torfoleum Corp.: Torfolium is a proprietary sheet insulation that is fire resistant and provides both heat and sound insulation

Permanent Heat—N.Y. Steam Corp.

Lighting Fixtures—Garybar Electric Co.

Lighting Fixtures: Office and Observation Tower—Cox Nostrand & Gunnison

Hardware—Yale & Towne

Mirror Frames—Metal Utilities Co

Access Doors—Schleicher, Inc.

Nirosta for Building—Krupp Nirosta Co. licensed to Crucible Steel, Ludlum Steel, and Republic Steel

Elevator Equalizers—Evans equalizer Co.

Foundation Water Proofing—Anti-Hydro Water Proofing Co

Reflectors in Lobby—The Frink Corp.

Reflectors in observation tower—French & Co

Electric clock in Lobby—Electric Time Co

Power Transformers—United Electric Light & Power Co

Ornaments—stamped by Miller & Doing, Brooklyn

Chapter Notes

Chapter 1

1. http://www.skyscraper.org/EX/FAVORITES/fav_exhibits.htm, accessed 6/30/16.
2. Walter P. Chrysler and Boyden Sparkes, *Life of an American Workman* (New York: Dodd, Mead, 1950).
3. U.S. Passport Applications, William Van Alen, 23 December 1908, accessed through Ancestry.com, June 2014.
4. Neal Bascomb, *Higher: A Historic Race to the Sky and the Making of a City* (New York: Doubleday, 2003): 34.
5. *New York Times*, May 23, 1954.
6. Kenneth Murchison, "The Chrysler Building as I See It," *American Architect* 138 (September 1930): 24.
7. *Springfield City Directory* (Springfield, MA: The Price & Lee Co., 1888) and *Springfield Municipal Register* (Springfield, MA: City of Springfield, 1887–1890).
8. David Stravitz, *The Chrysler Building: Creating a New York Icon, Day by Day* (New York: Princeton Architectural Press, 2002): 155.
9. *New York Times*, November 7, 1928.
10. *The New Yorker*, November 3, 1928.
11. https://measuringworth.com/DJA/, accessed 6/30/16.
12. Massachusetts Session Laws, Acts of 1910, Ch. 349, Springfield Municipal Ordinances, 1910.
13. David Stravitz, *The Chrysler Building*: 154.
14. David Stravitz, *The Chrysler Building*: 26.
15. Vincent Curcio, *Chrysler: The Life and Times of an Automotive Genius* (New York: Oxford University Press, 2000).

Chapter 2

1. *Springfield Union*, July 14, 1958.
2. Harold A. Ley, *The Recollections of Harold A. Ley* (New York: privately printed, 1955): 5.
3. Harold A. Ley, *The Recollections of Harold A. Ley*: 5.
4. *Springfield Republican*, December 20, 1869.
5. *Springfield Republican*, February 3, 1900.
6. *Springfield Republican*, April 18, 1872.
7. Donald J. D'Amato, *Springfield—350 Years* (Norfolk, VA: Donning Co., 1985): 70.
8. *Orpheus Club—Fiftieth Anniversary*, 1924, Springfield Archives, IV–75.
9. *Springfield Republican*, May 22, 1875.
10. *Springfield Republican*, March 29, 1876.
11. http://mass.historicbuildingsct.com/?p=457, accessed 6/30/16.
12. *Springfield Republican*, February 5, 1879.
13. *Springfield Republican*, April 10, 1879.
14. *Articles of Faith and Covenant, and Standing Rules of the Piedmont Congregational Church,*

Notes. Chapter 2

Worcester, Massachusetts: With the Names of Officers and Members, and Historical Sketch, Organized 1872 (Worcester, MA: Goddard, 1876).

15. *Worcester Star*, April 14, 1883.
16. *Springfield Republican*, April 25, 1912.
17. Charles J. Bellamy, *Representative Men of Springfield and Vicinity* (Springfield, MA: Daily News, 1907): 167.
18. *Springfield City Directory* (Springfield, MA: The Price & Lee Co., 1886): 239.
19. *Springfield City Directory* (Springfield, MA: The Price & Lee Co., 1890): 192.
20. *Springfield Republican*, March 9, 1886.
21. Harold A. Ley, *The Recollections of Harold A. Ley*: 6.
22. Harold A. Ley, *The Recollections of Harold A. Ley*: 11.
23. *Springfield Republican*, July 13, 1886.
24. *Springfield Union*, July 14, 1958.
25. *Springfield Municipal Register* (Springfield, MA: City of Springfield, 1888): 86 and *Springfield City Directory* (Springfield, MA: The Price & Lee Co., 1889): 182.
26. National Society of Professional Engineers, www.nspe.org, accessed 6/19/16.
27. Harold A. Ley, *The Recollections of Harold A. Ley*: 13.
28. *Springfield Republican*, January 8, 1889.
29. Harold A. Ley, *The Recollections of Harold A. Ley*: 2.
30. Harold A. Ley, *The Recollections of Harold A. Ley*: 15.
31. *Springfield Republican*, April 22, 1889.
32. *Springfield Republican*, October 3, 1889.
33. Harold A. Ley, *The Recollections of Harold A. Ley*: 2.
34. Harold A. Ley, *The Recollections of Harold A. Ley*: 47.
35. Harold A. Ley, *The Recollections of Harold A. Ley*: 16.
36. *Springfield Municipal Register* (Springfield, MA: City of Springfield, 1891): 477.
37. *Springfield Union*, July 14, 1958.
38. *Springfield Municipal Register* (Springfield, MA: City of Springfield, 1893): 479.
39. Springfield History Museum Archives, photograph IV 48–2.
40. Harold A. Ley, *The Recollections of Harold A. Ley*: 17.
41. Harold A. Ley, *The Recollections of Harold A. Ley*: 16–17.
42. *Springfield Republican*, March 13, 1894.
43. *Springfield Republican*, April 18, 1894.
44. Henry Russell-Hitchcock, Jr., *Catalog of an Exhibition of Photographs Illustrating Springfield Architecture, 1800–1900 at the Springfield Museum of Fine Arts* (Springfield, MA: Springfield Museum of Fine Arts, 1934): 13.
45. *Springfield Republican*, May 13, 1896.
46. *Springfield Republican*, February 18, 1898.
47. Keith Hodgson, "Wild Bill Who? The Country's Best What?" *Sports Illustrated*, December 4, 1972.
48. *Springfield Republican*, October 7, 1898.
49. *Springfield Republican*, July 5, 1894.
50. *Springfield Republican*, May 19, 1900.
51. *Springfield Republican*, September 3, 1896.
52. *Springfield Republican*, November 24, 1897.
53. *Springfield Republican*, January 25, 1896 and November 18, 1897.
54. *Springfield Republican*, March 4, 1898.
55. *Springfield Republican*, February 2, 1895 and April 12, 1896.
56. *Springfield Republican*, November 1, 1896.
57. *Boston Advertiser*, July 24, 1893.
58. *Springfield Republican*, March 6, 1898.
59. *Springfield Republican*, June 17 and June 29, 1894.
60. *Springfield Republican*, October 2, 1898.
61. *Springfield Republican*, July 25, 1898.
62. *Springfield Republican*, August 26, 1898.
63. *Springfield Republican*, September 4, 1898.
64. *Springfield Republican*, October 18 and 19, 1898.
65. *Springfield Republican*, November 20, 1898.

66. *Springfield City Directory* (Springfield, MA: The Price & Lee Co., 1897): 266, 1044.
67. *Springfield City Directory* (Springfield, MA: The Price & Lee Co., 1899): 291, 1017.

Chapter 3

1. Benjamin T. Van Alen, *Genealogical History of the Van Alen Family* (Chicago: privately published, 1902): 37.
2. Benjamin T. Van Alen, *Genealogical History of the Van Alen Family*: 11.
3. Benjamin T. Van Alen, *Genealogical History of the Van Alen Family*: 37.
4. *New York Times*, May 23, 1954.
5. Robert A.M. Stern, *New York 1900: Metropolitan Architecture and Urbanism 1890–1915* (New York: Rizzoli, 1983): 360.
6. Lamia Doumato, *Richard Michell Upjohn, and the Gothic Revival in America* (Monticello, IL: Vance Bibliographies, 1984).
7. *The Real Estate Record and Builders Guide*, 1899.
8. U.S. Census, 1890.
9. www.pratt.edu/the-institute/history/, accessed 6/30/16.
10. Christopher Gray, "Streetscapes/William Van Alen; an Architect Called the 'Ziegfeld of His Profession,'" *New York Times*, March 22, 1998.
11. Christopher Gray, "Streetscapes/William Van Alen; an Architect Called the 'Ziegfeld of His Profession.'"
12. "Beaver Building Designation Report," New York Landmarks Preservation Commission, 13 February 1996.
13. Joan Dejean, *The Age of Comfort: When Paris Discovered Casual—and the Modern Home Began* (New York: Bloomsbury, 2009): 52.
14. Elizabeth Hawes, *New York, New York: How the Apartment House Transformed the Life of the City (1869–1930)* (New York: Alfred A. Knopf, 1993): 5–7.
15. Christopher Gray, "Streetscapes/The Langham, Central Park West and 73rd Street; Tall and Sophisticated, and Just North of the Dakota," *New York Times*, September 20, 1998.
16. Elizabeth Hawes, *New York, New York*: 161–164.
17. Elizabeth Hawes, *New York, New York*: 181–182.
18. Christopher Gray, "Streetscapes/William Van Alen; an Architect Called the 'Ziegfeld of His Profession.'"
19. Robert A.M. Stern, *New York 1900*.
20. Francis S. Swale, "Draftsmanship and Architecture, V, as Exemplified by the Work of William Van Alen," *Pencil Point* 10 (August 1929): 516–526.

Chapter 4

1. *Springfield Republican*, June 20, 1844.
2. *Springfield Republican*, September 1, 1844.
3. *Springfield Daily Republican*, February 18, 1858.
4. *Springfield Daily Republican*, October 10, 1860.
5. *Springfield Daily Republican*, March 17, 1863.
6. *Springfield Daily Republican*, June 25, 1863.
7. *Springfield Daily Republican*, March 20, 1863
8. *Springfield Daily Republican*, December 2, 1863.
9. *Springfield Daily Republican*, June 25, 1863
10. *Springfield Daily Republican*, June 23, 1863.
11. *Springfield Daily Republican*, February 3, 1864.
12. *Springfield Daily Republican*, June 30, 1863.
13. *Springfield Daily Republican*, February 22, 1868.
14. *Springfield Daily Republican*, June 20, 1868.
15. *Springfield Daily Republican*, April 15, 1869.
16. *Springfield Daily Republican*, September 11, 1869 and September 30, 1869.
17. *Springfield Daily Republican*, September 16, 1869.

18. *Springfield Daily Republican*, October 26, 1869.

19. *Springfield Daily Republican*, September 14, 1869.

20. *Springfield Daily Republican*, November 20, 1869.

21. *Springfield Daily Republican*, November 24, 1869.

22. *Springfield Daily Republican*, December 3, 1869.

23. *Springfield Daily Republican*, March 29, 1870.

24. http://historymuseumsb.org/early-south-bend/, accessed 6/30/16.

25. *Springfield Daily Republican*, October 5, 1888.

26. *Springfield Daily Republican*, November 5, 1889.

27. James E. Tower, *Springfield Present and Prospective* (Springfield, MA: Pond & Campbell, 1905): 177.

28. *Springfield Republican*, July 30, 1881, and "Electric Lighting at Springfield Mass," *American Architect* 10, no. 288 (July 2, 1881): 1.

29. Edward H. Marsh, *300 Hundredth Anniversary, Springfield Massachusetts, 1636–1936* (Springfield, MA: 300th Anniversary Committee, 1936): 33.

30. James E. Tower, *Springfield Present and Prospective*: 176.

31. Edward Mason, *The Street Railway in Massachusetts: The Rise and Decline of an Industry* (Cambridge: Harvard University Press, 1932): 7.

32. *Springfield Daily Republican*, December 9, 1890.

33. *Springfield Union*, July 14, 1958.

34. *Springfield Daily Republican*, March 6, 1894.

35. Harold A. Ley, *The Recollections of Harold A. Ley*: 18.

36. *Springfield Republican*, August 10, 1895.

37. *Springfield Republican*, September 16, 1897.

38. *Street Railway Journal*, Vol. 17, No. 5, February 2, 1901: 203.

39. Harold A. Ley, *The Recollections of Harold A. Ley*: 18.

40. Harold A. Ley, *The Recollections of Harold A. Ley*: 21.

41. *Springfield Republican*, November 8, 1898.

42. *Springfield Republican*, April 18, 1899.

43. *Springfield Republican*, December 30, 1899.

44. *Western New England Magazine* 2, no. 7 (June-July 1912): 136.

45. Herbert L. McChesney, *A History of Ludlow Massachusetts: 1774–1974* (Ludlow, MA: Ludlow Bicentennial Committee, 1978): 325–329.

46. *Springfield Republican*, September 22, 1900.

47. *Springfield Republican*, December 10, 1900.

48. *Springfield Republican*, December 28, 1900.

49. *Springfield Republican*, December 20, 1900.

50. *Technology Review*, Massachusetts Institute of Technology, Vol. 3 (1901): 223.

51. *Springfield Republican*, September 17, 1901.

52. John H. Conkey and Dorothy D. Conkey, *History of Ware, Massachusetts, 1911–1960* (Barre, MA: Gazette, 1961): 41.

53. *Boston Herald*, November 7, 1900.

54. Springfield Preservation Trust, Inc., *A Guide to Forest Park Heights: Springfield's Largest "Streetcar Suburb,"* Springfield, Massachusetts.

55. *Springfield Republican*, February 19, 1902.

56. *Springfield Republican*, February 2, 1902.

57. *Springfield Republican*, March 20, 1902.

58. *Springfield Republican*, March 3, 1902

59. *Springfield Republican*, April 28, 1902.

60. *Springfield Republican*, August 2, 1902.

61. Harold A. Ley, *The Recollections of Harold A. Ley:* 48–50.

62. *Springfield Republican*, March 23, 1903.

63. O.R. Cummings, "A History of the Berkshire Street Railway," *Transportation Bulletin* 79 (January–December 1972), Warehouse Point, Connecticut: 4–9.

64. O.R. Cummings, "A History of the Berkshire Street Railway": 15–22.

65. O.R. Cummings, "A History of the Berkshire Street Railway": 35–42.

66. O.R. Cummings, "A History of the Berkshire Street Railway": 43.

67. O.R. Cummings, "A History of the Berkshire Street Railway": 44–46.

68. *Springfield Republican,* August 13, 1903.

69. O.R. Cummings, "A History of the Berkshire Street Railway": 47–49.

70. O.R. Cummings, "A History of the Berkshire Street Railway": 49–50.

71. *Transportation Bulletin* 75 (July–December 1968), Connecticut Valley Chapter, National Railway Historical Society, Warehouse Point, CT.

72. *Springfield Republican,* November 15, 1908.

73. Glendon L. Moffett, *Uptown—Downtown, Horsecars—Trolley Car: Urban Transportation in Kingston, New York, 1866–1930* (Fleischmanns, NY: Purple Mountain Press, 1997): 77–78.

74. *Springfield Republican,* June 4, 1909.

75. *Springfield Republican,* January 14, 1909.

Chapter 5

1. Grace Hoadley Dodge and Thomas Hunter, What Women Can Earn (New York: Frederick A. Stokes, 1899): 109.

2. Francis S. Swale, "Draftsmanship and Architecture, V, as Exemplified by the Work of William Van Alen," *Pencil Points* 10 (August 1929): 516.

3. *Western Architect* 18: 41, 1908.

4. Robert A.M. Stern, *New York 1910*: 181–183.

5. *Winning Designs 1904–1927: Paris Prize in Architecture, Society of Beaux-Arts Architects* (New York: The Pencil Point Press, 1928).

6. Joan Dejean, *The Age of Comfort* (Bloomsbury: New York, 2009): 48.

7. A.D.F. Hamlin, "The Influence of the École Des Beaux-Arts on Our Architectural Education," *The Architectural Record* 23 (April 1908): 4.

8. *Winning Designs 1904–1927.*

9. *New York Times,* May 23, 1954.

10. Francis S. Swale, "Draftsmanship and Architecture, V, as Exemplified by the Work of William Van Alen."

11. *Winning Designs 1904–1927.*

12. Raymond Rudorff, *The Belle Epoque: Paris in the Nineties* (New York: Saturday Review Press, 1973): 310–311.

13. Letters, William Van Alen to Edward Tilton, the Van Alen Institute Archives.

14. Mary McAuliffe, *Twilight of the Belle Époque* (Lanham, MD: Roman & Littlefield, 2014): 155–174.

15. Arthur Drexler, *The Architecture of the École Des Beaux-Arts*: 459.

16. A.D.F. Hamlin, "The Influence of the École Des Beaux-Arts on Our Architectural Education," *The Architectural Record* 23, no. 4 (April 1908): 241–247.

17. David Garrard Lowe, *Beaux-Arts New York* (New York: Whitney Library of Design, Watson-Guptil Publications, 1998): 11–13.

18. Francis S. Swale, "Draftsmanship and Architecture, V, as Exemplified by the Work of William Van Alen."

19. David Garrard Lowe, *Beaux-Arts New York*: 11–13.

20. The Van Alen Institute Archives.

21. The Van Alen Institute Archives.

22. Kenneth Murchison, "The Chrysler Building as I See It."

Chapter 6

1. *Springfield Republican,* April 30, 1905.

2. *Springfield Republican,* May 3, 1903.

3. *Springfield Republican,* May 27, 1903.

4. Harold A. Ley, *The Recollections of Harold A. Ley*: 23.

5. *Springfield Republican,* January 12, 1905.

6. *Springfield Republican,* October 15, 1905.

7. Personal communication from Dr. Linda Schmidt, daughter of Dr. Patterson.

8. *Springfield Republican,* October 23, 1905.

9. Herbert L. McChesney, *A History of Ludlow Massachusetts: 1774–1974*: 346–348.
10. *Springfield Republican*, November 23, 1905.
11. *Springfield Republican*, March 20, 1906.
12. *Springfield Republican*, May 13, 1906.
13. *Springfield Republican*, November 14, 1905.
14. *Springfield Republican*, April 12, 1906.
15. *Springfield Republican*, June 20, 1906.
16. *Springfield Republican*, November 27, 1906.
17. *Springfield Republican*, December 11, 1906.
18. *Springfield Republican*, July 18, 1907.
19. *Springfield Republican*, August 23, 25, and 28, 1908.
20. *Springfield Republican*, August 29, 1908.
21. *Springfield Republican*, September 11, 1908.
22. *Pipolo v. Fred T. Ley and Company*, 216 Mass. 246 (1913).
23. *Springfield Republican*, October 7, 1909: 9.
24. *Springfield Republican*, February 27, 1910.
25. *Springfield Republican*, March 13, 1910.
26. *Western New England Magazine* 1, no. 1 (December 1910), inside cover.
27. *Springfield Republican*, April 19, 1910.
28. *Boston Journal*, March 31, 1910: 11.
29. *Springfield Republican*, December 8, 1909.
30. *Architecture and Building* XLV, no, 2 (February 1913): 65.
31. *Springfield Republican*, August 31, 1910.
32. *Springfield Republican*, January 10, 1911.
33. *Springfield Republican*, March 23, 1911.
34. *Springfield Union*, July 14, 1958.
35. *Springfield Journal*, February 9, 1989.
36. *Springfield Republican*, April 14, 1908.
37. *Springfield Republican* and *New York Times*, September 15, 1908.
38. *Springfield Republican*, February 17, 1910.
39. *Springfield Republican*, June 7, 1910.
40. *Springfield Republican*, June 19, 1910.
41. *Springfield Union*, July 14, 1958.
42. Thaddeus M. Szetela, *History of Chicopee, Chicopee, Mass.* (Chicopee, MA: Szetela & Rich Pub. Co., 1948): 118–120, 134.
43. *Springfield Union*, July 14, 1958.
44. *Western New England Magazine* 1, no. 2 (January 1911), inside cover.
45. Harold A. Ley, *The Recollections of Harold A. Ley*: 31.
46. Halbert P. Gillette and Richard T. Dana, *Construction Cost Keeping and Management* (New York: McGraw-Hill, 1922): 406 ff.
47. *Springfield Daily News*, June 7, 1911.
48. *Springfield Republican*, June 2, 1912.
49. *Western New England Magazine* 3, no. 4 (April 1913): 184.
50. Thomas L. Higgins, M.D., and Linda S. Baillargeon, *Baystate Medical Center* (Charleston, SC: Arcadia, 2014): 45–49 and *Modern Hospital* 12 (January 1919): 189.
51. *Springfield Union*, July 14, 1958.
52. Frances Gagnon, *Eastern States Exposition, 1916–1996: An Illustrated History at 75 Years* (West Springfield, MA: The Exposition, 1997).
53. *Springfield Republican*, January 16, 1915.
54. *Springfield Republican*, January 16, 1915.
55. *Springfield Republican*, December 22, 1915.
56. *Springfield Republican*, December 29, 1915.
57. *Springfield Republican*, September 19, 1916.
58. *Springfield Republican*, December 30, 1915.
59. *Springfield Republican*, April 6, 1916.
60. *Springfield Republican*, May 2, 1916.
61. *Springfield Republican*, May 14, 1916.
62. *Springfield Republican*, June 4, 1916.

63. *Springfield Republican*, June 16, 1910.
64. *Springfield Republican*, June 26, 1916.
65. *Springfield Republican*, July 2, 1918.
66. *Springfield Republican*, September 19, 1916.
67. *Springfield Republican*, October 22, 1916.

Chapter 7

1. Andrew S. Dolkart and Matthew A. Postal, *Guide to New York City Landmarks, Third Edition* (New York: John Wiley & Sons, 2004): 75.
2. Harold C. Werner and August P. Windolph, *Architectural Sketches: Photographs of Buildings Designed by Werner & Windolph, Architects, Erected and in Course of Erection During the Year of 1897* (New York: City and Suburban Architecture, 1897).
3. Neal Bascomb, *Higher*: 67.
4. Francis S. Swale, "Draftsmanship and Architecture, V, as Exemplified by the Work of William Van Alen": 523.
5. Library of Congress, Copyright Office, *Catalogue of Copyright Entries: Part 4, New Series, Volume 7, for the Year 1912, Nos. 1–4* (Washington, D.C.: U.S. Government Printing Office, 1913): 586.
6. Library of Congress, Copyright Office, *Catalogue of Copyright Entries: Part 4, New Series, Volume 7, for the Year 1912, Nos. 1–4* (Washington, D.C.: U.S. Government Printing Office, 1918): 586.
7. Lowe, *Beaux-Arts New York*: 53.
8. *Real Estate Record and Builders Guide* 91 (March 1, 1919): 475.
9. *American Architect and Building News*, April 30, 1913.
10. Library of Congress, Copyright Office, *Catalogue of Copyright Entries: Part 4, New Series, Volume 7, for the Year 1913, Nos. 1–4* (Washington, D.C.: U.S. Government Printing Office, 1914): 269.
11. Library of Congress, Copyright Office, *Catalogue of Copyright Entries: Part 4, New Series, Volume 7, for the Year 1912 (And 1913), Nos. 1–4* (Washington, D.C.: U.S. Government Printing Office, 1913 and 1914).
12. *Real Estate Record and Builders Guide* 94 (September 12, 1914): 452.
13. Paul Starrett, *Changing the Skyline: An Autobiography* (New York: Whittlesey House, 1938): 30.
14. Christopher Gray, "Streetscapes/William Van Alen; an Architect Called the 'Ziegfeld of His Profession.'"
15. New York City Office for Metropolitan History.
16. *Real Estate Record and Builders Guide* 94 (September 19, 1914): 489.
17. Kenneth Frampton and Yukio Futagawa, *Modern Architecture 1851–1945* (New York: Rizzoli, 1983): 56.
18. Lorraine B. Diehl and Marianne Hardart, *The Automat* (New York: Clarkson Potter, 2002): 21, 22, 28, 34, 39.
19. *New York Times*, August 2, 1914.
20. Francis S. Swale, "Draftsmanship and Architecture, V, as Exemplified by the Work of William Van Alen": 523.
21. Paul Starrett, *Changing the Skyline: An Autobiography*.
22. *Van Alen vs. Aluminum Co. of America*, 43 Federal.Supplement 833 (1942), District Court of the Southern District of New York.
23. *Springfield Republican*, February 21, 1915.
24. *New York Times*, August 2, 1914.
25. *Real Estate Record and Builders Guide* 94 (September 12, 1914): 452 and (October 17, 1914): 662.
26. New York City Office for Metropolitan History.
27. *Real Estate Record and Builders Guide* 95 (February 27, 1915): 335, 350.
28. New York City Directory, 1915.
29. U.S. Census, 1920.
30. Christopher Gray, "Streetscapes/William Van Alen; an Architect Called the 'Ziegfeld of His Profession.'"
31. *Real Estate Record and Builders Guide*, Vol. 97: 343, February 26, 1916; 164, March 18, 1916; 452, March 18, 1916, 179, March 25, 1916; 302, May 20, 1916; 849, June 3, 1916.

32. *The Architectural Record*, Vol. 44, September 1918, 259.
33. *The Architectural Record*, Vol. 44, October 1918, 358–359.
34. *New York Times*, August 26, 1922.
35. New York City Office for Metropolitan History.
36. *New York Times*, January 1, 1922.
37. Leon V. Solon, "The Passing of the Skyscraper Formula in Design," *Architectural Record* 55 (February 1924): 144
38. *Real Estate Record and Builders Guide* 105 (June 12, 1920): 791.
39. Museum of the City of New York, http://collections.mcny.org/Collection/566–5th-Avenue.-J.M.-Gidding-and-Co.-Building.-2F3XC59MT4.html, accessed 6/30/16.
40. *New York Times*, January 1, 1922.
41. New York City Office for Metropolitan History.
42. Francis S. Swale, "Draftsmanship and Architecture, V, as Exemplified by the Work of William Van Alen": 526.
43. Alastair Duncan, *American Art Deco* (London: Thames and Hudson, 1986): 7.
44. Bevis Hillier, *Art Deco* (London: Herbert Press Limited, 1968): 10–12.
45. Alastair Duncan, *American Art Deco*: 10
46. Alastair Duncan, *American Art Deco*: 127.
47. Bevis Hillier, *Art Deco*: 26–55.
48. Christopher Frayling, in Charlotte Benton, Tim Benton and Ghislaine Wood, *Art Deco: 1910–1930* (New York: Bulfinch Press, 2003): 41–48.
49. Oriana Baddeley in Charlotte Benton: 57–64.
50. Charlotte Benton and Tim Benton, in Charlotte Benton, *Art Deco: 1910–1930*: 101–110.
51. Penelope Curtis, in Charlotte Benton, *Art Deco: 1910–1930*: 51–55.
52. Bevis Hillier, *Art Deco*: 26–55.
53. David Stravitz, *The Chrysler Building*: 6.
54. Robert A.M. Stern, Gregory Gilmartin and Thomas Mellins, *New York 1930: Architecture and Urbanism Between the Two World Wars* (New York: Rizzoli International Publications, 1987): 545.
55. *Real Estate Record and Builders Guide* 110 (July 17, 1922): 745.
56. New York City Office for Metropolitan History.
57. *Real Estate Record and Builders Guide* 110 (July 15, 1922): 54.
58. *Real Estate Record and Builders Guide* 110 (November 4, 1922): 594.
59. *The Prudence Building, New York City*, Architecture and Building 56 (March 1924): 19, plates 51–56.
60. *American Architect* 5, no. 2438 (January 1924): 106.
61. Neal Bascomb, *Higher*: 4–5.

Chapter 8

1. *Real Estate Record and Builders Guide* 93 (January 24, 1914): 188.
2. http://www.iridetheharlemline.com/tag/hartsdale/, accessed 6/30/16.
3. *Springfield Republican*, July 5, 1915.
4. http://afterthefinalcurtain.net/2011/03/23/proctors-palace-theatre/, accessed 6/30/16.
5. *Real Estate Record and Builders Guide*, August 19, 1916: 266–267.
6. *Real Estate Record and Builders Guide* 93 (May 30, 1914): 984.
7. http://www.tedhake.com/viewuserdefinedpage.aspx?pn=whco, accessed 6/30/16.
8. *Real Estate Record and Builders Guide*, August 14, 1915: 298.
9. *Real Estate Record and Builders Guide*, September 11, 1915: 457.
10. *Real Estate Record and Builders Guide* 96 (December 4, 1915): 944.
11. Paul Starrett, *Changing the Skyline: An Autobiography*: 187.
12. *Real Estate Record and Builders Guide*, August 19, 1916: 265–270.
13. U.S. Census Bureau.
14. *Real Estate Record and Builders Guide* 97 (January 15, 1916): 113.
15. *Real Estate Record and Builders Guide* 98 (August 19, 1916): 118
16. Witwold Rybczynski and Laurie Olin, *Vizcaya: An American Villa and Its Makers* (Philadelphia: University of Pennsylvania Press, 2007): 10–14.
17. www.vizcaya.org, the official web site of the Vizcaya Museum, accessed 6/16/16.

18. Witwold Rybczynski, *Vizcaya*: 15, 26, 136.
19. Letter, James Deering to F. Hoffmann, February 2, 1915, Vizcaya Museum Archives and Harold A. Ley, *The Recollections of Harold A. Ley*: 27.
20. Witwold Rybczynski, *Vizcaya*: 140.
21. Letter, James Deering to Paul Chalfin, April 8, 1916, Vizcaya Museum Archives.
22. Letters from August Koch, May–September 1916, Vizcaya Museum Archives.
23. Contract between Fred T. Ley & Co. and James Deering, September 18, 1919, Vizcaya Museum Archives.
24. Harold A. Ley, *The Recollections of Harold A. Ley*: 23.
25. Robert A.M. Stern, *New York 1930*: 31–34.
26. Oak Grove Cemetery register.

Chapter 9

1. *Springfield Republican*, April 7, 1917.
2. *Springfield Republican*, April 7, 1917.
3. *Springfield Republican*, April 8, 1917.
4. *Springfield Sunday Republican*, April 15, 1917.
5. *Springfield Republican*, April 28, 1917.
6. *Springfield Republican*, May 12, 1917.
7. *Springfield Republican*, May 16, 1917.
8. *Springfield Republican*, May 17, 1917.
9. *Augusta (Georgia) Chronicle*, July 16, 1917.
10. *Springfield Republican*, May 17, 1917.
11. *Springfield Republican*, May 18, 1917.
12. *Springfield Republican*, May 19, 1917.
13. *Springfield Republican*, May 28, 1917.
14. Starrett, Paul, *Changing the Skyline: An Autobiography*: 187.
15. Harold A. Ley, *The Recollections of Harold A. Ley*: 37.
16. William J. Graham, *Report of the Committee on Expenditures in the War Department—Camps*, 66th Congress, 2nd Session, House of Representatives, House Calendar No. 190, Report No. 816, April 10, 1920: 156–157.
17. William J. Graham, *Report of the Committee on Expenditures in the War Department—Camps*: 18.
18. William J. Graham, *Report of the Committee on Expenditures in the War Department—Camps*: 56.
19. *Decisions of the War Department Board of Contract Adjustment* 5 (1920): 551.
20. *Springfield Republican*, June 12, 1917.
21. Harold A. Ley, *The Recollections of Harold A. Ley*: 38.
22. Harold A. Ley, *The Recollections of Harold A. Ley*: 42.
23. *Decisions of the War Department Board of Contract Adjustment* 5 (1920): 551.
24. *Springfield Republican*, June 19, 1917.
25. Harold A. Ley, *The Recollections of Harold A. Ley*: 42.
26. Fred T. Ley & Company, *Camp Devens: National Army Cantonment, Ayer, Massachusetts, Built by Fred T. Ley & Co., Inc. Boston, Springfield, Mass., New York*, Fred T. Ley, 1918.
27. Fred T. Ley & Company, *Camp Devens*.
28. Harold A. Ley, *The Recollections of Harold A. Ley*: 40.
29. *Springfield Republican*, July 27, 1917.
30. *Springfield Republican*, August 26, 1917.
31. *Springfield Republican*, September 2, 1917.
32. Anthony M. Sammarco, *A History of Howard Johnson's: How a Massachusetts Soda Fountain Became an American Icon* (Charleston, SC: American Palate, 2013).
33. *Springfield Republican*, October 19, 1917.
34. *Springfield Republican*, November 10, 1917.
35. Fred T. Ley & Company, *Camp Devens*.
36. *Springfield Republican*, December 11, 1917.
37. *Springfield Union*, July 14, 1958.

38. *Decisions of the War Department Board of Contract Adjustment* 5 (1920): 932 ff.
39. *Decisions of the War Department Board of Contract Adjustment* 5, 1920: 551 ff.
40. Fred T. Ley Co. vs. United States, 273 U.S. 386 (1927).
41. U.S. Department of Justice *Report on the Aircraft Inquiry* (Washington D.C.; Pusey, Hughes, 1918).
42. House Reports, Vol. 2. 66th Congress, Second Session, Report No. 816, April 1, 1920.
43. *Springfield Republican*, June 9, 1927.

Chapter 10

1. *New York Times*, August 29, 1943.
2. Christopher Gray, "Streetscapes: The Childs Building; Fast Food, Then and Now on Stylish Fifth Avenue," *New York Times*, November 6, 1988.
3. New York City Office for Metropolitan History.
4. Photograph, Museum of the City of New York, MNY239439.
5. G.H. Edgell, *American Architecture of To-Day* (New York: Scribner, 1928).
6. Francis Swale, "Draftsmanship and Architecture, V, as Exemplified by the Work of William Van Alen": 526.
7. Robert A. M. Stern, *New York 1930*: 275–76.
8. New York City Office for Metropolitan History.
9. Donald L. Miller, *Supreme City: How Jazz Age Manhattan Gave Birth to Modern America* (New York: Simon & Schuster, 2014).
10. Debbie Carmody, Monmouth County Historical Association, personal communication.
11. Monmouth (NJ) County Historical Association, http://www.monmouthhistory.org/Sections-read-179.html, accessed 6/30/16.
12. *Selections from the Recent Work of William Van Alen, Architect* (New York: Architectural Catalog Co., 1928).
13. Francis Swale, "Draftsmanship and Architecture, V, as Exemplified by the Work of William Van Alen": 523.
14. Christopher Gray, "Streetscapes/William Van Alen; an Architect Called the 'Ziegfeld of His Profession.'"
15. Kenneth M. Murchison, "The Chrysler Building as I See It."
16. Christopher Gray, "Streetscapes/William Van Alen; an Architect Called the 'Ziegfeld of His Profession.'"
17. New York City Office for Metropolitan History.
18. http://www.emporis.com/building/sportsplazabuilding-newyorkcity-ny-usa, accessed 6/30/16.
19. Robert A.M. Stern, *New York 1930*: 115.
20. "Grand Central Terminal Opens," *Railway Age*, September 2006: 78.
21. William A. Starrett, "Mountains of Manhattan," *Saturday Evening Post* 200 (May 12, 1928): 76.

Chapter 11

1. Harold A. Ley, *The Recollections of Harold A. Ley*: 32–36.
2. Harold A. Ley, *The Recollections of Harold A. Ley*: 32–36.
3. Daniel Masterson, *The History of Peru* (Westport, CT: Greenwood Press, 2009): 82–89.
4. Harold A. Ley, *The Recollections of Harold A. Ley*: 32–36.
5. Harold A. Ley, *The Recollections of Harold A. Ley*: 32–36.
6. Harold A. Ley, *The Recollections of Harold A. Ley*: 32–36.
7. *Springfield Sunday Union and Republican*, December 30, 1928.
8. Daniel Masterson, *The History of Peru*.
9. *Springfield Sunday Union and Republican*, December 30, 1928.
10. Harold A. Ley, *The Recollections of Harold A. Ley*: 32–36.
11. *Springfield Union*, July 14, 1958.
12. *Real Estate Record and Builders Guide* 100 (October 6, 1917): 446.
13. *Real Estate Record and Builders Guide* 100 (October 6, 1917): 446.

14. *Real Estate Record and Builders Guide* 99 (December 23, 1917): 871.
15. Harold A. Ley, *The Recollections of Harold A. Ley*: 52.
16. *Real Estate Record and Builders Guide* 105 (January 3, 1920): 18.
17. *Real Estate Record and Builders Guide* 105 (January 10, 1920): 55.
18. *Real Estate Record and Builders Guide* 105 (January 10, 1920): 55.
19. *Springfield Republican*, July 14, 1958.
20. Transcript of a tape-recorded interview with Jean Paul Slusser, March 14, 1970, by Dennis Barrie, for the Archives of American Art, Smithsonian Oral History Collection: 29–30.
21. *Real Estate Record and Builders Guide* 105 (January 10, 1920): 54.
22. *Real Estate Record and Builders Guide* 105 (January 10, 1920): 54.
23. John T. Boyd, "The New York Zoning Resolution and Its Influence Upon Design," *Architectural Forum* 25 (October 1921): 210.
24. *Real Estate Record and Builders Guide* 105 (May 15, 1920): 652.
25. Robert A.M. Stern, *New York 1930*: 539.
26. *Real Estate Record and Builders Guide* 105 (January 24, 1920): 118 and (March 20, 1920): 394.
27. *Real Estate Record and Builders Guide* 110 (July 1, 1922): 23, (September 9, 1922): 346, and (July 1, 1922): 26.
28. Robert A.M. Stern, *New York 1930*: 533.
29. Harold A. Ley, *The Recollections of Harold A. Ley*: 52–53.
30. New York Passenger Lists, accessed through Ancestry.com, June 2016.
31. *The Boston Herald*, January 1, 1928.
32. *The Boston Herald*, March 26, 1928.
33. The *Springfield Republican*, January 18, 1928.
34. *The Boston Herald*, July 28, 1930.
35. *The Boston Herald*, November 24, 1936.

Chapter 12

1. Walter P. Chrysler, *Life of an American Workman*: 191–97.
2. Vincent Curcio, *Chrysler*: 411.
3. *New York Times*, October 4, 1928.
4. Vincent Curcio, *Chrysler*: 411.
5. John B. Reynolds, *Chrysler Building: 42nd to 43rd Streets, Lexington Avenue, New York City "The World's Tallest Building"* (New York: John B. Reynolds, 1930) and Neal Bascomb, *Higher*: 53.
6. Interim Report of the Joint Legislative Committee on Housing, New York Legislative Documents, One Hundred and Forty-Fifth Session XV, nos. 58 to 72 (Albany: J.B. Lyon Company, 1922): 43.
7. Mt. Pleasant Cemetery, Hawthorne, New York, Bradford McCormick, personal communication.
8. Patricia Volk, *Stuffed: Adventures of a Restaurant Family* (New York: Alfred A. Knopf, 2001): 83–95.
9. Neal Bascomb, *Higher*: 18.
10. Hugh Ferriss, *The Metropolis of Tomorrow* (New York: Princeton Architectural Press, 1986): 192.
11. Hugh Ferris, *American Architect* 135 (May 20, 1929): 15.
12. David Stravitz, *The Chrysler Building* (New York: Princeton Architectural Press, 2002): 8.
13. Neal Bascomb, *Higher*: 55.
14. David Stravitz, *The Chrysler Building*: 10.
15. John B. Reynolds, *Chrysler Building*.
16. David Stravitz, *The Chrysler Building*: 16.
17. David Stravitz, *The Chrysler Building*: 14–19.
18. Neal Bascomb, *Higher*: 57.
19. Neal Bascomb, *Higher*.
20. John B. Reynolds, *Chrysler Building*: 2.
21. Neal Bascomb, *Higher*: 85.
22. David Stravitz, *The Chrysler Building*: 24.

23. John B. Reynolds, *Chrysler Building*: 3.
24. David Stravitz, *The Chrysler Building*: 26.
25. John B. Reynolds, *Chrysler Building*: 17–18.
26. John B. Reynolds, *Chrysler Building*: 17–18.
27. John B. Reynolds, 17–18.
28. Neal Bascomb, *Higher*: 111.
29. David Stravitz, *The Chrysler Building*: 33.
30. David Stravitz, *The Chrysler Building*: 45.
31. John B. Reynolds, part 7.
32. David Stravitz, *The Chrysler Building*: 37.
33. John B. Reynolds, *Chrysler Building*: 17–18.
34. John B. Reynolds, *Chrysler Building*: 7–8.
35. U.S. Patent 1794809, filed September 18, 1929, published March 3, 1931.
36. *Van Alen v. Aluminum Co. of America et al.*, 43 F.Supp. 833 (1942), District Court of the Southern District of New York, March 18, 1942.
37. Neal Bascomb, *Higher*: 129.
38. John B. Reynolds, *Chrysler Building*: 3.
39. http://www.districtenergy.org/pdfs/03AnnConfPresen/JacobsNYSteamSystem.pdf, and http://www.coned.com/history/, accessed 6/30/16.
40. John B. Reynolds, *Chrysler Building*: 43–45.
41. John B. Reynolds, *Chrysler Building*: 49–51.
42. John B. Reynolds, *Chrysler Building*: 51.
43. John B. Reynolds, *Chrysler Building*: 7–8.
44. John B. Reynolds, *Chrysler Building*: 55–59.
45. John B. Reynolds, *Chrysler Building*: 3.
46. John B. Reynolds, *Chrysler Building*: 3.
47. John B. Reynolds, *Chrysler Building*: 25.
48. New York City Landmarks Preservation Commission Report, Designation List 118, LP-0996, September 12, 1978.
49. New York City Landmarks Preservation Commission Report, Designation List 118, LP-0996, September 12, 1978.
50. U.S. Patent 1646045, filed June 14, 1923, published October 18, 1927.
51. Robert A.M. Stern, *New York 1930*: 609.
52. New York City Landmarks Preservation Commission Report, Designation List 118, LP-0996, September 12, 1978.
53. John B. Reynolds, *Chrysler Building*: 41.
54. John B. Reynolds, *Chrysler Building*: 3.
55. David Stravitz, *The Chrysler Building*: 36–69.
56. John B. Reynolds, *Chrysler Building*: 17–18.
57. John B. Reynolds, *Chrysler Building*: 7–8.
58. John B. Reynolds, *Chrysler Building*: 11.
59. John B. Reynolds, *Chrysler Building*: 17–18.
60. John B. Reynolds, *Chrysler Building*: 17–18.
61. Neal Bascomb, *Higher*: 207.
62. David Stravitz, *The Chrysler Building*: xiii, 77–78.
63. Neal Bascom, *Higher*: 221.
64. John B. Reynolds, *Chrysler Building*: 17–18.
65. David Stravitz, *The Chrysler Building*: 102, 107, 123.
66. John B. Reynolds, *Chrysler Building*: 3.
67. Kenneth M. Murchison, "The Chrysler Building as I See It."
68. *The Chrysler Building, New York* (Massachusetts Mutual Life Insurance Company and Richard S. Gordon, 1978): frontispiece.

Chapter 13

1. Christopher Gray, "Streetscapes/William Van Alen; an Architect Called the 'Ziegfeld of His Profession.'"

2. *The New Yorker*, July 12, 1930: 67–68.
3. Lewis Mumford, "Notes on Modern Architecture," *The New Republic* 66 (March 18, 1933): 120.
4. "Criticism of the Chrysler Building," *Architectural Forum* 53 (October 1930): 410.
5. *New York Times*, June 18, 1930.
6. *New York Times*, August 22, 1931.
7. Clinton H. Blake, "What to Put in a Contract to Keep Out of Trouble with Clients," *American Architect*, September 1930: 34.
8. *Dallas Morning News*, May 12, 1930.
9. Harold A. Ley, *The Recollections of Harold A. Ley*: 53.
10. *Springfield Republican*, January 12, 1930.
11. *New York Times*, December 21, 1930.
12. Christopher Gray, "Streetscapes: The Beaux-Arts Ball," *New York Times*, January 1, 2006.
13. Society of Beaux-Arts Architects, *The Beaux-Arts Boys on the Boulevards* (New York: Society of Beaux-Arts Architects, 1931).
14. *New York Times*, January 30, 1932.
15. USPTO, *Catalog of Copyright Entries: 1929*, pt. iv, n.s., v. 24: 160.
16. John Fistere, "Skyline Architects Turn to Houses," *House and Garden*, January 1934: 35.
17. Philip Langdon, *Orange Roofs, Golden Arches: The Architecture of American Chain Restaurants* (New York: Alfred A. Knopf, 1986): 33.
18. *Time Magazine*, April 1, 1935.
19. U.S. Patent 2260353, filed May 10, 1938, published October 28, 1941.
20. *Cleveland Plain Dealer*, April 22, 1936.
21. *Jewish Chronicle* (Newark, NJ), June 26, 1936.
22. *National Labor Tribune* (Pittsburgh, PA), May 9, 1936.
23. *Decorative Art* 32 (1937): 42.
24. http://www.artdecoresource.com/2013/10/all-about-modernage.html, accessed 6/30/16.
25. *Miami Sun-Sentinel*, April 14, 2007.
26. Christopher Gray, "Streetscapes/Sea Gate, Brooklyn; Beachfront House, Shining White and Made of Steel," *New York Times*, August 6, 2000.
27. New York City Office for Metropolitan History.
28. *The New Yorker*, December 18, 1937: 18–19.
29. *Repository* (Canton, OH), October 4, 1936.
30. *New York Times*, January 14, 1938.
31. Christopher Gray, "Streetscapes/William Van Alen; an Architect Called the 'Ziegfeld of His Profession.'"
32. *Springfield Republican*, February 18, 1936.
33. *Springfield Republican*, May 2, 1936.
34. *Springfield Republican*, April 23, 1937.
35. *Springfield Union*, July 14, 1958.
36. *Springfield Republican*, May 15, 1937.
37. *Springfield Republican*, February 5, 1937.
38. *Springfield Republican*, April 19, 1937.
39. *Springfield Republican*, June 14, 1938.
40. *Springfield Union*, July 14, 1958.
41. *Springfield Republican*, June 14, 1938.
42. *Springfield Republican*, December 18, 1939.
43. Springfield Armory Museum archives and http://www.collinselectricco.com/fluorescent.html, accessed 6/30/16.
44. http://www.vanalen.org/about/history, accessed 6/30/16.
45. *New York Times*, May 25, 1954.
46. *New York Times*, May 25, 1954.
47. Cold Spring New York Cemetery Register.
48. *Springfield Union*, July 14, 1958.
49. *New York Times*, July 14, 1958.
50. *Springfield Republican*, May 13, 1956.
51. *Springfield Republican*, August 19, 1953.

52. Personal communication from Dr. Linda Schmidt, daughter of Dr. Patterson.
53. *Springfield Union*, July 14, 1958.
54. www.buildwelliver.com, accessed 6/30/16.
55. *New York Times*, August 7, 1964.

Appendix D

1. John B. Reynolds, *Chrysler Building*: 41.

Bibliography

Bascomb, Neal. *Higher.* New York: Doubleday, 2003.

Burnham, Alan, ed. *New York Landmarks: A Study and Index of Architecturally Notable Structures in Greater New York.* Middletown, CT: Wesleyan University Press, 1963.

Champlin, Winslow S. *East Longmeadow, Mass.: 50 Years a Town.* East Longmeadow, MA: Town of East Longmeadow, 1944.

Condit, Carl W. *The Chicago School of Architecture.* Chicago: University of Chicago Press, 1964.

Curtis, William J.R. *Modern Architecture Since 1900.* Englewood Cliffs, NJ: Prentice-Hall, 1982.

Dalzell, Frederick. *Engineering Invention: Frank J. Sprague and the U.S. Electrical Industry.* Cambridge: MIT Press, 2010.

Dunlap, David W. *On Broadway: A Journey Uptown Over Time.* New York: Rizzoli, 1990.

Ferriss, Hugh. *The Metropolis of Tomorrow.* New York: Ives Washburn, 1929.

Frisch, Michael H. *Town into City: Springfield, Massachusetts, and the Meaning of Community, 1840–1880.* Cambridge: Harvard University Press, 1972.

Gloag, John, and Derek Bridgewater. *A History of Cast Iron in Architecture.* London: George Allen and Unwin, 1948.

Gray, Christopher. "Streetscapes/Row House Wrangler, Chuck Wagon Consultant." *New York Times*, May 8, 2011.

Gray, Christopher. "Streetscapes/William Van Alen; an Architect Called the 'Ziegfeld of His Profession.'" *New York Times*, March 22, 1998.

Jody, William H. *American Buildings and Their Architects; Progressive and Academic Ideals at the Turn of the Twentieth Century.* Garden City, NY: Anchor Books, 1976.

Konig, Michael F., and Martin Kaufman. *Springfield, 1636–1986.* Springfield, MA: Springfield Library and Museums Association, 1987.

Library of Congress, Copyright Office. *Catalogue of Copyright Entries: Part 4, New Series, Volume 7, for the Year 1912, Nos. 1–4.* Washington, D.C.: U.S. Government Printing Office, 1918.

McPhee, Edward. *Springfield's New Little River Water System.* Springfield, MA: McPhee, 1910.

Middleton, William D., and William D. Middleton, III. *Frank Julian Sprague: Electrical Inventor & Engineer.* Bloomington: Indiana University Press, 2009.

New York City Landmarks Preservation Commission. *Guide to New York City Landmarks*, 3rd Edition. New York: John Wiley & Sons, 2004.

Plunz, Richard. *A History of Housing in New York City.* New York: Columbia University Press, 1990.

Rajs, Jake. *New York City Landmarks.* Woodbridge, Suffolk: Antique Collectors' Club, Old Martlesham, 2012.

Reynolds, John B. *Chrysler Building: 42nd to 43rd Streets, Lexington Avenue, New York City "The World's Tallest Building."* New York: John B. Reynolds, 1930.

Robinson, Cervin, and Rosemarie Haag Bletter. *Skyscraper Style: Art Deco New York.* New York: Oxford University Press, 1975.

Bibliography

Society of Beaux-Arts Architects. *Winning Designs 1904–1927: Paris Prize in Architecture.* New York: Pencil Point Press, 1928.

Starrett, Paul. *Changing the Skyline: An Autobiography.* New York: Whittlesey House, 1938.

Stern, Robert A.M. *New York 1900: Metropolitan Architecture and Urbanism 1890–1915.* New York: Rizzoli, 1983.

Stern, Robert, A.M., Gregory Gilmartin, and Thomas Mellins. *New York 1930: Architecture and Urbanism Between the Two World Wars.* New York: Rizzoli, 1987.

Stravitz, David. *The Chrysler Building: Creating a New York Icon, Day by Day.* New York: Princeton Architectural Press, 2002.

Swale, Francis S., "Draftsmanship and Architecture, V, as Exemplified by the Work of William Van Alen." *Pencil Points* 10 (August 1929), 516–26.

Tower, James E., ed. *Springfield Present and Prospective.* Springfield, MA: Pond & Campbell, 1905.

Werner, Harold C., and August P. Windolph. *Architectural Sketches: Photographs of Buildings Designed by Werner & Windolph, Architects, Erected and in Course of Erection During the Year of 1897.* New York: City and Suburban Architecture, 1897.

Index

221

Index

Index

Index